AIRBRUSH PAINTING

ART, TECHNIQUES, & PROJECTS

AIRBRUSH PAINTING

ART, TECHNIQUES, & PROJECTS

NORMAN FULLNER

Professor of Art

California State University, Northridge

Photography by

CHESTER PRZELOMIEC

DAVIS PUBLICATIONS, INC.

Worcester, Massachusetts

Acknowledgments

My thanks to the many people who helped make this book possible, all those who offered photographs, information, and other assistance. In particular I thank Chester Przelomiec, who provided invaluable assistance in many areas, especially in preparing photographs for this book.

Much of the material in this book is derived from the airbrush classes I teach. I thank those students whose work I have used in the book and my colleagues Art Weiss and Morris Zaslavsky. Brad Benedict and many others helped too.

Many individuals provided assistance at various stages of the book. My thanks go to Gerald Brommer, who provided initial inspiration and guidance; Shirley Alfers, who provided excellent secretarial services; Michael Maurice of the Tigard Airbrush Company, Portland, Oregon, and Editor and Publisher of *Airbrush World Magazine,* who gave technical assistance; George Fox Mott, Ph.D., president of Wold Airbrush Manufacturing Company, who provided assistance with some of the later stages of the book; and my family, who were patient through the long hours I spent in preparing the book.

Norman Fullner

Printed in the United States of America
Library of Congress Catalog Card Number: 82-73301
ISBN: 0-87192-138-3

Graphic Design: Susan Marsh

10 9 8 7 6 5 4 3 2

751.494
Fullner

Contents

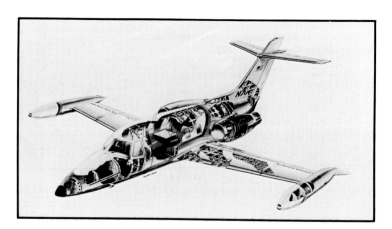

Richard Leech *Executive Jet*. Courtesy of the artist.

Peter Polombi. *Exotic Pets*. Courtesy of Elizabeth Asher.

P A R T T W O

Specific Applications

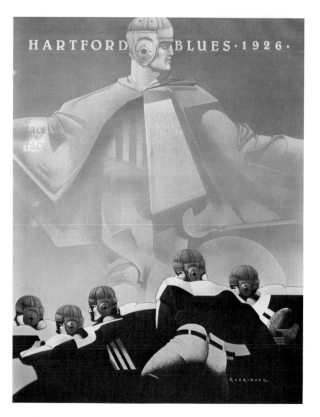

Robert Rodriguez. *Hartford Blues*. Courtesy of the artist.

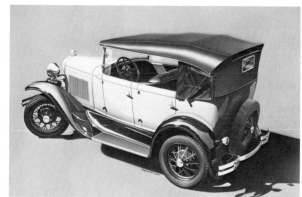

Gene Allison. *1930 Ford Phaeton*. Courtesy of the artist.

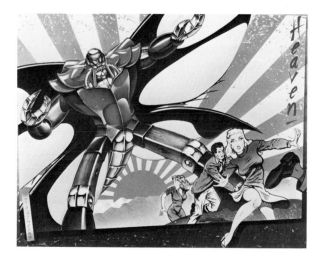

Todd Schorr. *Heaven Goes East*. Courtesy of the artist.

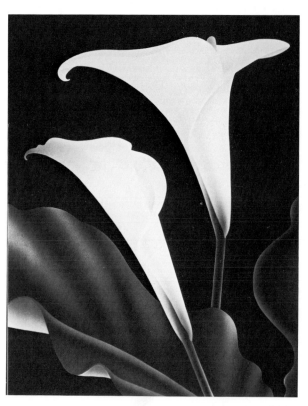

Brian Davis. *Calla*. Multiple edition hand painted with airbrushes, using a series of precisely cut metal stencils. Courtesy of the artist.

Foreword

Magazines and medical, architectural, and technical publications are permeated with airbrushed illustrations. Yet many people have never seen an airbrush, do not know what it looks like nor how it works. Now, at last, the ideal book has been written to help the craftsperson, the artisan, and the artist use the airbrush to the best advantage. This book fully explains the airbrush and its uses, and should become a standard in the field.

Airbrushing, in its infancy about ninety years ago, started with a poor reputation. It was seen as a way to draw buyers' attention to cheap merchandise. The first large use of the airbrush was in the mail order catalog. Today the airbrush has become a respectable—nay, an avant garde—art tool, appreciated for its uses in fine art.

The author, Norm Fullner, knows much more about his subject than the limits of a book can contain. From this wide knowledge he warns against costly trial and error and conveys instruction in a most economical and helpful way. All the processes, equipment, pigments, and hardware are dealt with. The illustrations are many and useful. The project method of describing each step of airbrush work is a tried and true method of help to the learner; but in this book it never becomes a dull, rote process.

Norman Fullner brings to his task all the right credentials: sound artistic and technical training, practical experience, visual imagination, and the skill to present every aspect of airbrushing. He has neglected nothing, from the most mundane aspects of product illustration to the most sophisticated techniques of fine art. This new volume is excellent.

George Fox Mott, Ph.D.
President, Wold Airbrush Mfg. Co.

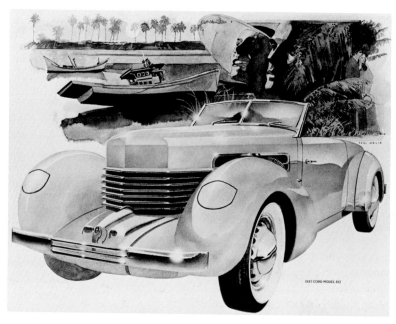

Paul Melia. *1937 Cord Model 812.* Courtesy of General Tire and Rubber Company.

Preface

Airbrush painting is an exciting, growing field. The airbrush can produce aesthetically pleasing surfaces, delightfully subtle transitions of color, and fascinating special effects.

The concern of this book is art and related areas which can utilize airbrush techniques. It covers more than just the methods of applying spray. This book explains how basic art elements can be produced and manipulated with the airbrush. It discusses techniques, and explains coordination of spray with other materials and methods. Many kinds of tools, accessories, masking materials, painting supports, airbrushes, and air guns are covered in this book.

Painting with an airbrush can be a very satisfying experience. Skill development should be sequential, however, due to the mechanical nature of the airbrush and airbrush techniques. Numerous projects in Part One and Part Two suggest methods for development of these skills. Some invite creative design solutions, as well. Student artworks shown in these pages demonstrate possible results for both kinds of exercises.

It is recommended that students work from two-dimensional images such as those offered here, rather than starting with three-dimensional models for the exercises. This allows students to concentrate on the mastery of airbrush tools and techniques, rather than on the problems of translating from an object to a two-dimensional representation.

For the more creative projects, such as rendering, it is best to use three-dimensional models. Examples of these projects are included to show what some students have done with the project, and should not be copied.

A double-action airbrush is recommended for use with this book. Student needs are limited to the tools and materials commonly associated with this kind of airbrush. Skills derived from these lessons can be applied to other materials and approaches to airbrushing.

Jeannie Kim. Plant stencils.

A word of caution: Because the spraying process releases some materials into the air, safety procedures should be followed, especially when doing moderate to heavy spraying. Adequate ventilation and a respirator worn over the nose and mouth must be utilized when spraying a medium which includes a volatile solvent. Statements of caution are included throughout this book. They are easily located, being in bold face type.

Norman Fullner

PART ONE

THE

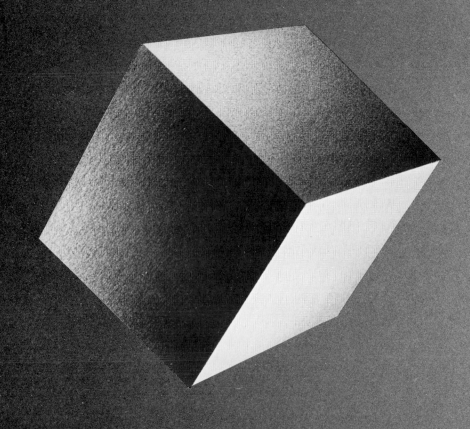

FUNDAMENTALS

The first six chapters present an introduction to airbrushing, describing the basic skills needed for use of the small, double-action airbrush and media normally associated with fine, small-scale work.

Chapter 1 Introduction to Airbrushing

Airbrush painting utilizes spray produced by air pressure from air-brushes, air guns and other tools. There are three noteworthy characteristics of paint spraying: the artist's tool (the airbrush) does not come into direct contact with the painting surface; spray produces areas with diffused edges. Other tools such as masks and brushes can be used to create sharper contours. The amount of spray that is propelled or falls onto surfaces and the uniformity of spray can be controlled with great precision.

The airbrush can create a broad range of images and effects. Artists can develop color gradations of amazing uniformity, and can develop opacity or transparency with unusual exactness. With properly thinned liquid media, artists can apply unusually smooth, even coats on surfaces. Spray can be applied in broad spatter-like patterns or, with a fine airbrush, in very small areas. Some airbrushing tools are appropriate for creating broad fields of color; others are capable of unusual precision. Paint can be applied quickly or in a slow, controlled manner.

Airbrushing can be appreciated as a complement to other processes as an alternative to the limitations imposed by other forms of painting. Regular brush painting, for example, may be too slow and not uniform or precise enough for the artist. Because of the limitations of photography and the demands of reproduction, the airbrush is an important tool of the photo retoucher. With mixed media it may be used to counter problems of transition that often occur when one material is placed next to another. In rendering, the airbrush may be the best means of reproducing the surface quality of some materials.

Traditional and Current Uses of the Airbrush

Spray processes are used in an interesting range of art forms, including color field paintings, animation backgrounds, large panoramic scenes, highly skilled color photo retouching in advertisements, color coatings on sculpture, album covers, car or van decorations, and clothing designs. Airbrush painting is also useful in industrial, production, home, hobby, and other fields.

Spray can be created and applied in various ways. Here we will focus on spraying with the airbrush—the most common tool used by artists in air painting. Artists use the larger air guns when it is necessary to cover larger surfaces or to use more viscous media. The discussion of airbrushing is emphasized in this book, rather than air gun use, because of the areas of art in which airbrushes are used. The

1-1 Peter Polombi. *Is It In?* Watercolor, 22 by 22 inches. Courtesy of Jeff Rund.

study of airbrushing gives the best basic training in air painting.

Although airbrush uses are constantly increasing, most approaches to airbrush painting employ fundamental processes. An understanding of these fundamentals will prepare you for more complex problems, such as those that involve a combination of basic processes or an addition of special techniques. You can then learn special techniques to create effects by mixing media, combining spray with different tools, varying textures, rendering form, establishing color or spatial relationships, or rendering the illusion of materials and surfaces.

Painting with Spray: A Historical Perspective

Documented uses of spray date back to the prehistoric Aurignacian period when paint was blown through a hollow bone onto stone surfaces. Later, spray was produced by blowing through hand-held atomizers or hand-operated bellows. However, it was not until the turn of the century that airbrush equipment and air painting, as we know them, developed. At that time, compressed air could be produced either by hand- or foot-operated pumps, or early versions of today's electric air compressors.

In this century, most approaches to air painting emphasized technical uses, until the period between 1920 and 1930. In looking back to this era, it is interesting to note some of the differences in uses. For example, an early airbrush book, *A Manual of Airbrush Techniques* by J. Carroll Tobias, places such importance on shoe illustrations, show cards, and monument designing (tombstones) that he devotes separate chapters to them. Although early uses of spray processes by notable artists are difficult to document, there are some interesting historical examples. Wassily Kandinsky and other artists at the Bauhaus in the 1920s and '30s used spray in some of their works.

During the 1930s and 1940s the airbrush became a popular and widely used commercial art tool. Its widespread acceptance seemed to coincide with current style preferences that emphasized such characteristics as precision, craftsmanship, clarity of contour, the finished look common to manufactured products, and streamlined styling (which was initially influenced by airflow dynamics). The airbrush was

1-2 Wassily Kandinsky. *Watercolor No. 272: From Cool Depths.* Watercolor on paper, mounted on paper, 19½ by 12¾ inches. Courtesy of the Norton Simon Museum of Art at Pasadena.

well suited for product, technical, and architectural renderings. That period's popular styles of handling the human form were also compatible with airbrush processes. Although much of the work of this period may look overly stylized by today's standards, it can be appreciated for its technical virtuosity. In fact, after differences in stylistic imagery are recognized, it is interesting to note that much of the work of that period is similar in technique to the work of many of today's illustrators.

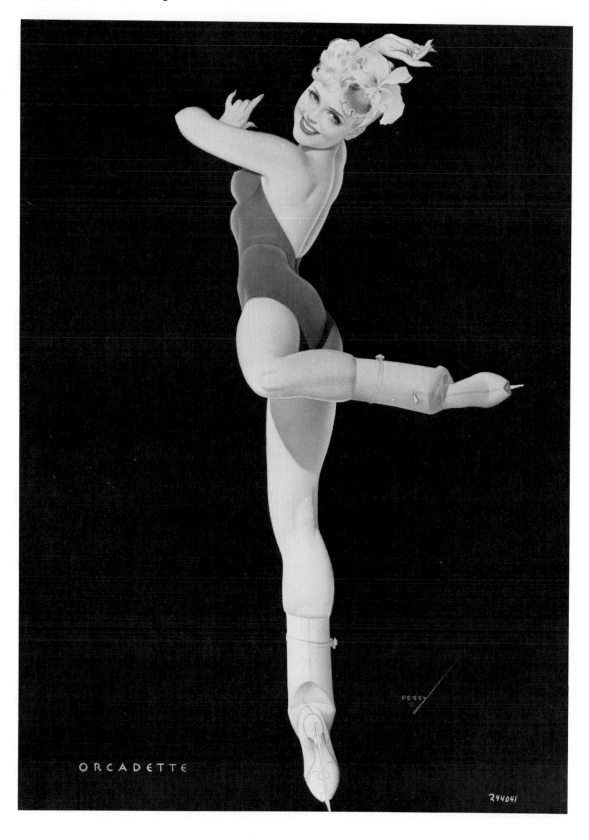

1-4 Otis Shepard. *Twin Girls—Straw Hat.* Watercolor, 16 by 48 inches. Car card. Courtesy of the Wm. Wrigley Jr. Company.

Even though many artists continued to use the airbrush during the 1950s and '60s, and although the work of some airbrush artists such as Otis Shepard continued with some success, airbrush imagery was not widely accepted. Its use in photo retouching continued to grow, however, as advertising needs and the development of mass media demanded significantly more photographs. During this period the airbrush also became more frequently used in hobby and craft fields.

Airbrush painting again became popular in the mid-seventies, both in traditional areas and in new and exciting directions inspired by new media, tools, and techniques. This new interest has been widespread in the fine arts, where the airbrush process previously had been largely ignored. (See **C-1**, color section.)

1-5 Chuck Close. *Self-Portrait.* Watercolor on paper mounted on canvas, 81 by 58½ inches. Collection of the Museum Moderner Kunst, Vienna (Ludwig Collection). Photo courtesy of the Pace Gallery, New York.

◄

1-3 George B. Petty. *Orcadette.* Watercolor, 14 by 11 inches. Courtesy of Ice Capades Inc.

Chapter 2 **Preparations for the Beginner**

In this book, airbrush painting is primarily taught through small-scale use of the double-action airbrush, related equipment or tools, and water miscible media. It is assumed that the skills learned with this tool will also provide excellent training for the use of other materials, airbrushes, and air guns, and for the problems of large-scale painting.

This chapter briefly introduces what you need to begin airbrush painting. More specific information is given in Part III and in the appendixes.

Equipment

Airbrushes

The small double-action airbrush with the small assembly head **(2-1)**, or the same airbrush with the larger assembly head, is recommended for those mostly interested in small-scale applications with gouache, transparent watercolors, or dyes. Artists primarily interested in somewhat larger-scale work

or the use of more viscous media, such as acrylic polymer, will want to purchase a large-barrel, double-action airbrush. The small head assembly of this airbrush should be used for small-scale work and media of low viscosity and the larger assembly heads are appropriate where either more spray or more viscous paint is necessary.

Artists whose work does not include fine manipulations such as those required in the lessons in this book can gain necessary understanding and skill with either a small or large barrel single-action airbrush.

Accessories

You will need a ¼-inch hose that is long enough to reach between the air source and the airbrush. It should also have sufficient slack so that you can handle it properly and easily move around without the line becoming taut. For classroom use where air outlets are placed close to air-painting stations, 10 feet of hose is usually sufficient.

Most airbrushes come with a metal color cup for either painting medium or water. However, it is especially important for the beginner also to have either an additional large metal cup, assembly jar, or eyedropper for spraying water through the airbrush and cleaning it. Without these accessories it is difficult to prevent the buildup of hardened medium in the airbrush. Photograph **2-2** shows a large metal cup, an assembly jar, magnifying glass, color cup, eyedropper and reamer.

Air supply

Whether the beginning student's initial experiences with airbrush painting are in the classroom or elsewhere, the air requirements for the lessons are about the same: a constant 35 pounds of pressure is sufficient for most situations. You may find it best to delay making a financial commitment to a particular type or size until you can clearly determine your

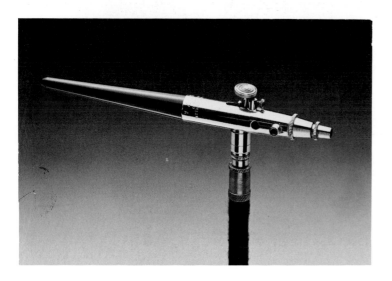

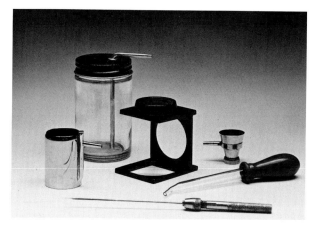

2-2

Materials

It is usually best to purchase materials as needed. Top-quality art materials are often expensive, so you may wish to make do with fewer and/or less expensive substitutes until you are sure of your continuing interest in airbrush painting. However, a more thorough mastery of airbrush painting requires that you use quality materials and tools. Appendixes 1 and 2 provide lists of materials and painting media needed for airbrush painting.

The Working Space

Safe working conditions are important in airbrush painting. For details on ventilation, respirators, and pressure systems, see the boldface information in chapters 12, 13, 14, and 18.

specific needs. However, if you must make a decision before you have a chance to gain some experience, the information in chapter 14 will probably be adequate for you to make a good selection. Photograph **2-3** shows a piston compression, a small diaphragm compressor, and a carbon dioxide tank.

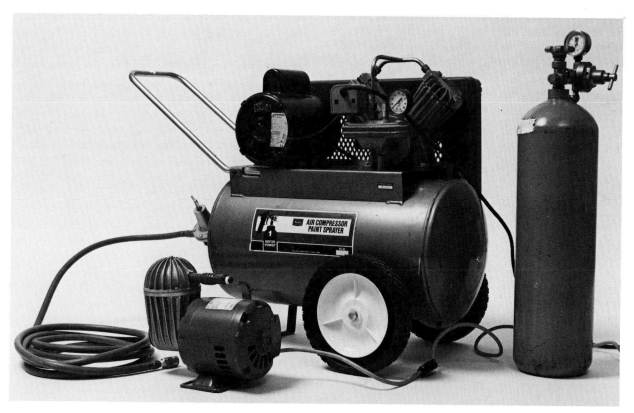

2-3

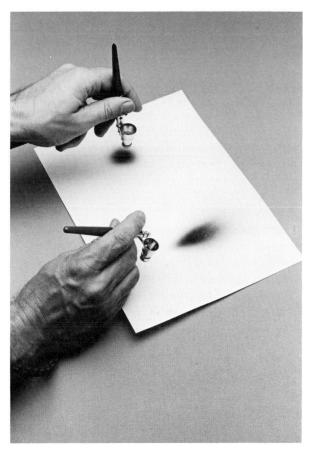

2-4

Cleanliness

The working area should be clean; dirt and other materials can easily be transferred to the painting surface by your hands and tools. In addition to creating hard-to-remove marks or smudges, some of this material may resist your spray medium. It is also a good idea to wash your hands before spraying and place a protective cover over painting surfaces that will not be sprayed.

Lighting

Good, constant lighting is important in accurately establishing colors and gradations. You will also want to discriminate clearly between sprayed sections, and between sprayed and other surface areas. The beginner is often surprised to discover how difficult it is to see these distinctions under poor or varying lighting conditions.

Surface angle

When spray hits the surface at an angle, it creates more of an ellipse spray pattern and more overspray. In most instances, therefore, it is best to spray with the airbrush held perpendicular to the painting surface **(2-4)**. The easiest way of doing this is to raise the painting surface to an angle that is perpendicular to your natural hand position for the airbrush. This is a more foolproof method than trying to maintain this angle by cocking your wrist.

Readying or preparing materials

Always try to have everything set up before you begin spraying. Accidents often occur when you have to put the airbrush down to get or prepare something. Keep clear the areas immediately adjacent to the painting surface. Because spraying usually involves a lot of concentration, it is easy for a hand, arm, or hose to spill containers, drag material across the painting surface, and run into objects.

Project 1
Introducing the Airbrush

Although the following information is a guide for the beginner, it also serves as a review for artists who have learned this material partially or in a trial-and-error manner. Some cross-referencing with other areas of the book is necessary in completing this project. Bullets designate the actual tasks to be completed.

Double-Action Airbrush Parts and Functions

A new airbrush should come with a diagram of the parts. If you do not have a diagram of your airbrush, you should get one from the manufacturer or the supplier. Even though you will probably not remember the names of the parts, study the diagram with the objective of relating the parts and names to their specific functions.

- Follow the path of air as it enters the airbrush, through the valve assembly where it is released into the body of the airbrush, and then through the head assembly.
- Follow the different route of the painting medium as it enters the body of the airbrush, moves through

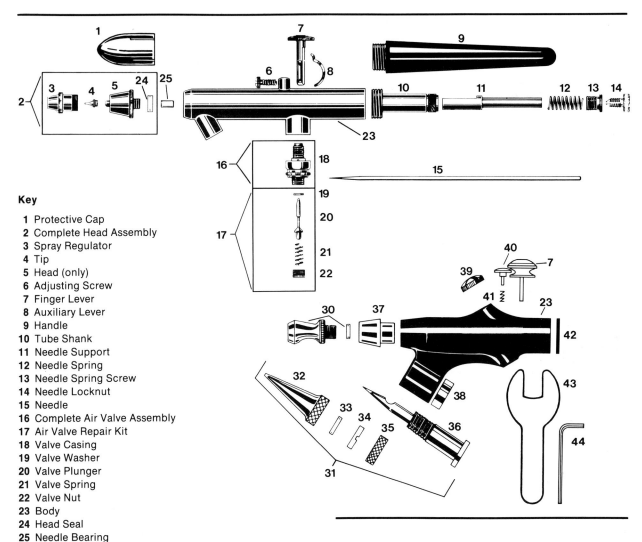

Key

 1 Protective Cap
 2 Complete Head Assembly
 3 Spray Regulator
 4 Tip
 5 Head (only)
 6 Adjusting Screw
 7 Finger Lever
 8 Auxiliary Lever
 9 Handle
 10 Tube Shank
 11 Needle Support
 12 Needle Spring
 13 Needle Spring Screw
 14 Needle Locknut
 15 Needle
 16 Complete Air Valve Assembly
 17 Air Valve Repair Kit
 18 Valve Casing
 19 Valve Washer
 20 Valve Plunger
 21 Valve Spring
 22 Valve Nut
 23 Body
 24 Head Seal
 25 Needle Bearing
 30 Air Cap
 31 Fluid Assembly
 32 Fluid Tip
 33 Packing Seal
 34 Packing Nut
 35 Fluid Assembly Locknut
 36 Fluid Needle
 37 Air Cap Bushing
 38 Fluid Needle Spacer
 39 Finger Button (plunger head)
 40 Stipple Adjuster
 41 Stipple Spring
 42 Body Seal
 43 Fluid Needle Wrench
 44 Locknut Wrench

2-5 Airbrush Parts Diagrams. Top: Double-action airbrush. Bottom: Single-action airbrush. Courtesy of Badger Airbrush Co., Franklin Park, Illinois.

the head assembly, and then mixes with the air to produce spray.

■ Notice all the parts that the needle must pass through, especially where it is tightened by the needle locknut, pushed forward by the needle spring, pulled back with the finger lever, and finally activated back and forth through the tip.

Manufacturers of airbrushes may include different parts in similar airbrushes or label similar parts differently. So that airbrush functioning can be easily discussed, the terminology given in illustration **2-5** is used in this book. Notice that in this diagram two examples are shown for some parts. For example, Paasche's *air cap* is designed to focus the air flow primarily from the screwed-on position. Thayer & Chandler uses the term *spray regulator* for their cor-

responding part since it is designed to be screwed to different positions for varying the coarseness of spray.

Setting up the airbrush

Compressor check To operate, some compressors are simply plugged into an electrical socket, some have on/off switches, and compressors with tanks turn on and off automatically. Some compressors need to be oiled periodically and compressors with tanks regularly need to be drained of water. Air filters should be replaced when they become clogged. Care should be taken with larger compressors not to overload electrical circuits.

Setting air pressure Smaller compressors often do not have gauges. They are either set at a normal spraying pressure or have adjusting screws that allow pressure variations. Your specific pressure setting will depend on the type and brand of your airbrush, the particular functioning characteristics of your airbrush, and the variations in the nature of your air system. Your will need a pressure setting range of between 20 and 35 pounds per square inch (psi). However, settings for classroom or other large studios with many air outlets may be as high as 40 psi; or, the setting for stippling (grainy spray) may be as low as 5 psi.

Filter/moisture trap check Compressors with attached filter traps should be periodically emptied of water, particles, and other matter.

Attaching the hose Be sure that the proper thread sizes on fittings are matched. The hose from one brand of airbrush may not fit another brand of airbrush. Most compressors have 1/4-inch pipe fittings for attaching a hose. Most airbrush hoses come with one end this size.

- Screw the airbrush on slowly so you do not strip the threads.
- After the connections have been made, you may wish to turn on the air and apply a soap and water solution to each of the fittings with a soft paintbrush. Bubbles will appear where there are air leaks. On large fittings, if additional tightening does not stop the leaks you may wish to use Teflon pipe sealing tape on the threads. If a properly sealed and tightened connection still leaks on a small fitting, the unit may be defective. Leak-free fittings are especially important if your air source is a pressurized tank of carbon dioxide.

2-6

Paint preparation

The medium used in your airbrush must be thoroughly dissolved, mixed, and diluted enough to move freely through the very small opening between the airbrush tip and needle. Dissolving makes the medium liquid, mixing blends and disperses the components, and diluting properly thins the medium for use in the airbrush.

Dyes and inks are usually purchased already fluid enough to spray. However, some sediment may need to be reconstituted or some diluting may be necessary to weaken the colorant or to make the medium easier to spray. On the other hand, paints must be mixed with a diluent (water or reduction agent applicable to the paint medium used) to reduce viscosity and to thoroughly dissolve resistant concentrations of paint. To do this, gradually add the vehicle and mix it with a grinding motion using a stiff bristle brush **(2-6)**. With large quantities, strain the diluted paint through a fine mesh (such as nylon stocking). If you are using a color cup, remember that you should not allow the paint to thicken or settle at the bottom.

Paint is usually prepared in containers or on palettes. With palettes, small quantities are mixed either from wet paint or dried cakes. The loaded brush is then dragged over the lip of the color cup and the paint flows to the bottom **(2-7)**. Larger quantities are usually mixed in containers and then transferred to special jars that are part of airbrush jar assembly units. Spraying from these jars saves constant refilling; however, the medium does not flow (siphon) as easily from them as from the cup. This is a factor in fine, small-area painting. When using the jars, be

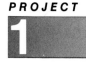

2-7

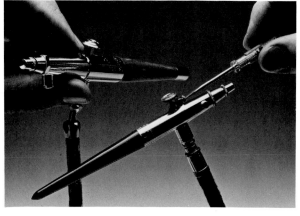

2-8

sure to keep the small hole on the cap open so that the medium will siphon properly.

Prepare a small quantity of black designers' colors on your palette and then use your cup when you are ready to practice spraying.

Attach and position cup or jar assembly Be sure that the color cup and jar assembly are compatible with your airbrush. They should normally be from the same company and of the same type as your airbrush. They should snugly attach to the airbrush so that the painting medium will draw well. Also, be sure that the position of the cup or jar is right for your spraying angle.

Airbrush adjustments Because the airbrush is a precision tool, the proper positioning of parts is essential to proper airbrush functioning.

1. The needle should be positioned in so that it touches the tip.

2. The needle chuck at the rear end of the needle point should be tight enough so that it holds the needle but not so tight that it retards the spring action of the needle.

3. The spring tension, which is controlled by the needle spring or the needle adjusting sleeve, should be stong enough so that the trigger consistently returns to the off position.

4. The adjusting screw is designed to precisely hold the needle away from the tip. It should be in the out position when the needle is put in. It may be left in this position or screwed in when you need to repeat a specific spray pattern (as in the lines and dots). Pictured are two types of adjusting screws **(2-8)**.

5. The air cap or spray regulator at the front of the airbrush should normally be screwed to the position suggested in the directions that come with the airbrush **(2-9)**. However, you may find that your air-

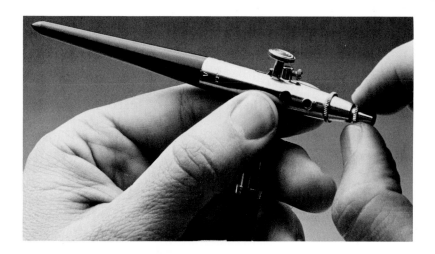

2-9

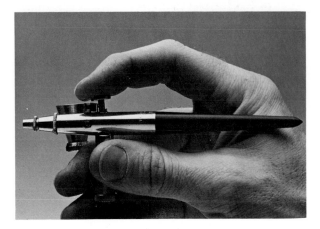

2-10

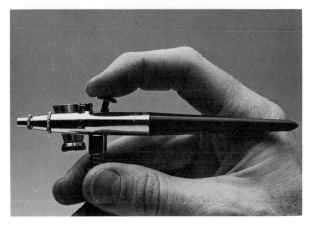

2-11

brush requires a different position. Experiment with screwing it in and out until you find the best spray pattern. Note that with some airbrushes it is suggested that you regulate the coarse-to-fine quality of the spray with the spray regulator.

Operating the airbrush

Hold the airbrush as you would a pencil. The index finger is used to control the air and the flow of medium. It may take a while for you to establish proper triggering coordination. Press down for air **(2-10)** and pull back for spraying **(2-11)**. Normally, the air pressure is controlled by the compressor and the regulator, as indicated by the air gauge. However, some variations in air pressure can be established with the airbrush. Fine variations in the amount of spray and the size of the sprayed area can be achieved with delicate finger control of the trigger. To gain a more precise spray pattern, as with lines and dots, the adjusting screw should be used. The adjusting screw should be returned to its normal position whenever the needle chuck is loosened. Do not release the finger lever when it is pulled back; the spring action of the needle returning forward may split the tip. Experiment operating the airbrush both with and without the use of the adjusting screw.

Troubleshooting

Most of the problems common to airbrush painting can be corrected through an understanding of materials, correct procedures, and airbrush functioning. In this book the term *troubleshooting* is used to title the sections that explain the causes and, where appropriate, the solutions to common problems in airbrush painting. These sections provide a quick reference for immediate or future problems.

The troubleshooting sections in chapters 3 and 14 should be reviewed before you begin project 2. However, you may wish to review all of these sections at this point to gain early familiarity with their contents.

Maintenance and cleaning

Beginners should pay special attention to frequent cleaning of their airbrush with water and to the other procedures explained in chapter 14. Review chapter 15 and actually try some of the recommended procedures before beginning project 2. Improper cleaning and maintenance of the airbrush are the most common failings among beginners and often limit their performance and development.

Chapter 3 **Basic Techniques of Spraying**

Many of the fascinating possibilities of airbrush painting can be understood if you are familiar with a few basic spray processes. Skill in manipulating spray is necessary to control the amount and coarseness of the spray, the evenness of flat and graded applications, and the precise depiction of dots and lines. Since most spray techniques use a combination of these control skills, it is important that you become familiar with all of them.

The projects in part I provide opportunities to become more familiar with the various airbrush painting techniques and aesthetic possibilities. As you progress through them, you will begin to incorporate the techniques, recommended procedures, and vocabulary into your personal work processes and habits. While you work on these early projects, look at as many examples of airbrush painting as possible and note how even complex works can be reduced to several simple procedures.

Most of the projects in this book suggest small-scale applications. Most skills learned in this way can be easily translated to larger formats while processes learned in large-scale work do not necessarily produce the level of skill necessary for small-area spraying. The following fundamental techniques apply most directly to the small double-action airbrush.

Instead of applying medium all at once, gradually build up sprayed areas. Careful, deliberate development of value areas often takes less time than using fewer, heavier applications, which produces mistakes. By working slowly it is easier to perceive and evaluate the development of painted areas and to respond to variations as they emerge.

Where fine, detailed applications are desired, close hand-to-eye coordination is essential. It is sometimes hard to understand how some effects are developed through very mechanical handling of the airbrush. Before completing the series of projects in this chapter, be sure that you have worked out the finger, wrist, and body motions necessary for best results.

Spray-painted areas not only reflect the direction and amount of medium applied but also the movement of the airbrush. Because of this, our natural arm movements must usually be altered to produce desired effects. It is ironic that subtle, aesthetically pleasing effects of spray are usually produced with machinelike movements; and that to do this it is often necessary to emphasize the larger arm or body muscles rather than those of the wrist and fingers. Therefore, position your body, arms, and even (if you're standing) your feet in a manner that will allow you to respond easily to the demands of your work.

Sometimes it is necessary to begin, end, or both begin and end spraying sequences on the exposed painting surface. This requires skills that you will gradually develop. At times it is also necessary to use circular or irregular movements. Much of your spraying, however, will be done with a simple back and forth motion and most spraying begins and ends off the exposed painting surface. This usually involves the following sequence: (a) off the painting surface, begin the motion of the airbrush while pressing down for air and pulling back for spray; (b) after crossing the exposed painting surface, push the trigger forward, release it, and then stop the motion.

When a work requires a series of small-scale applications, especially where fine gradations are involved, use a thin medium (paint such as designers' colors should be diluted). A number of layers may be required before the desired opacity or intensity of color is achieved. Use a high ratio of air volume to spray; this allows greater control and uses the air to dry the paint as it is being applied. This technique may be frustrating at first but it may be learned in order to avoid the problems that develop when either too much air or paint is applied; paint may puddle, the air may push the paint into centipedes, or air pressure may create holes in the center where the paint is pushed aside, leaving the ground exposed. Although a gradual build-up of layers is time consuming, the results are worth it. Remember, the problem with this technique is usually not one of difficulty but of patience.

Small-area spraying usually requires more fre-

quent cleaning of the airbrush with water. Small amounts of paint usually are sprayed through a very small opening between the airbrush tip and needle. A buildup of paint on either of these surfaces will normally inhibit the flow of paint, producing spatters.

Flat Applications

An opaque layer of paints does not reflect light from lower layers as does a transparent layer. With a transparent layer the eye can perceive aspects of both the top and lower layers. The word *translucent* is often used to describe a degree of transparency that is almost opaque (the light is diffused). Although the various colorants, binders, and fillers of different media influence the degree of transparency or opacity, our major concern in this chapter is how the amount of paint applied to a surface controls the degree of transparency. An exciting range of color possibilities exists between these two types of paint application.

It is important to know the distinctions between opaque and transparent applications because they look quite different, even when the same hues are used. For example, spray a transparent layer of cadmium red light over a white surface and then match the same value and intensity of this color by spraying alternate layers of white and the same red to produce an opaque color. The opaque color is a cooler tint than the transparent wash.

Opaque Applications

Fully opaque layers should be built up gradually until there is no indication of the preceding color or background. This is best accomplished with slowly developed, even layers of well-mixed medium. Be sure that the medium used is itself of sufficient opaqueness. Use of the slow, gradual process of applying the medium should counteract problems such as bleeding under the tape, puddling, or the excessive buildup of paint that sometimes causes chipping or cracking. Remember that water spots and stains from puddling are difficult to correct.

Transparent Applications

Artists often apply spray in thin, transparent layers to achieve variations of color (hue, intensity, and value). Because only achromatic (black, white, and grays) transparent applications are used in the projects of this chapter, your recognition of potential color variations will probably emerge in later projects that include full color. Sprayed transparent overlays can produce colors of surprising beauty, complexity, variety, and depth because of the way in which background colors can interact with overlays.

Before beginning transparent applications, you may control the graininess of the spray by adjusting the spray regulator (if your airbrush has one). Make sure your medium is diluted enough so that the desired amount of paint is established after a series of applications. Also, check to be sure that you have sufficient air pressure. Practice your applications first on scrap paper. Mechanical, back-and-forth movements that extend beyond the boundaries of masked borders are very important if transparent areas are to be free of bands and lines.

Transparent areas are difficult to correct because continued spraying changes the nature of the color; they become opaque, gain saturation (intensity), or change in value. This can be a frustrating problem if beginning the work over again will be time consuming, especially if the area is part of a larger piece that has already involved a substantial amount of time. Whiting out the particular area works well if the ground and the whited-out area are the same color; however, the color of your support will usually slightly contrast with the paint you used for corrections. For example, a resprayed black over a whited-out area will look bluish next to other areas where a transparent black wash is sprayed over unprepared illustration board.

Through the two exercises in project 2, you will have the opportunity to demonstrate skill in spraying both opaque and transparent flat applications. By focusing your attention on a few specific skills, the exercises are designed to immediately promote good craftsmanship.

These exercises introduce taping as one type of masking. Drafting tape is suggested for all lessons where tape is used on illustration board. See chapter 4 for detailed information on taping.

After matching the grays of the two exercises, note distinctions between them. Although the values will be virtually identical, they will look quite different. The opaque grays on the left produced with neutral grays will look cooler, smoother in texture, and "solid" or "on the surface." The transparent grays on

the right, produced with only black, will look warmer, more grainy, "airy", and will have more depth than opaque grays.

Project 2
Flat Applications

With ½-inch drafting tape, border all four sides of an 8- by 10-inch piece of illustration board. Then evenly divide the board vertically with tape to form two 4 ¼- by 7-inch exposed areas.

Exercise 1: Opaque Application

Mask off the right section with tape and scrap paper; the tape should be applied only over the tape that vertically divides the board (thus creating a mask that can be positioned on either side). This allows the mask to be lifted like a flap when it is necessary to compare stages of the second exercise to the completed first exercise. Apply an opaque area of a light medium gray such as no. 2 retouch gray or no. 2 designers' colors gray.

Exercise 2: Transparent Application

Flip over the mask dividing the board to expose the right rectangle. Dilute black gouache until it is about two times thinner than normal consistency. Lightly apply the gouache over the exposed area until the value matches the lightest opaque gray. Develop this area very slowly and deliberately; spray all of the exposed area with each spray cycle. Apply the spray horizontally. Your arm motion should extend over the taped edge so that an even layer of paint is applied; no light areas should occur at the edges of tape. Practice even strokes; try not to create lines. Begin your spray from alternate sides, and turn your board 180 degrees while applying paint to each band to ensure greater uniformity (**3-1**). Stop as soon as you duplicate the value of the left rectangle. Photograph **3-2** shows one student's completed work on exercises 1 and 2.

▶

3-2 Vicki Luna. Student work, project 2.

Gradated Applications

Some of the more desirable or characteristic effects identified with airbrush painting relate to the manner in which gradations can be achieved with opaque or transparent sprayed areas. Gradations may suggest transition from one area to another, the illusion of a limited or deep space, representation of subtly shaded form, or the presence of light and its effects on various surfaces.

The importance of control should be mentioned here again. The slow, methodical development of painted areas actually saves time because it encourages checking and rechecking as transition areas

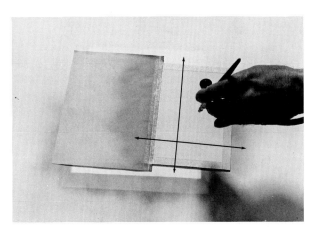

3-1

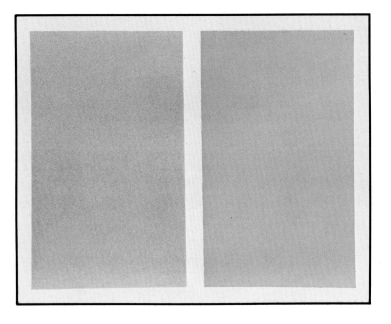

evolve. There is less likelihood of creating such problems as overly dark areas, lines or bands, or the heavy buildup of paint.

It is also important to note that unrecognized darkening of gradations is a problem to resolve early. Unnoticed overspray that darkens a mask as well as the painting surfaces reduces your frame of reference. For example, a mask such as tape can block out the natural white frame of reference of the illustration board. Therefore, overspray on the tape may give the appearance of the painting surface being lighter than it actually is. To correct this, keep close at hand a piece of unpainted illustration board. In other situations, colored swatches that designate a desired color can be used for reference.

Project 3
Gradated Applications

For exercises 1 and 2, mask off an 8- by 10-inch board the same way the board was masked in project 2.

Exercise 1: Transparent Gradations

Slowly develop a gradated, transparent application by using only black and the white board to establish an even light-to-dark gradation.

The left rectangle should be sprayed with the di-

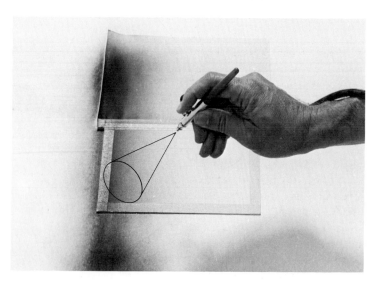

3-3

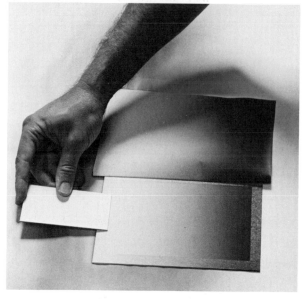

3-4

luted gouache used in project 2. Begin at the bottom to form a solid black area and evenly gradate upward so that no spray falls on the white at the top of the rectangle **(3-3)**. To retain the white at the top of the board, continually check your progress **(3-4)** and do not aim the spray directly at the top one-third of your board—rely instead on overspray to complete this area. Ideally, when you finish, the solid black and white areas should comprise about ¼ inch of the top and bottom and the area between them should be evenly graded without jumps or bands.

Exercise 2: Opaque Gradations

Evenly coordinate two colors (in this instance black and white gouache) in developing an even, opaque gradation. The right rectangle should be evenly graded from black at the bottom to white at the top. Begin with black applied to approximately two-thirds up the board and then work white in from the opposite direction. Alternate back and forth as needed. The gradations in the first two exercises should match. As with exercise 1, the solid black and white areas should comprise about ¼ inch of the top and bottom and the area between them should be evenly graded without jumps or bands.

This type of gradation is normally developed by first spraying the darker color a little more heavily than it will appear in the finished work. The lighter

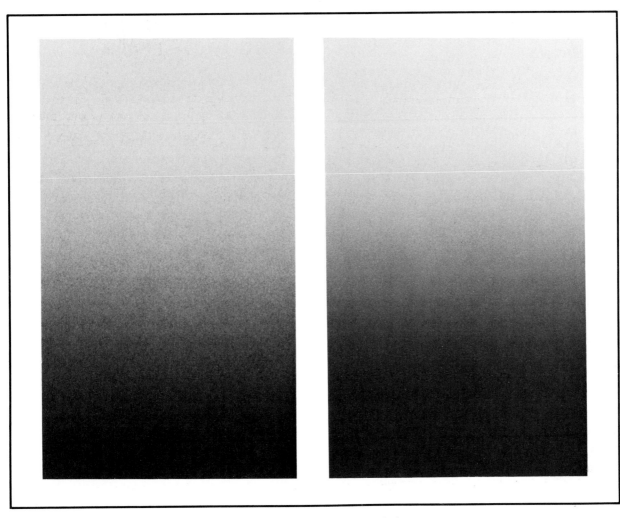

3-5 Arlene Manougian. Student work, project 3, transparent and opaque gradations.

color is then applied, lightening all but the very darkest area. Repeated applications will perfect the transition; however, it is important to carefully apply each passage so as not to build up too much paint.

Of special note in this exercise is the decided change in color when white is sprayed over the black. The bluish color of the opaque gradation appears to be made with a different black than the apparently warm black used in exercises 1, 3, and 4. Photograph **3-5** illustrates the difference between transparent and opaque gradations.

Exercise 3: Curved Gradations

For exercises 3 and 4, use tape and scrap paper to mask off two 4 ⅛- by 4 ⅛-inch exposed areas on an 8-by 10-inch board. This will involve horizontal measurements of ½, 4 ⅛, ¾, 4 ⅛, and ½ inches and the vertical measurements will be 1¹⁵⁄₁₆, 4 ⅛, and 1¹⁵⁄₁₆ inches. Exercises 3 and 4 may also be completed by centering the 4 ⅛-inch squares separately on two 8-by 10-inch boards.

Continuing with previously learned skills, exercise 3 stresses the development and coordination of curved gradations. This exercise also introduces the technique used in rendering rounded forms, vignetting (to shade off gradually at the edges), and spotlighting (to focus attention on an area). Within the left square, try to come as close as possible to creating a gradated circle. Guidelines on the mask might be helpful. To avoid marring the painting surface, tape a small piece of illustration board to the center of the

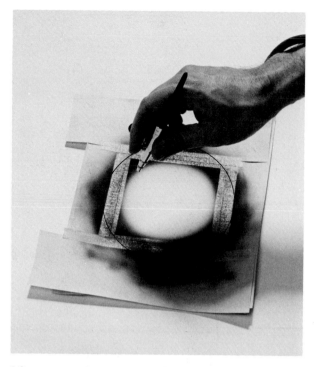

3-6

square. Then place the point of a drafting compass on this cushion and draw a circle on the mask outside the square painting surface. Remove the piece of board.

With the airbrush, build up to a solid black in the ⅜- to ½-inch area of each corner and then form a gradated area approximately ½ inch wide. Spray toward and across the corners with even, circular motions so that a circle emerges that touches in the middle of all four sides **(3-6)**. Try to retain the white of the board in the center of the circle. Partially develop each corner and then revolve the board until the circle gradually emerges **(3-7)**.

Exercise 4: Checkerboard

This exercise involves the repetition of identically graded, small sprayed areas that are developed while working close to the board. This exercise also provides an introduction to the movable stencil. In this chapter a few masking processes are introduced before being more thoroughly covered in chapter 4. The movable stencil made of inexpensive material is one of the simplest stencils.

Using either heavy paper, light cardboard, or acetate, cut an L-shaped (an exact 90-degree angle) mask with straight sides that are at least 2 ½ inches wide. Divide your square board by lightly ruling nine equal 1 ⅜-inch squares. On each square, shade opposing corners. Complete the upper left corners of all of the squares first, then turn your board around and spray the opposing corners. Because the squares connect, each square must be stenciled separately. Spray directly into the corner area to limit the effects of overspray. Develop a crisp edge by pressing the mask tightly to the board **(3-8, 3-9)**.

Lines and Dots

Some of the more fascinating effects of the airbrush are those involving very small areas of spray. This tool is capable of lovely and even sensuous applications that have characteristics of clarity and precision. Skill with very small, controlled applications of spray is important to the development of confidence and the working vocabulary of the airbrush artist.

Lines and dots, of course, are really small sprayed areas. The dot is a small amount of spray confined to a small area and a line can be interpreted

3-7 Alice Park. Student work, project 3, curved gradations.

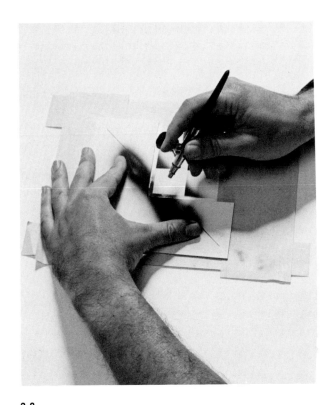

3-8

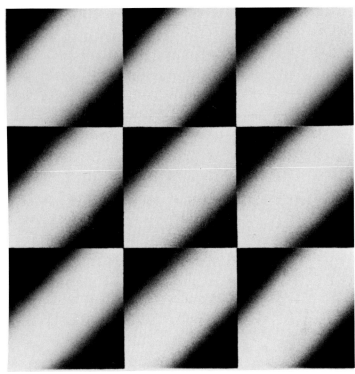

3-9 Brad Merville. Student work, project 3, checkerboard.

as a moving dot. Both, when applied on a small scale, challenge the limitations of the artist, the airbrush, and the medium: the tendency of the medium to build up at the tip may cause the airbrush to clog, too much air and medium causes centipedes, a lack of precision in handling diminishes control, too much paint or spraying at an angle causes excess overspray.

These problems may seem formidable at first. They can be overcome, however, if you are willing to apply time and patience in learning techniques like those presented in project 4. An important factor in small-scale work of this type is the development of close hand-to-eye coordination. Project 4 provides this type of disciplined practice that applies to the skills needed to excel in later lessons. Another factor is recognizing the range of technical possibilities in making lines and dots. Both before and after completing project 4, note applications of lines and dots in the illustrations provided in this book or in other available examples.

For the beginner, project 4 involves a difficult series of exercises. A high degree of success should not be expected at first. The beginner should instead

go as far as time and patience allow. A variation to project 4 is provided for those who have not achieved sufficient mastery at this point to complete the project on illustration board, or for those who simply prefer a quicker version of project 4. The following suggestions should prove helpful in meeting common problems with the skills used in making small-scale lines and dots.

1. Use a dilute medium such as Dr. Martin's Synchromatic black for this project. If black gouache is used, dilute the medium so that it flows evenly when a $1/16$-inch line is drawn. The resulting lines may be middle gray. An important lesson in airbrush painting is that the consistency of the medium can be changed for different types of applications. With fine applications it may be necessary to thin the medium to a point where, because of its diluted state, a number of layers are necessary to achieve desired saturation or opacity. Experiment with different consistencies of medium before beginning project 4.

2. When doing detailed work, clean the airbrush with water even *more frequently* than recommended

earlier so as to inhibit medium buildup that will force unwanted adjustments.

3. Even with a relatively clean airbrush, always recognize that after the airbrush has been turned off for awhile, the sudden application of air when spraying is started again produces an initial splattering or centipede effect because of paint buildup. Anticipate this problem by placing an initial small amount of spray on a practice surface before beginning regular spraying.

4. Hold the airbrush perpendicular to the surface to counteract overspray.

5. Practice the triggering and body movements of each application before working on the finished board. This allows you to gain confidence and to concentrate on execution rather than discovering the hard way what will happen next.

6. If the ground (illustration board) becomes exposed at the center of a line or dot, the airbrush is being held too close, with an application that is too heavy on air and too light on paint.

7. If a spray regulator and adjusting screw are included on your airbrush, this project can provide experience in manipulating them. Before making special adjustments to your airbrush, practice making dots and lines. Begin with the airbrush held 4 to 5 inches from the surface and gradually move closer as you gain more control. Adjust your spray regulator outward to gain a fine spray. Then screw in the adjusting screw to a point that allows a ¹⁄₁₆-inch continuous line when you press down on the finger lever. Begin your preliminary experiments with regular air pressure and then slightly lower the pressure as necessary.

Project 4
Freehand Lines and Dots

On an 8- by 10-inch board, rule nineteen light lines ½ inch apart across the width of your board. On the back of the board, number the horizontal lines 1 through 19 from top to bottom. Then lightly rule vertical lines between lines 12 and 13 at the following intervals: ½, 2½, 3, 5, 5½, and 7½ inches. Finally, vertically rule light lines ½ inch apart across horizontal lines 14 through 19, making a 2½-by-8-inch grid at the bottom of the board.

Make any penciled guidelines light enough so that they can be easily removed. All spraying is with a

¹⁄₁₆-inch wide line or dot. Do not use any guides when spraying. Dots and lines using guides and masks are covered in project 5, variation 1, in chapter 4. Refer to illustration **3-10** as you complete this project.

Between lines 1 through 5 Place a variety of lines of your choice in this space. You may wish to plan the type and design of this series on a practice surface before beginning the finished project. Include curved, circular, straight, pointed, and a range of angular sequences.

Between Lines 6 and 7 From the diagram for this project, lightly copy in pencil the continuous markings on line 7. This cursive line is derived from the alphabet. Follow this line with an airbrushed line.

Lines 8 and 9 Between these two lines write the words "Airbrushed Lines." Apply your best cursive writing. The guidelines should correspond to the body of the lowercase letters.

Between Lines 10 and 11 Make a series of separate shapes and symbols.

On Lines 12 and 13 Spray 2-inch long, ¹⁄₁₆-inch wide freehand lines at the intervals prescribed earlier. See to what degree the ½-inch spaces can be retained. Spray each 2-inch line separately.

On Lines 14 and 15 On the first two vertical rows of the grid, moving horizontally across your board, hold the airbrush about ½ inch from the surface and place dots, ¹⁄₁₆ inch in diameter, on the first six vertical rows of the grid. On vertical rows 7 to 10 make ⅛-inch dots by beginning with ¹⁄₁₆-inch dots and gradually expanding them with circular, outward movements. Similarly, on rows 11 to 14 make ¼-inch dots.

Lines 16 through 19 Connect points on the remaining last rows of the grid. Follow the design shown on the diagram. You may wish to stop spraying lines at any cross point, however, remember that the airbrush should be moving when you begin and end spraying. You may wish to lightly pencil in guidelines before starting. Illustration **3-11** shows a student's execution of this project.

Project 4, Variation
Basic Techniques for Lines and Dots

Place a sheet of tracing paper over the illustration of project 4 or use a photocopy. Use drafting tape to tape the illustration to the underside of the tracing paper. Practice each of the exercises after first reading the project 4 descriptions for each line. Because

Freehand lines of your choice

HSZEONBDErst

Airbrushed Line

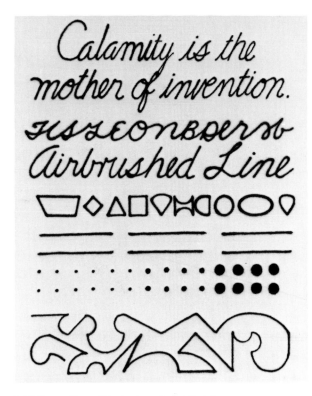

3-11 Byron Koga. Student work, project 4.

the objective of this variation is to quickly practice each exercise, errors that result from working on tracing paper should be ignored. With smoother, less porous surfaces such as this, air pressure more easily creates centipede effects and white areas in the middle of dots and lines.

Troubleshooting

The following problems focus on the actual process of spraying. They relate to either the amount of time spray is directed onto one place, the path you create in guiding the airbrush, or where you point the spray.

Blobs Spots can occur at the beginning or end of strokes (3-12). This is caused by the difficulty of simultaneously stopping the spray and the hand movement.

Solution: At the beginning of each stroke, start your hand motion before spraying. At the end of the sprayed stroke, cease spraying before you complete the hand motion.

Buckling paper When paper becomes too wet it buckles or develops waves (3-13).

Solution: (1) Apply less spray to the surface; (2) adjust the air-to-spray ratio (more air volume and less liquid) by not pulling back the lever as much; (3) thicken the painting medium.

Centipede effects When you spray too close to the surface with too much spray, the air will create little "crawlers" (3-14).

Solution: Unless fine lines or dots are being sprayed, spray from a higher position. When it is necessary to work close to the painting surface, pull the lever very gradually, use less spray, and take a little longer to build up the painted areas. Use the adjusting screw wherever continuous, close spraying is necessary. If you still have a problem, temporarily reduce the air pressure.

3-12

3-13

3-14

Unpainted areas in the middle of dots and lines
When spraying close to the surface, the air pressure
will sometimes push the painting medium aside, ex-
posing the surface underneath **(3-15).**

Solution: You may have to try a combination of
the following: (1) move away from the painting sur-
face; (2) use the air pressure that provides the spray
quality you want; (3) use slightly thicker medium.

Flared strokes Flares occur at the beginning or
end of strokes **(3-16).** They are normally caused by a
turning of the wrist.

Solution: Use whole arm movements with the
wrist rigidly locked when spraying back and forth.

3-15

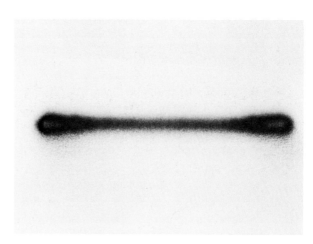

3-16

Curved stroke Curved strokes with the apex of the curve up are usually caused by the natural curving motion of the wrist or forearm. Curved strokes with the apex down are usually caused when the airbrush is dipped toward the surface in mid-stroke **(3-17)**.

Solution: Where a straight, uniform line is desired, use a straight back-and-forth motion at an even height above the painting surface.

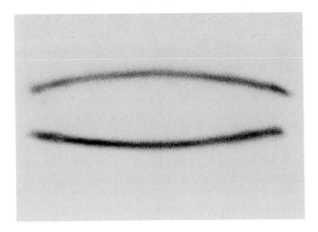

3-17

Overspray Some overspray occurs in most airbrush painting. Excess spray occurring outside of intended areas can result from several factors: (1) too much air can bounce some spray back off the surface onto other areas; (2) spraying at an angle can cause overspray away from the airbrush; (3) spraying too far from the surface (when you intend limited-area spraying) will cause the spray pattern to substantially widen.

Solution: It is generally best to spray perpendicular to the painting surface, at an appropriate distance for the spray pattern intended, using a ratio of air to painting medium that will gradually develop painted areas.

Border buildup of medium Border buildup becomes apparent with transparent applications. It is the result of more spray hitting the surface where the direction of the stroke is changed at the border of painted areas.

Solution: With areas that have real edges or masked borders, spray well beyond the border before turning for a return stroke. When it is necessary to create areas within borders, practice varying the speed of your stroke as you change direction so that all areas receive the same amount of spray.

Bands With transparent applications, this problem occurs when the motion used in spraying is not uniform enough to develop an even application of spray to the surface **(3-18)**.

Solution: Coordinate even, machinelike, back-and-forth motions with equally consistent movement up or down. If gradations are developed with movements that gradually move away from or toward the surface, be sure to do this with methodically spaced movements. Do not rely upon seeing the surface developing; by the time you see the result of spraying, you may have already made a mistake.

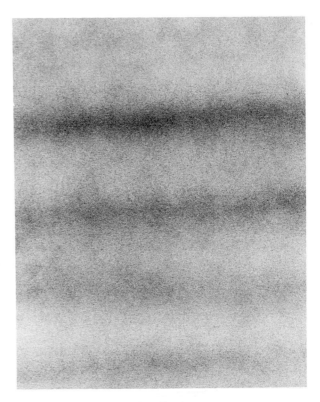

3-18

Heightened texture The rough texture of painting surfaces will be emphasized in proportion to the sharpness of the spraying angle **(3-19)**.

Solution: For the least emphasis on texture, spray in a direction that is perpendicular to the painting surface.

Cracking and chipping paint Try to avoid cracking and chipping with carefully thought-out sequences.

Solution: Consider the following after reviewing the particular properties of your medium.

1. Instead of spraying thick layers, build up a series of thin layers.

2. Do not allow paint to dry too fast.

3. Use rigid supports when it is necessary to use a medium that cracks easily or to build up thick layers of paint.

4. For thick layers of paint, try using a flexible binder, such as acrylic polymer medium.

5. Limit the chipping at the edges of tape by applying a new layer of tape as more paint is applied (upon removal, each layer of tape will therefore pull away less paint).

6. Always use frames or mats to protect the edges of sprayed work from chipping.

7. When spraying with oil-based paints, always apply fat (layers containing more oil) over lean (layers containing less oil).

8. Use caution with a medium that includes strong solvents because thickly applied, superimposed layers may dissolve lower layers.

9. When one medium is sprayed over another, be sure that they are compatible; dilute succeeding layers only as much as or less than the layers they are to cover.

Puddle marks When you spray too heavily with very diluted gouache, the medium does not always dry evenly. The edges of this dried puddle may be slightly discolored (especially apparent in darker colors). These puddle marks are hard to cover.

Solution: To cover puddle marks, lightly and slowly spray over the area from a higher level than normal. This will allow drier, more viscous drops of spray to dry almost immediately upon touching the surface.

Paint separation Sometimes pigments will separate when heavily sprayed. This is because the paint has been diluted to a lower viscosity for spraying.

Solution: These colors should be sprayed more lightly and slowly so that large, wet areas will not build up.

Chapter 4 **Masking and Stenciling**

Masks account for much of the precision and many of the interesting effects of airbrush painting. For example, the three-dimensional effects in the painting shown here **(4-1)** were achieved by spraying over organic objects. Because even the smallest airbrushes are capable of only soft lines and dots, a mask is the only means by which a crisp, hard edge or shape can be achieved with spray.

For the purpose of this book, a mask is defined as a device for restricting the flow of paint to a surface. A stencil is a mask of a particular design that can be used repeatedly to achieve the same effect. A template is an accurately formed guide that provides a prescribed, measured shape. Templates and other precut shapes are often used as stencils in spraying.

Use the simplest means that will adequately complete the masking effect you need. In selecting the proper masking technique, you may wish to consider the following factors.

- Which technique would be the fastest to use?
- How much precision or uniformity is necessary?
- What is the size or complexity of the area to be masked?
- Do any areas need to be protected from overspray?
- Is there a logical sequence of masking that would suggest one type of masking over another?
- Is there the possibility of repeated use for the mask either on the work at hand or on future projects?

Movable Materials

Movable masks are usually faster to use and can normally be reused. They include a broad range of

4-1 Sylvia Glass. *Seaweed Pool #11*. Acrylic polymer, 33 by 45½ inches. Courtesy of the artist.

shapes, materials, and thicknesses, and can be flimsy or rigid, flat or raised.

With thick or raised masks, the angle of spray to the surface can be an important factor. When movable masks are very light or not flat, it may be advisable to use weights to hold them down; artists often save type slugs, washers, and other flat objects for this purpose. When it is not feasible to use weights, allow less air pressure to hit the painting surface, either by gradually building up paint with little air or by holding the airbrush high above the surface so that the air pressure is dissipated by the time the painting medium reaches the surface.

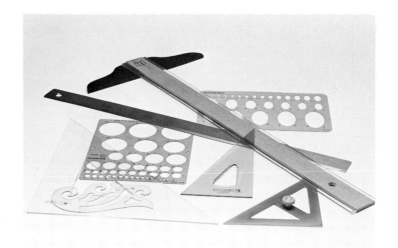

4-2

Commercial and Artist-Prepared Masks

Straight Edges Common masks of this type are the metal ruler, the T square, and the plastic triangle. The stainless steel bevel edge works best for spraying. When used with the beveled side down the ruler provides a slightly raised mask; if reversed, the thickness of the leading edge is minimized. Stainless steel guides are good because they do not easily accumulate the little nicks and dents that can alter the quality of the sprayed edge. Thus they can be used as cutting edges as well as masks. Plastic guides are damaged easily and should not be used for both cutting and masking.

Your basic supplies should include at least one long, metal edge and one triangle. The 45- and 30/60-degree triangles are the most common. The large 12-inch size is recommended because it can cover the dimensions of the 8- by 10-inch boards used on the projects in this book. A second triangle may be useful for its different angle and because it can be used with the first triangle in making a raised guide. Also, you may want to retain one guide for drawing and one for masking.

Shown in **4-2** are triangles, a French curve, circle and ellipse guides, a metal ruler, and a T square.

Curved guides Various French curves and ships curves are commonly used in industrial design and related fields. Also available are flexible curves that can be molded to different contours. When used alone or in combination, these guides can produce a broad range of simple to complex even curves.

When used as stencils, ellipse and circle guides are useful in saving time in cutting masks. Your basic supplies should include one circle guide and one ellipse guide. Ellipse guides can be purchased in large-

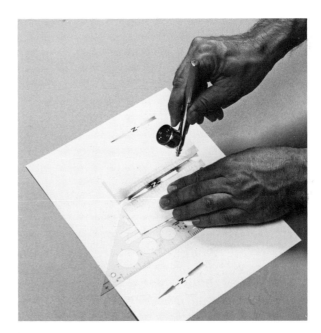

4-3

and small-size sets. These sets are expensive for the beginner who has limited use for them. Therefore, for projects in this book, an isometric ellipse guide that includes major axis measurements of $1\frac{3}{8}$ to $2\frac{1}{2}$ inches is suggested.

Miscellaneous guides Most art stores stock a broad range of templates and stencils **(4-3)**. In addition to those used in technical fields, there are stencils for uses as diverse as fabric design, ceramics, cake

decorating, tole painting (on traditional metalware), sign painting, and stained glass work.

Papers and boards Heavy papers such as stencil paper and parchment paper, and light boards such as tagboard and chipboard are often used in making stencils. They can be cut with a knife or scissors, or torn if irregular or frayed edges are desired. A cut-paper stencil was used over and over in **4-4** (note the variations in how the stencil was sprayed).

Light, inexpensive papers attached with tape are

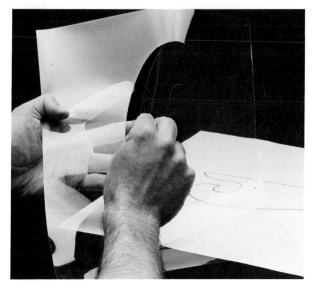

4-6

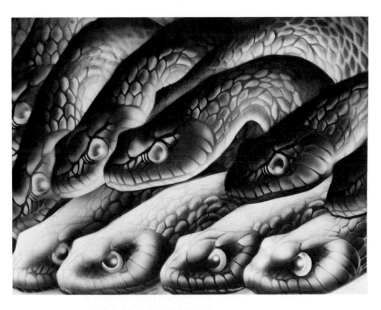

4-4 Melody Pena. Student work.

4-5

used as large masks and to protect areas from over-spray. However, even light papers such as bond or newsprint can be used to quickly prepare masks that do not require precision placement. It is sometimes useful, for example, to cut or tear paper into a variety of shapes before working on subjects such as clouds.

Artist-prepared acetate stencils Although stencils can be made out of a variety of materials, clear or frosted .005 mil acetate sheets work very well for this purpose, unless, of course, a torn, frayed edge is desired. Acetate retains its edge, does not buckle when wet, and is easy to wash off.

The easiest way to prepare masks with this material is to tape down the acetate over a drawing of the shape desired. Use a very sharp knife when tracing the contour, being sure to retain the line of the cut with each stroke **(4-5)**. Rotate when cutting in order to always retain a good arm motion. It is not necessary to cut completely through the acetate because the stencil will break away when the sheet is bent along the cut; bend carefully in areas with sharp curves or angles **(4-6)**. Smooth the cutout with fine sandpaper.

Raised masks A raised mask is simply a mask whose leading edge is above the surface of the painting. It is used where a guide is necessary to produce a degree of softness or gradation at the edge of a sprayed area; or, it is used where you may not want to place a mask directly onto the surface. It may be used flat or tilted at an angle **(4-7)**. The mask can be

hand held or, if a prescribed height above the painted surface is required, it can be placed on a riser. The material used to raise the mask is best placed as far behind the leading edge as possible or spaced so that it is beyond the borders of the painting. To create a soft sprayed edge, gradually change the angle of the airbrush to the leading edge of the raised mask. Also consider openings (holes) in masks or two raised masks used in conjunction. For example, two straight edges can be raised at even or uneven heights to create various line qualities.

Found Objects and Aggregates

Found objects and aggregates can contribute to the uniqueness of your work. The process of discovering new images through experiments with these materials

4-8

4-7

can also be a lot of fun. Possibilities in this area are so varied that it is difficult to provide useful categories; however, the following may be helpful.

1. Stamped cutouts such as gaskets, washers, and paper doilies.

2. Small tools and gadgets.

3. Small objects that are not flat but are small enough to serve as stencils (nails, screws, wire, string, fasteners). These objects often leave interesting combinations of sharp to gradated areas.

4. Aggregates of objects. Try small rocks, pellets (various sizes and materials), eraser shavings, and sequins. By holding the spraying tool high above these materials and allowing the spray to fall to the surface, it is possible to spray without air pressure moving the materials around **(4-8)**. With this technique it is even

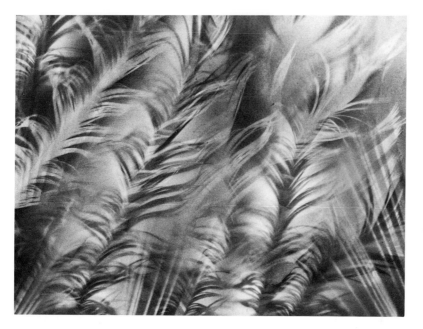

4-9 Susan Markey. Student work.

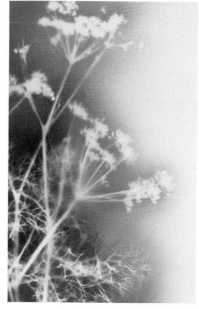

4-10 Mary Weeks. Student work.

possible to get good definitions of such objects as feathers **(4-9)**.

5. Plants, including leaves, blades of grass, small twigs, seed pods, and flowers **(4-10)**.

Netting Techniques

Screen, netting, and other mesh materials can be used to create simple textures and patterns. Greater complexity can be created by moving them and then re-spraying, or by overlapping screens between sprayings. The designs in handmade or machine-made pieces of lace **(4-11)**, crochet, eyelet, and other materials provide interesting decorative stencils **(4-12)**. Handmade pieces are increasingly hard to find but offer the most unique designs. Machine-made yardage pieces come in a broad range of designs and can be purchased in fabric stores.

Secure these materials flat against the support before spraying. Experiment with different amounts of air and paint to find the right combination for the particular material and design selected. Also, after creating sprayed designs with these devices, try working into these areas with additional spraying or with brushed and mixed-media techniques. These stencils can be cleaned with soap and water if a paint such as designers' colors is used, or with the proper solvent for other media.

4-11 Howard Chennalt. Student work.

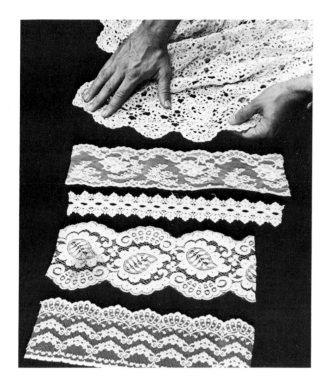

4-12

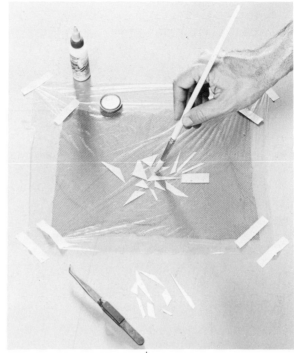

4-13

Materials can also be glued to netting or screens to set pieces into a design or to produce more intricate designs than are normally produced with cut-outs. Prepare these stencils by arranging on a protective sheet of plastic, the flat stencil materials then laying the netting over the stencils. Brush white glue through the screen onto the mask, keeping the glue away from the edges of the mask **(4-13)**. Spray from either side. A similar technique can be used in which a thick mixture of acrylic medium and powdered paint (the consistency of heavy syrup) is applied to netting that has been evenly spread over a plastic sheet **(4-14)**. When dry, the stencil pulls away from the plastic.

Large, complex, and flimsy stencils cut from heavy paper or light boards can be reinforced with small pieces of netting. If the netting shows up on the painting and is obtrusive, it can usually be sprayed over and eliminated.

Large, Artist-Prepared Screens

The techniques described above can be applied to a screen attached to a frame that is usually as large or larger than the painting support. Masked screens of

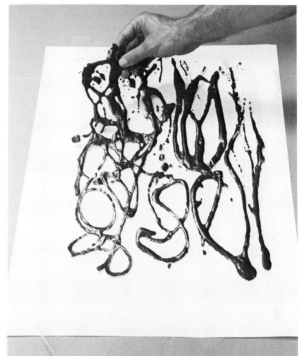

4-14

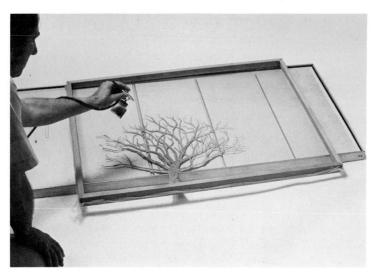

4-15

this type are most commonly used in screen printing (serigraphy, silk screening). Instead of using a squeegee to force medium through the screen, as in screen printing, the airbrush or air gun is used to spray a more diluted medium through the screen (**4-15**). The resulting layer is usually not as thick as ink applications in screen printing.

The mesh of the screen may show, and there is a paint build up on the screen that will clog unless removed quickly. In spite of these problems, this process offers potentials to the artist who is interested in a masking process that allows a sprayed image to be repeated over and over again. An advantage of this process over regular serigraphy techniques is that, through spraying, intricate changes of color and gradation variations are easily obtainable either during the spraying of the screen or afterward.

With this process the following factors should be noted.

1. Sources on serigraphy should be reviewed for methods of preparing serigraphy screen frames, masking of fine screens, and for photo serigraphy techniques.

2. A serigraphy screen can be used where fine detail is desired or necessary (here the masks used in serigraphy are appropriate). A larger mesh screen, which is needed when acrylics are used, calls for masks made of paper or artist-prepared liquid mask (described later in the chapter).

3. This is not the precision process found in normal serigraphy. After spraying through screens, de-

tail can be achieved through other airbrush painting techniques.

4. It is necessary to be able to wash the painting medium off the screen without harming the mask. Check the relationship between the binder used in masking and the painting medium.

5. This process is appropriate for producing a series of almost identical paintings (prints), a series of related variations, or for producing a series of backgrounds or base paintings on which other techniques are applied. The appeal of this process is that after you have made your series of "prints," you can focus your time and energy on the detailed or finished processes that lead to the finished work. You can begin with a point of departure (the print) and then concentrate on developing or evolving concepts in a manner similar to the printmaker whose work includes a series approach to problem solving.

6. Acrylic polymer is suggested for larger works using this process. Other media, such as designers' colors, work well for works to be placed under glass. An interesting variation is to spray the "printed" stage of the painting with acrylic polymer and then use designers' colors over the print. The advantage of this technique is that most mistakes with designers' colors can be washed off while the acrylic underpainting will not wash off.

7. Large screens may require the use of a regular air gun or retouch air gun rather than an airbrush. The air gun expels more paint and exerts more pressure to force paint through the mesh.

Applications for spraying that are variations of common serigraphy techniques can be derived easily from sources that cover this area of printmaking. Because of this, only two approaches, primarily for fine artists, will be discussed here. The first is a process involving the development of a single screen and the second incorporates a series of screens. The single-screen technique is faster and the screen can be thrown away after the last color has been applied. With the mutiple-screen process, the artist can reuse the screen at any time to create a new painting or series of paintings.

For both, an inexpensive netting commonly referred to as *bridal veil* is suggested, which has a large $1/16$- to $1/8$-inch mesh. It stretches and rips easily, but can be repaired quickly. Also suggested is the artist-prepared liquid masking material described later in this chapter. The frame is constructed so that the screen will lie flat on the surface of the painting.

Single-screen technique For the single-screen technique, the screen should be attached to the frame with staples.

1. To begin, you may wish to work directly with the mask, or prepare a preliminary painting or drawing. However, the approach suggested here is to first make a preliminary painting the size of the final work. Place a clear plastic sheet over the preliminary painting, then lay the screen flat over the plastic.

2. The masking material can then be applied to the screen placed over the preliminary painting. After the mask is thoroughly dry, remove the protective plastic layer and clean the plastic before reusing it.

3. After proper registration points have been established, begin by spraying the surface with the first color. Then use the screen with the first mask and spray the second color. This isolates the first color area. After preparing the second mask on the screen, spray the third color. Repeat this sequence until all the color areas have been sprayed.

4. When spraying through the stencil, try spraying vertically or at a consistent angle. Resist applying too much paint. The screen should be hosed off (outdoors) immediately after spraying in order to minimize paint buildup on the screen.

Multiple-screen techniques The same masking techniques may be used with multiple screens. With this approach the screens must be used in sequence because each screen progressively blocks out added colors: the first screen masks the first color, the second screen masks the first and second colors, the third screen masks the first, second, and third colors, and so on. A more advanced technique is to isolate each color area on a separate screen. Begin with either the white of the support or a background color and then spray the color for the first area through the first mask, the second through the second mask, and continue the cycle until each of the masked areas has been completed. The base color is important because you may not be spraying all of the painting through the masked screens; it should be thought of as an integral part of the color scheme.

Instead of using a series of frames, you may wish to reinforce the edges of screens with canvas strips and grommets that fit over nails on the frame. These screens should be hung to dry when other screens are being sprayed. When storing, place them together so that they will not crease easily. When removable screens are used, exact registration is difficult because of the stretchy characteristics of netting; however, for most fine art needs, simple adjustments should prove adequate.

Dry Adhered Masks

Some masks are attached to the surface to ensure greater precision, secure placement, or better overspray protection. There are generally two types, dry and liquid.

Tapes

Tapes are used separately as masks (especially when linear masking is needed) or as the adhered leading edge of a larger mask, which may be scrap paper.

Drafting tape This type of tape is usually recommended for working on good quality paper or cardboards such as illustration board because it should properly adhere but not rip when carefully removed.

White tape This tape adheres like drafting tape. It has a smooth, white paper surface that can be used as a painting surface. It may also be easier to cut with a frisket knife than drafting tape when preparing special contours for masking.

Masking tape Artists using acrylic polymer on canvas or hardboards should use masking tape. It is a stronger sticking tape than drafting tape. It is also good to use in taping nonpainting surface areas, as when it is necessary to tape down protective paper.

Charting and graphic art tapes These tapes are available in various widths and shapes. They are good for detail work. The crepe type is excellent for making curved lines.

Friskets

Friskets are masks made of relatively thin paper or plastic coated with an adhesive. Because their tacky surfaces create a weak bond with painting supports, they can be easily removed. They can also be easily cut with a frisket knife.

Frisket materials Both paper tissue and vinyl or acetate cellulose frisket film are available. Paper friskets have been used successfully for years; however, you may find the newer vinyl or acetate type easier to use because it resists buckling when wet. You can purchase these materials treated or untreated. Commercially prepared friskets are coated with a stronger adhesive than the type you prepare yourself with rub-

ber cement. Properly used, artist-prepared friskets, however, are less likely to pick up paint. Artists sometimes use the commercially treated frisket on unpainted backgrounds and their own friskets over less stable surfaces.

In making friskets, use a good grade of white rubber cement that has been thinned with rubber cement thinner. Use two or three parts thinner to one part cement. The combination dispenser jar and brush is very useful. Be sure the brush that comes with the dispenser has good stiff bristles and is at least ¾-inch wide. Use a rubber cement pickup instead of an eraser to remove excess rubber cement. Pickups can be purchased at most art stores, or a simple pickup can be made by spreading rubber cement over the side of a smooth surface (like the dispenser jar) and then rolling the dried cement into a ball. In a pinch, a looped piece of tape can also be used as a pickup.

Have a sharp frisket knife of good quality with a handle that allows easy manipulation. Always use sharp blades. There are three kinds of knives to consider: the fixed blade, the removable blade, and the swivel blade. For cutting circles, there are blades that can be inserted into a drafting compass. When using a compass, remember that tape and a small piece of light board can be used to protect the support from the hole made by the point of the compass at the center of the circle.

Preparation Prepare only the frisket material needed for immediate use. Dried rubber cement loses its tackiness as it ages. Anticipate overspray and cover all exposed areas. Begin by tacking down the frisket paper to a larger board either with four dabs of rubber cement at the corners or with tape. Apply two thin coats of diluted rubber cement or three coats if the frisket will be applied to a relatively tough surface. Apply each coat perpendicular to its lower layer. Allow the cement to dry after each application. Frisket paper should never be used when wet.

Application When laying the frisket on the painting surface, do not allow the tacky side of the frisket to fold back upon itself. When applying a large frisket sheet, allow the paper to contact the center of the support first and then let the sheet gradually curl down to the ends **(4-16)**. Another method of frisket application is to put down one border point and then a second border point before allowing the rest of the frisket to slowly curl into place **(4-17)**. Avoid creases; paper that has been creased

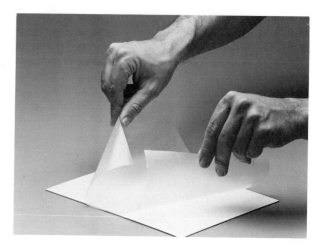

4-16

4-17

4-18

may allow painting medium to easily work under the frisket.

After the frisket is down, gently secure it more firmly to the support with your hands, a straight edge, or a burnishing device (a brayer is used in **4-18**). When reapplying a frisket, be sure that it adheres to the surface. If there is a problem, either use a new frisket or apply fresh cement to the old one. When applying one frisket next to another, be sure that the juncture where the two areas meet is properly aligned.

Drawing and cutting It is often best to make preliminary drawings before drawing on friskets that have been adhered to the painting support. Draw lightly, so as not to mark the painting support. Crisp, thin lines are easier to follow accurately with the knife. It is normally best to hold the knife nearly perpendicular to the surface when cutting. Try to cut as little of the painting support as possible. With practice your blade will barely touch the support. It is usually best to cut toward the apex of an angled or curved line **(4-19)** and then to change position before continuing, so that cutting continues toward the apex. Therefore, a line composed of a series of angles or curves may require a series of cuts.

Removing the frisket pieces prior to spraying Frisket parts can be removed by lifting an edge of the frisket paper with a knife and then holding the paper between a finger of the other hand and the knife **(4-20)**. Tweezers can also be used in removing friskets. Work slowly and carefully, noting ripped areas of the mask that pull loose and need to be repositioned. Friskets that have been left on the support more than a few days may be harder to remove and may pick up paint, may themselves rip, or may rip the painting support on removal. Excess rubber cement should be removed from the surface to be sprayed. Use a rubber cement pickup; then the edges should be rechecked before spraying begins.

Save the removed pieces; usually they can be reapplied. Place them on a smooth, glossy surface such as glassine or plastic wrap. Additional coats of cement can be applied to a used frisket if it loses its initial coating. It should be noted that paint may work through the area between two frisket edges. This can be a problem when parts of a frisket are removed in succession and then reapplied. Forestall this problem by covering these edges with either another layer of frisket or tape.

Spraying the frisket Be patient when spraying over a frisket. Spray lightly, and gradually build up layers of paint. When areas are carefully developed in this manner, the problem of paint bleeding under the frisket is minimized. Care should also be taken in relating the spray applications of one area to another. This, of course, is difficult when some of the areas to be unified must be covered by the frisket. Sometimes this problem can be met only by intelligently anticipating or remembering what the other area or areas are like. An accurate preliminary sketch can be used to solve this problem.

It may be appropriate to work back and forth between painted areas even when it is necessary to continually remove and reapply friskets. A related problem is caused by the frisket restricting the artist's

4-19

4-20

4-21

4-22

frame of reference (relative to other areas of the painting's surface). Sprayed areas often turn out to be too dark or to have a restricted value range. Preliminary studies can be used to solve this problem, or color swatches can be used for references.

Pressure-Sensitive Dry Transfer Materials

Because pressure-sensitive transfer materials can be removed easily, they can be used as ready-made friskets. A variety of letters, numbers, objects, and symbols is available. However, complex designs with delicate parts may transfer on a clear film. They cannot be used as masks for spraying because the image cannot be removed from the film background.

Dry transfer material is very thin and may be difficult to remove if heavy layers of paint are sprayed over it. Because medium easily leaks under it, develop your image by slowly building up layers of spray. For maximum adhesion and to reduce cracking, burnish transfers with the appropriate size burnisher **(4-21)**. Use the burnisher lightly when transferring the film to the support; then, with the use of a protective cover sheet, burnish it again. Before removing the sprayed mask, loosen the material with rubber cement thinner

applied to the painting. The mask can then be removed either by lifting the edge with a knife or by gently pulling it off with tape **(4-22)**.

Liquid Masking Materials

Liquid masks are normally used in specialized situations and should be tried only after some experimentation.

Commercially Prepared Liquid Masks

The two most commonly used types of commercially available liquid masks are designed for two different purposes. Artists working on porous or semiporous surfaces should use such preparations as Miskit, Maskoid, and Pink Peel. This material can be used on papers, cardboards, prepared wood hardboards, and prepared canvas. It can be applied with a pen or a wet brush (preferably wet with soap). Try a ruling pen when precise lines are needed **(4-23)**. A liquid mask is normally covered with water-based paint. If acrylics are used, do not build up heavy layers over the mask. This material should dry a few minutes before being

sprayed. Remove the mask by peeling or rubbing it off with a soft eraser **(4-24)**.

The second kind of commercially prepared liquid mask is designed for nonporous surfaces commonly used on sign faces (acrylic, cellulose acetate butyrate, styrene, and polycarbonate). It can also be used on other nonporous surfaces, such as glass and Mylar. Although this material is normally used by sign painters, there are also potential fine art applications. An acrylic lacquer paint is used with this masking material when it is applied to plastic. Check with a paint store or an outlet specializing in sign supplies to be sure that the correct paint is used on other surfaces. This product is normally sprayed onto the full surface of the painting support. The mask is then cut with a stencil knife and the areas to be sprayed are peeled off. After spraying, the rest of the mask is peeled off.

Artist-Prepared Liquid Masks

Artists who work with acrylic polymer may wish to experiment with their own preparations of the liquid mask, which are washed off after use. They may be used by fine artists interested in large-scale use of liquid masks without the high cost of commercial preparations. The solution is made with powdered paints (the type prepared for school children) and liquid dishwashing soap or glycol (available at pharmacies). This combination produces a water-soluble masking material that can easily be remoistened. This solution can be diluted slightly to permit detail. It may be difficult to remove when applied in minute

4-24

4-25

detail. This liquid is applied to a surface that will hold up under rubbing and, possibly, the water pressure from a garden hose.

For example, it is possible to use a 120-pound, 100 percent rag content paper, but it would be difficult to use illustration board because the water used to wash off the mask would probably ruin the board. Medium tempered Masonite prepared on all surfaces with acrylic gesso works best. Other hardboards and canvas, similarly prepared, can also be used (a gesso-coated board is used in **4-25**). This process works best when, before applying the masking medium, the surface is sprayed with a clear, "wet" layer of acrylic medium to reduce surface texture. Acrylic polymer colors should be sprayed over the mask in relatively thin layers because with thicker

4-23

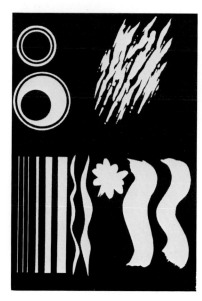

4-26 4-27 4-28

layers the mask is harder to remove **(4-26).** Choose carefully the color of powdered paint used in the mask mixture; there can be some residue left by this mask even when the suggested layer of acrylic medium has been applied.

To remove the mask, wait until the paint is completely dry and then use water and a sponge to vigorously wash off the mask **(4-27).** Better yet, take the painting outside and hose off the masked area. When hosing, hold the nozzle close to the surface to achieve maximum pressure. Stubborn areas can be scratched with your fingernail or a pointed wood stick. The finished test piece can be seen in **4-28.**

Sequential applications of sprayed masked areas can be developed either by removing the mask after each spraying or by removing the mask after successive layers of masking and spraying. The second method works as long as the acrylic buildup over the first layer remains thin enough to be removed.

Wax

Batik is a process of dyeing fabric after designs have been applied to the surface with hot liquid wax. When the wax is removed, a "print" of the waxed area is left. The dye can be applied in various ways and the process is often repeated a number of times before the work is completed. Airbrush techniques, spraying fabric dye, allow the following when com-

bined with traditional batik techniques: subtle and controlled gradated areas; various degrees of dye saturation; spraying only specific areas; small-area spraying; and complex color relationships. Airbrush painting may be done at any time in the batik process. Artists interested in this technique should consult sources on batik or fabric design.

Troubleshooting: Common Problems with Masks

Masking sequence

Artists often waste time when they do not work out their masking sequence before spraying. A number of factors can influence the order in which you apply and remove masks:

1. It may be possible to use a dark-to-light sequence whereby a masked area, once exposed, is not covered again when adjacent lighter areas are sprayed. (Exercise 1 in project 7 is an example of this technique.)

2. It may be possible to treat separate similar areas at the same time. For example, with a composition that has fifty separate cutout parts, you may be able to remove and spray ten background areas in one step.

3. A beginner will sometimes go through indi-

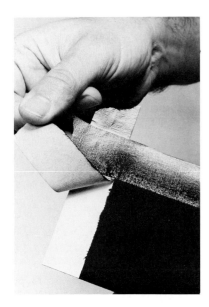

4-29

Leaking masks

Your painting medium may creep under the mask's edge because the angle of spraying is wrong or the spray has been administered too heavily. If there is enough buildup of medium at the edge of the mask, it will flow under the mask, causing irregular leak marks (**4-29**) or a fairly even line inside the mask that is the color of the first layer of paint sprayed (it will therefore contrast with the upper layer if it is a different color). Artists working with acrylics should try brushing clear acrylic medium onto the leading edge of tape. The transparent medium will immediately creep under the edge, and the excess medium can be quickly wiped off the surface. Spray after the acrylic under the tape has had a chance to dry. When using this method on slightly textured supports such as canvas, it may be necessary to apply a second coat of acrylic medium before spraying. After removing the tape, note that a small ridge remains on the painted edge.

Spray under raised masks

Raised masks should normally be sprayed from a vertical position or from a position slightly back from the leading edge. Positioning the airbrush at too great an angle over a raised mask will force spray under and behind the leading edge of the mask (**4-30** illustrates the incorrect angle).

vidual sequences of exposing areas, spraying them, and then re-covering them as many times as there are separate spraying areas in their composition. However, these areas can be strategically grouped so that none of the areas exposed for spraying are adjacent or too close to each other. For example, a complex composition that has fifty separate cutout parts might be divided into four groups. The areas of the first group are exposed and sprayed separately. The cutout parts are then replaced. The remaining three groups are completed separately in the same manner.

Color and Mask Sequence

Figuring out whether a color should be applied before or after masking can be a problem in complex compositions. This forces you, at times, to actually write out a plan for color and mask sequence. In using masks, the color of an area will be determined by the color already on the surface when the mask is sprayed over or by the color sprayed. For example, if you cut a circle from a piece of paper you have two potential masks. Take the circle cutout and use it as a mask on a red surface. By spraying green over the mask you get a red circle shape on a green ground. On the other hand, you can take the piece of paper with the circle cut out of it and also use it as a mask on the red surface. By spraying green over the mask you get a green circle on a red ground.

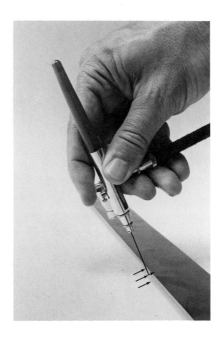

4-30

Buckling masks

Some masking materials (usually paper) will buckle when saturated with water **(4-31)**. This can cause leaking and unwanted variations at the edge of sprayed areas. Choose your masking materials carefully.

Unsprayed area at edge of mask

Spray applied at too great an angle behind the edge of the mask may cause an unsprayed or partially sprayed area at the edge of the mask **(4-32)**. This problem increases with the angle of spray and the height (thickness) of the mask's edge.

A similar problem is unsprayed areas caused by improper placement of adjacent masks **(4-33)**. This problem is most common with friskets. After an area has been sprayed, the mask is replaced improperly so that it overlaps onto an unsprayed area. When this adjacent area is sprayed, the overlapped area remains unsprayed.

Overspray

It is difficult to foresee the buildup of overspray outside of intended areas. Try to anticipate the effects caused by an increased cone of spray as you work at higher levels, the effects of spraying at an angle in-

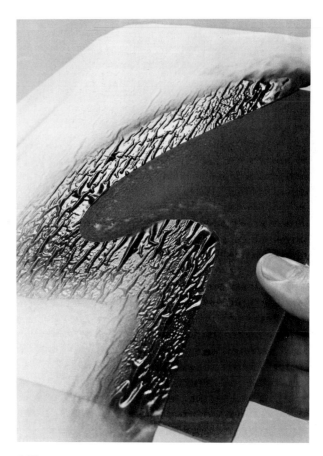

4-31

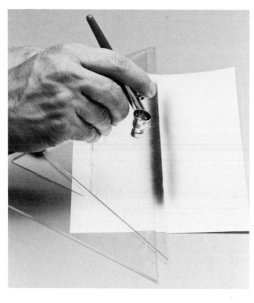

4-32

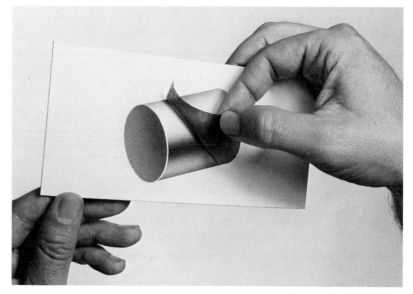

4-33

4-34

stead of perpendicular to the surface, and the effect of some spray (especially with heavy spraying) bouncing off the painting surface into the air and then settling back onto the painting.

Normally, overspray cannot be perceived until adjacent masks are removed. Unless you are spraying very small areas very close to the surface, cover parts of the painting beyond the borders of areas to be sprayed.

Paint pickup or tearing from adhered masks

Adhered masks have varying degrees of adhesive strength. Use a type that is appropriate for your painting medium and support. For example, masking tape can be used on acrylics but will pick up designers' colors and tear illustration board. Fresh paint that is dry to the touch but not thoroughly dry may pick up. Also, you will find that small brushed areas such as highlights will pick up more easily than sprayed areas. Even when you use proper materials and carefully remove adhered masks, you may get some paint pickup or ripping of the support, which will have to be corrected with retouching procedures.

The problem of tape ripping away part of the support can be minimized by slowly pulling the tape back upon itself at a 45-degree angle **(4-34)**. Also remove friskets slowly. In addition to reducing the probability of pickup or tearing, this also allows you to see these problems when they first occur. You can then pull from a different direction or tear through

the tape close to the area that is being pulled away. This sometimes prevents further ripping.

Color matching

Because the mask is sprayed at the same time as the surface of the painting, it is often difficult to see how freshly sprayed parts relate to covered adjacent areas. This is especially a problem with adhered marks, such as friskets. When using masks, always revert to a frame of reference. This may mean comparing sprayed areas with color swatches, or it may involve periodically lifting the mask to see if the exact variations of color value, intensity, and hue have been achieved.

Project 5
Masking and Stenciling

Prepare four 8- by 10-inch illustration boards. If you wish to work on smaller sizes, mount them on the 8- by 10-inch boards after they have been completed. With each exercise, experiment broadly and demonstrate skill, craft, and inventiveness within the given restrictions. Where applicable, you may wish to focus on one option or combine techniques from more than one option within an exercise. However, include only those masking devices listed under each exercise. Except for retouching, apply media only with the airbrush.

4-35 Carolyn McCabe. Student work, project 5, exercise 1.

Each exercise should include a black-to-white range of value. A different achromatic palette is included in each exercise so that you will gain experience with these variations before trying the color exercises in chapter 5. As an *option,* you may wish to include the use of one color hue in any of the exercises. A different hue may be used in each exercise.

Exercise 1: Cut or torn scrap paper

Prepare a number of papers for use in this exercise. Cut or tear a variety of straight and curved lines. Include holes, various angles, and changes in the direction and length of lines. Palette: black. (Cut paper was used in **4-35**, torn paper in **4-36**.)

Option: Screens. The screens or netting in this experiment should be $\frac{1}{16}$- to $\frac{1}{8}$-inch mesh. Cut or tear pieces of paper or other flat materials of various sizes and shapes (**4-37** uses round shapes). On a piece of smooth plastic wrap, place your screen over these materials and brush white glue through the screen onto the stenciling material, keeping the glue away from the paper edges. Spray from either side.

Exercise 2: Commercially prepared guides

Experiment with as wide a range of guides as

4-36 Robin Armstrong. Student work, project 5, cut or torn paper.

4-37 Niska Flammer Cheffet. Student work, project 5, screens.

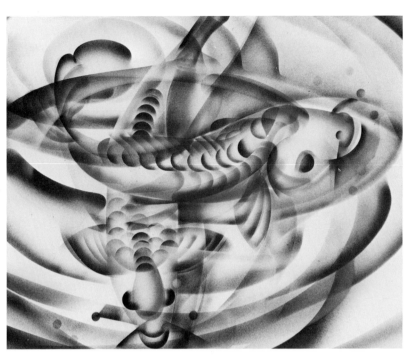

4-38 Niska Flammer Cheffet. Student work, project 5, commercially prepared drafting tools.

▼

4-39 Cynthia Morton. Student work, project 5, friskets.

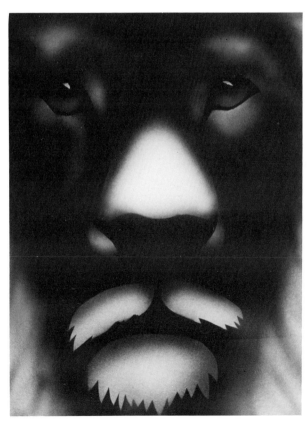

possible. Palette: black and white. (French curves, ellipses, T squares, and circles were used in **4-38**.)

Option 1: Commercially prepared stencil cutouts

Option 2: Charting or graphic art tapes

Exercise 3: Friskets

Instead of limiting yourself to a one-step cutout design, try a number of techniques **(4-39)**. Consider the following:

1. Combine freehand cutting with the use of guides.

2. Save the cutout frisket pieces so they may be reused. For example, after spraying, replace the frisket so that the area will not be covered by succeeding applications. Or reuse the shape cut from one area to partially cover another area to be sprayed.

3. After sprayed areas have been established, remember that they can be resprayed a different color or resprayed the color of the ground.

4. Sequentially develop painted areas by spraying thin layers of painting medium after each of a series of cutout areas are exposed. The areas cut out first will, therefore, be more saturated with medium than the last.

4-40 Janet Lombard. Student work, project 5, found objects and materials.

5. Distinguish between opaque and transparent, and flat and graded applications.

6. If adjacent sprayed areas have too much contrast, try spraying between them.

7. After spraying a cutout area, check it against other already sprayed areas by temporarily lifting the frisket or by using color swatches prepared for this purpose.

8. Try retouching unsprayed border areas by brushing, drawing, or additional spraying.

Palette: black and white and at least two commercially prepared grays.

Option 1: Liquid frisket
Option 2: Transfer materials

Exercise 4: Found objects and materials

Collect a variety of natural and man-made objects, such as leaves, grasses, twigs, flat machine parts, and other reasonably flat objects **(4-40).** Aggregates can also be used. In some instances where light materials are used, you may wish to spray from a high position above the support so that air movement will not alter the position of the masks. Palette: black and white and grays that you mix from black and white.

Chapter 5 **Color**

The airbrush is a marvelous tool in the hands of artists who are interested in establishing fine color relationships. It can be used to distinguish or render the slightest nuances of colors. With the airbrush you can make variations that would be difficult to achieve with the brush or other means. Also, as described in chapter 11, the airbrush is unmatched as a retouching tool in altering colors already established through other art processes. By spraying, you can be unusually specific in designating the exact value (tone), intensity (chroma or saturation), and hue (color designation) of a color. The airbrush is also useful when clarity is necessary in establishing transitions of color or complex color variations that are the result of numerous overlays of different colors.

Color is in itself a broad subject that can be studied over an extended period of time. This chapter introduces color considerations that relate specifically to airbrush painting without an involved study of color theory or extensive experimentation. However, the serious artist who does wish to pursue such a study should find airbrush painting an ideal means for this purpose.

The six exercises in project 6 are designed to introduce a series of techniques for varying color with spray. Exercise 1 establishes that a relatively transparent color overlay tends to flatten the value gradations of the underpainting and may cause a shift in hue. For example, yellow applied over neutral grays and black takes on a greenish hue. Exercise 2 is designed to demonstrate how overlays of neutral dark and light grays over a color hue not only produce a broad range of tones but may also produce a shift in hue. Exercise 3 shows that different colors result when hue intensity is altered by neutral grays as opposed to a complementary hue. Also demonstrated is that distinctive color variations may be produced when only a small amount of transparent color is sprayed. In exercise 4, it is possible to see the ease with which even and accurate hue changes, from one analogous hue to another, can be achieved. Exercise 5 is intended to reveal the full range of color that can be developed when complements are mixed with many alternating applications. Finally, in exercise 6, it is shown that through applications of each of the techniques described in exercises 1 through 5, many variations of a hue can be developed.

In variation 1, stripes provide the opportunity for each of these exercises to be creatively applied to a horizontally developed series of stripes.

Project 6
Color

Prepare an 8- by 10-inch illustration board by taping ½-inch borders on the two 10-inch sides, and ¾-inch borders on the two 8-inch sides. Then alternate 1-inch spaces with ½-inch taped areas across the 8-inch width of the board. In each exercise, apply solid colors with even, horizontal movements over each horizontal strip. All gradations should be applied in an up-and-down direction perpendicular to the strips. In each exercise, the exposed illustration board should be completely covered with paint so that the white of the illustration board does not influence the color of gradated overlays. Place a protective mask over areas not being worked on. Start with the top strip in exercise 1 and progress in order to the bottom strip in exercise 6.

Exercise 1

Using white and black gouache colors, establish an opaque white-to-black value progression, with white at the left. Follow the directions outlined in exercise 2 of project 3 on page 16. Then, working horizontally, apply an even wash of lemon yellow over the whole area until the full-strength color of the tube becomes apparent on the white. A small dot of thick lemon yel-

45

5-1

low on the left border can serve as a reference **(5-1)**. Try not to spray beyond this point so that the full effect of the underpainting will be apparent. Note how the darker values of the underpainting produce olive greens when overlaid with yellow and how the change in value in the underpainting from white to black is substantially reduced so that the right side dark gradation of the strip appears to have a flat underpainting rather than an even gradation (it is often necessary to counter this effect in airbrush painting).

Exercise 2

Apply an opaque layer of cadmium orange over the full strip. Then, working very slowly, deliberately, and perpendicular to the strip, apply an even progression from white at the left border through at least two commercially prepared grays to black at the right border **(5-2)**. Apply enough of these colors to alter the orange to various warm shades but not enough to attain a neutral or cool achromatic gray color. Note the many color tones achieved as you progress and how the orange shifts in hue to a range of tones that have a pink cast. Exercises 1 and 2, therefore, demonstrate not only the range of beautiful tones you can gain with these procedures but also how hues will change even when they interact with neutral values.

5-2

5-3

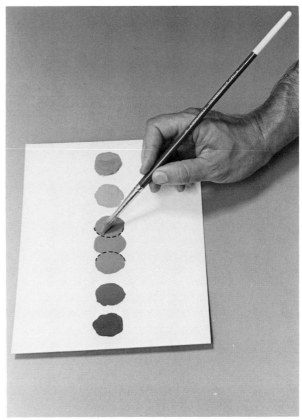

5-4

Exercise 3: Color Intensity Changes

Prepare a medium value tint of blue by mixing white and ultramarine blue to the same value as a neutral premixed gray, such as retouch gray no. 3 or Winsor & Newton gray no. 2. Apply an opaque layer of this mixed blue to the whole area. Then alter the intensity of the left side of this strip with the neutral gray and alter the intensity of the right side strip with the orange complement of the base blue. Ideally, the middle area (about one inch wide) will remain the original mixed blue color **(5-3)**. Begin the gradations with the gray; the left border should achieve the gray color of the tube and should gradate evenly almost to the center of the mixed blue. Mix cadmium orange with white to the same value as the mixed ultramarine blue. Slowly gray the right side by spraying orange until the right edge becomes a neutral gray. Note that only a very small amount of orange is necessary to achieve this effect. This exercise demonstrates that often you need only spray a very small

quantity of paint to achieve subtle or precise changes.

Exercise 4: Analogous Color Variations

Prepare tints of alizarin crimson and ultramarine blue by separately mixing them with white to the same value as a neutral premixed gray, such as retouch gray no. 4 or Winsor & Newton gray no. 4. Divide the painting area in half by placing pencil marks on both sides of the strip on the tape. Begin with the alizarin crimson tint at the left border and the ultramarine blue tint at the right border and evenly gradate through a purple mid area at the halfway mark. Note that an important factor in developing an even transition from one hue to another is whether the colors are on top as an overlay or underneath as part of the underpainting. Best results can probably be achieved with many alternating applications. This exercise demonstrates that even changes of analogous hues can be established when the original colors are pro-

perly selected and mixed. Within this hue range, it also demonstrates for the fine artist the range of colors that can be used without using colors that are more fugitive (colors that quickly fade). For example, because of the fugitive nature of many pigments used in designers' colors in the red to blue series, it is usually best for the fine artist to mix colors in this hue range.

NOTE: In mixing two hues to a particular value, paint the correct value gray in the center of a board and then separately mix the two tints. Test to see if the tints are of the right value by overlapping them on the dry gray area. Let the paint dry before judging the values (See **5-4**).

Exercise 5: Complementary Hues

Prepare two complementary colors by first mixing a red that is visually halfway between cadmium red pale and alizarin crimson, and then a green that is visually halfway between phthalocyanide green and lemon yellow. From the left border spray the red in a manner that gradates to white about two-thirds of the way across the strip. From the right, gradate the green in the same manner. Alternate the spraying to achieve an even transition between the two hues that centers on a neutral gray at the midpoint. The ungrayed red and green should be retained in the ½-inch area at the left and right borders. If you are careful in making your gradations, you should recognize the beautiful range of grayed colors that can be achieved with this technique (See **5-5**).

Exercise 6

Apply to the whole strip an opaque layer of a mixed red that is similar to that used in exercise 5. You may also wish to mix this red into or spray it over any of the other colors used in the exercise. Divide the painting area into six parts by placing pencil marks on both sides of the strip on the tape. Subtly, with either transparent or opaque layers of various hues, values, and intensities, apply as many variations as you can without moving out of what you would call the hue red. Make gradations in succession from left to right: (1) a pink tint that approaches white in value; (2) a shade that approaches black; (3) tones (mixed with red, black, and white) that are close to neutral gray; (4) reds that have been grayed with green; (5) and (6) analogous variations of red that shift almost

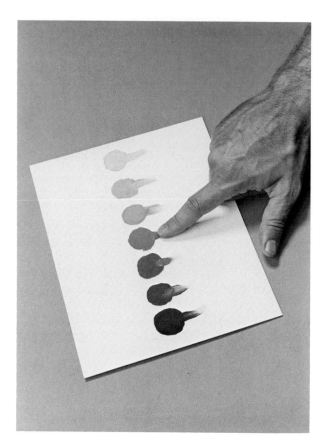

5-5 Project 6, exercise 5. Sometimes it is hard to accurately determine minute changes of hue in opaque areas. You may find it easier to do this when the paint is transparent. By dragging the wet paint across the board with your finger, to get a thin layer of paint, you may be able to see these variations more easily.

to violet and then to orange **(5-6)**. Your decisions pertaining to hue selection will be subjective but you will probably have gone too far when it is clearly appropriate to use the terms orange and purple to any area of the strip. If you go too far beyond the boundaries of red you can always spray some red over an area to bring it back into this hue range. Apply the lessons of the preceding exercises to this exercise. All six exercises are illustrated in color in **C-3**.

Project 6, Variation 1
Stripes

Design a series of stripes across the 8-inch dimension of an 8- by 10-inch illustration board. Your com-

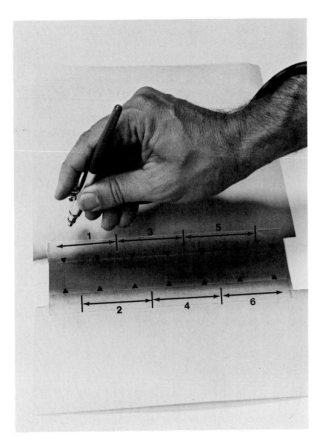

5-6

position should be conceived as a progression of horizontal stripes of varying widths. In most instances they should be applied separately; however, their design should result in a unified composition. Carefully consider both the size relationships of stripe widths and the color relationships that gradually develop as your painting progresses. Experiment broadly with each of the techniques of varying color discussed in this chapter.

Carefully develop opaque and transparent areas that are both flat and graded to maximum effect. Be particularly careful in your overall composition of the degree to which you work with a value range between black and white. Be sure to note that most areas will darken when overlays of transparent colors are applied. Carefully select the number of hues you plan to use, being sure not to use more than you can handle in your composition. One way of beginning is to start with thin washes of diluted paint and then carefully control value and intensity as you build up your color with thicker or more intense applications. As you establish color relationships, distinguish between achromatic, monochromatic, and polychromatic areas.

One student's interpretation of this project is seen in **C-4**, in the color section.

Chapter 6 **Rendering Forms**

Rendering is the process of representing or depicting subject matter. The airbrush can be a very useful tool in producing marvelous effects in rendering forms because it allows unusual control in creating beautifully finished surface qualities.

Although various considerations such as these may contribute to the development of your work, our purpose here is to examine a simplified approach. As an introduction to rendering with the airbrush, this chapter focuses on the element of form: the three-dimensional or volumetric nature of things. A more complete review of airbrush rendering skills can be gained by also studying chapter 8.

Basic Considerations

Perception

An important factor in rendering is how one perceives a form. This is why early experiences in art should include activities that assist perception and why artists attempt to rejuvenate their vision by more carefully studying their subject. When rendering, note how form is (or is not) revealed by light under various conditions. Carefully observe how light and dark work together to make contrast and transitional areas. Observe how light interacts with various surfaces and textures. Notice how color is a factor in the perception of form; and how color, when used incorrectly, can actually work counter to the objectives of rendering. Finally, note how the light/shade theory, presented in this chapter, can be used as an aid in rendering the illusion of form.

Drawing and design skills

The understandings or skills that you will need to produce good airbrush rendering are similar to those covered in beginning drawing and design courses. This content, for example, usually includes methods of pictorially producing form with line and value, the fundamentals of color, and simple perspective.

Preliminary studies

Some airbrush artists can progress from an idea to a finished piece without much preparation. Those who are inexperienced in airbrush rendering may need to work out visual problems in preliminary studies. This is especially important in airbrush painting because the artist must also focus on the difficult process of spraying as well as the many other artistic elements that contribute to the success of a work of art. You may also find that preliminary studies actually save time by resolving difficulties early.

There are more kinds of preliminary studies than quick sketches. Resolve the following problems before you begin the final stages of your work. This list does not represent a set of rules or a recommended sequence or procedure.

1. *Subject selection.* The subject should be carefully selected to be consistent with project objectives, media, tools, and techniques.

2. *Positioning.* Place the subject to establish form and spatial relationships. For example, a cylindrical form placed with only one side to the viewer only reveals a square shape.

3. *Lighting.* Design and control the lighting to reveal desired value relationships.

4. *Drawing.* Your rendering need not be a copy of the subject. It may be appropriate to change or alter size, position, proportion, or color (hue, value, or intensity). Clearly establish contours with careful attention to ellipses and converging lines. Establish the value range, placement of lights and darks, surface definition, and the desired degree of three-dimensional form.

5. *Color.* Establish specific colors and color sequences. Review chapter 5 for specific ways color can be achieved through spraying.

6. *Masking sequence* (especially with friskets).

When your project involves complex masking procedures, you may need to actually list the steps that will work best.

7. *Spraying.* When it is possible to anticipate either new or particularly difficult spraying problems, you should at least familiarize yourself with the skill or technique requirements of your project before spraying. Also, in addition to using a proper sequence to develop unique or complex color or to coordinate sequences of spray with masking techniques, you may need to consider how sprayed areas relate to those that are brushed or drawn. These techniques are discussed in chapter 7.

Sequence for the finished work

The number and content of the stages to be completed will vary from project to project. However, the following sequence may be useful in anticipating the actual steps you may wish to select. Although these examples assume the use of friskets, a similar process is used with other masking devices.

1. Be sure the painting support is clean.
2. Apply the line drawing to the painting support or to the frisket.
3. Apply the frisket over the areas to be sprayed. Be sure that all areas of the painting surface are adequately protected from overspray.
4. Cut and remove all friskets that should be sprayed in the first stage of spraying.
5. Base layers of opaque paint (if any) are applied at this time.
6. Drawn or brushed areas (if any) may be applied early so that subsequent spraying can clearly establish the degree they contrast with sprayed areas.
7. Slowly and accurately develop transparent sprayed areas. It is too often assumed that errors can easily be corrected with added spraying of white or other colors. However, such errors usually waste valuable time. Try to come as close as possible to the correct degree of light and dark, brightness or dullness, and hue designation (such as the right warm and cool combinations).
8. Check for correct values, intensities, or hues either by comparing freshly sprayed areas with already-prepared swatches or by lifting the frisket and comparing adjacent areas.
9. If necessary, reestablish drawn or brushed areas where too much spray has removed desired contrast.

10. Additional spraying can now establish more precise color or soften the contrast produced by drawn or brushed areas.
11. Reapply the frisket.
12. Repeat the sequence for each stage of the frisketing except the background.
13. Remove the frisket from all areas after each of the frisket stages (except the background) has been completed.
14. Retouch with the airbrush, brush, or drawing tools.
15. Apply a fresh frisket, remove the frisket from areas that have not been sprayed, and then spray in the background areas.
16. Apply a protective coat of fixative and/or a protective sheet of tracing paper or acetate.

Using Art Elements to Render Form

The emphasis of this chapter is on form as it is revealed by sprayed areas of value. It is also important to recognize how other art elements contribute to the development of form. Further information on techniques for controlling these elements is presented in other chapters.

Line

Lines are used to describe edges or extremely small forms or spaces between things, as with silhouette contours, inner contours, or detail areas. Lines also describe the more subtle changes of plane, hue, intensity, or value normally occurring within forms and shapes. In airbrush painting, lines are produced by tools (such as brushes or pens), by spray only, or by spray over masks. Because they are often the borders of masks, it may be necessary to interpret lines as they will be defined by the tools or techniques of a particular type of mask. For example, tapes can produce certain line qualities that are usually very different from the lines produced with liquid frisket or torn paper. These lines or edges usually are sharper or more defined than the airbrushed soft, transitional areas between lights and darks on forms.

Value

Because of the nature of spray, form is usually revealed with value. Therefore, it is important to know

basic ways that value is used to create the illusion of three-dimensional space.

Darks normally recede and lights advance; sharp contrasts in dark and light usually make objects seem closer than diffused or close-value color areas. Objects seem to become smaller as they recede in space. These fundamentals of vision, when applied in painting, create aerial perspective.

Light and shade theory or chiaroscuro is a system devised during the Renaissance to describe form as it is revealed by light and shadow. It usually relies upon the use of six tones: highlight, quarter tone (light tone), halftone (shadow), base tone (sometimes called dark core), reflected light, and cast shadow. See illustrations **6-1** on page 53 and **6-6** on page 56 to see how this system can be applied to rendering basic form.

In addition to its use in creating form, value is also important in composition. Airbrush artists frequently become concerned with creating individual forms and with the intricacies of masking. They can lose sight of the overall dark/light composition. However, the dark/light structure of a work is as important as the rendering of individual forms. The viewer needs to respond to a simple, clear compositional format. Works that are unnecessarily complex, have excess detail, or include incorrect applications of light and shadow usually confuse the viewer or create undesirable viewing conditions.

Color

Your use of color should support and even add to the illusion of the form you wish to achieve. Rendering that responds to minute variations in nature often requires complex, subtle, or unique color variations. Although the methods of achieving such colors are explained in chapter 5, the creation of colors that enhance form may also require an ability to perceive and understand how color works in subjects as well as airbrush skill. Consider the following factors as they contribute to the illusion of form.

1. The local color of an object as it interacts with the intensity or color of a light shining on it.

2. Variations in both hue and value resulting from the brightness of different lights shining on a subject. Note variations in the reflected light.

3. The influence of adjacent colors as they reflect onto surrounding surfaces.

4. The degree to which light on a surface is affected by the surface material or texture.

5. The relationship of warm and cool hues.

6. The subtle variations between transparent and opaque applications of color.

Surface

Textures, patterns, reflections of light, and cast shadows are surface qualities that can cause problems in rendering. When your intent is to emphasize form, carefully note the degree to which the basic forms of your subject should be retained or established. To create the necessary illusion of form, you may have to diminish or alter the surface qualities of your subject and create value relationships that do not exist on your subject. Chapter 8 describes techniques for rendering surfaces.

Basic Geometric Form

Artists and teachers traditionally refer to the benefits and even the necessity of learning to recognize basic geometric forms in subject matter. The ability to perceive complex forms requires skill in simplifying and requires an understanding of structure. Related problems of rendering form are those of rendering the relationships between a form and its setting, its ground, space, or other forms.

When we discuss basic geometric forms, it is important to note that we are referring to three-dimensional forms; geometric *shapes* are two-dimensional. Both are basic. Most objects can be reduced or simplified to relate closely to them. Lists vary, but for our purposes the most basic of shapes are the square, triangle, and circle. The basic forms are the cube, cylinder, cone, and sphere. Skills derived from rendering basic geometric forms are useful in rendering non-geometric three-dimensional forms.

In this chapter, selected problems of airbrush rendering are presented first through the geometric forms project. Increasing complexity or difficulty appear in succeeding lessons. One possible approach to value is introduced and is implemented in suceeding projects. A step-by-step procedure for using friskets is shown before projects in which you are expected to work out your own sequence, and a sequence of color palettes is suggested. One palette uses transparent black on geometric forms. Another palette suggests opaque black and white on a complex object. A third palette is for use of more than one hue.

C-1 Duane Hanson. *Self-Portrait with Model*. Polyvinyl acetate, life size. Courtesy of the artist.

C-2 Gene Allison. *Camaro*. Gouache, 12 by 14 inches. Courtesy of the artist.

C-3 Byron Koga. Student work, project 6.

C-4 Diane Harbold. Student work, project 6, variation one.

C-5 Wai Tak Lai. Student work.

C-6 Julie Matsuoka. Student work.

CONTEMPORARY ALBUM COVER ART & DESIGN BY BRAD BENEDICT & LINDA BARTON

Phonographics

C-8 Susan Roller. Detail, student work.

◀

C-7 Dave Willardson. Cover for *Phonographics*. Dyes and inks, 15 by 20 inches. The book title was prepared on a separate sheet of acetate and combined with the illustration when the cover was printed. Courtesy of the artist.

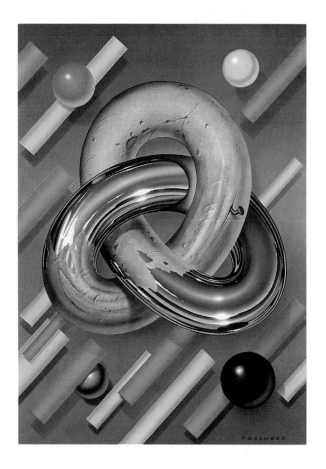

C-9 Todd Schorr. *Untitled*. Dyes and gouache, 12 by 17 inches. Courtesy of the artist.

C-10 John Altoon. *J-122*. Watercolor and ink, 30 by 40 inches. Estate of John Altoon, courtesy of Tortue Gallery, Los Angeles.

C-11 Ethel Todd. Student work. Papier-mâché, collage, and polyester resin.

C-12 Tom Fritz. Student work.

C-13 Nancy and Morris Zaslavsky, art direction and design. Norman Fullner, airbrush illustration. *Aeroglide '79.*

C-15 Linnett Moreno. Student work.

THE WRITER AND THE WEST

SPONSORED BY LEVI STRAUSS & Co.

JULY 5 − 8, 1978

AT THE SUN VALLEY CENTER

FOR THE ARTS & HUMANITIES

SUN VALLEY, IDAHO

C-14 Charlie White III. *The Writer and the West*. Watercolor, 20 by 30 inches. Courtesy of the artist.

C-16, C-17 Louis Grubb. *Air Canada Advertisement*. Bleaches and dyes on dye transfer print, 16 by 20 inches. Courtesy of the Warwick, Welsh and Miller agency. Before the color photo retouching work, a negative stripping process was used to change the width of the river. Retouch work included changes in the color and direction of the river current, nightfall coloring in the sky, and lights turned on along the river.

▶

C-19 Billy Al Bengston. *Busby*. 72 by 60 inches. Courtesy of Artist Studios, Venice, California.

C-18 Paul Sarkisian. *Untitled #3, 1980.* Acrylic on linen, 79 by 119 inches. Courtesy of the Nancy Hoffman Gallery, New York.

C-20 Jules Olitski. *Doulma*. Acrylic on canvas, 68 by 90 inches. Courtesy of Mr. and Mrs. David Mirvish, Toronto, Canada.

C-21 De Wain Valentine. *Three Red Discs.* Fiberglass, 64 by 84 inches. Courtesy of the Melinda Wyatt Gallery, Venice, California.

Diagram for Basic Geometric Forms Project: Application of light and shade theory without cast shadows

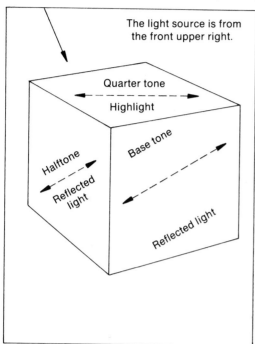

The light source is from the front upper right.

Quarter tone

Highlight

Halftone

Base tone

Reflected light

Reflected light

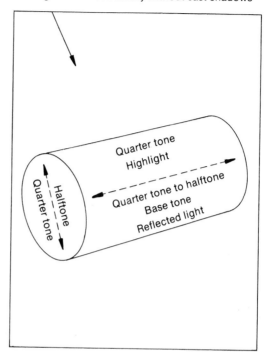

Quarter tone
Highlight

Halftone
Quarter tone

Quarter tone to halftone
Base tone
Reflected light

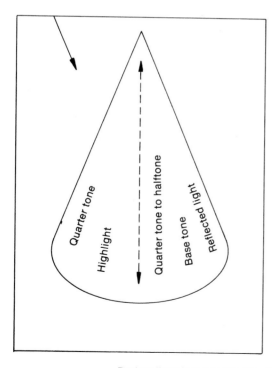

Quarter tone

Highlight

Quarter tone to halftone

Base tone

Reflected light

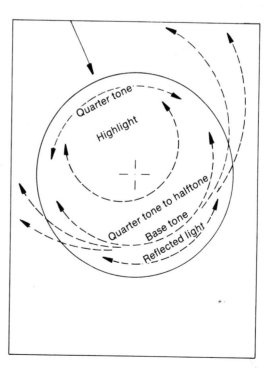

Quarter tone

Highlight

Quarter tone to halftone

Base tone

Reflected light

Broken lines indicate the direction of arm movements for spraying.

6-1

Project 7
Basic Geometric Forms

Render the four basic forms on 3¼- by 4¼-inch illustration boards. Then glue the four boards onto an 8- by 10-inch board, leaving ½-inch borders around and between each section.

Use friskets after first reviewing frisket techniques in chapter 4. Prepare frisket paper that is larger than the area to be covered, apply without creasing, lightly draw the line contours of the forms, cut the stencil, remove the stencil, and then remove excess rubber cement.

Use only transparent applications of paint with the airbrush. The palette is restricted to black designers' colors. To practice these forms, assume (don't set up) a light source that is slightly left of, above, and closer to you than the subject. Your deepest shadow will be at the lower right of the subject. Develop the values slowly with a minimum of overspray. Try to retain a black-to-white range of value in each of the forms. Use the diagram provided for your line drawing and for an indication of value area placement. To simplify the project, cast shadows have been left out of the rendering. Diagram **6-1** should be referred to while executing the geometric forms.

Exercise 1: Cube

Draw a cube in a traditional three-quarter view with the front edge "tilted" down. To save time, a simple sequence of removing frisketed areas is used. The lower right side is exposed first, because it will be the darkest. On this side, gradually build up a dark-core, gradated area that is darkest at the upper left and grades lighter to a reflected light at the lower right. The reflected light should be light enough to be observed as a separate value but dark enough to allow the side to be read as a plane. The middle value, the lower left plane, should be exposed and graded in a similar manner. Finally, the upper, lightest plane is exposed **(6-2)** and graded in the same way. **(6-6** shows the finished cube.)

Exercise 2: Cylinder

Draw a cylinder in a three-quarter view with the exposed end facing to the lower left. Begin by removing the frisket from the side of the cylinder. Set up a bridge (a raised edge above the working surface,

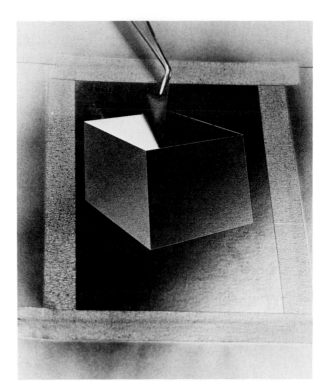

6-2

6-3

6-4

used to steady the hand). Using the bridge, begin with a dark band that is below center and above a reflected light area at the bottom. This bottom dark band should evenly gradate upward to a white band about two-thirds high on the side. It is best to alternate between the two sides until the desired value relationships are achieved.

Replace the side mask and remove the frisket covering the end of the cylinder. To achieve a solid effect rather than one that is hollow, try applying the dark areas so that they are perpendicular to those on the side **(6-3)**. (Cylinder is seen upside-down in **6-3**. See **6-7** for finished work.)

Exercise 3: Cone

Draw a cone so that it is tipped slightly forward. Develop the same value sequences as with the side of the cylinder except that each value tapers to the point of the cone. Begin most applications close to the board at the point of the cone and then flare outward toward the base. This can be done by holding the bridge closer to the surface at the tip of the cone. Remember that the same amount of spray is used to cover a wider area as the airbrush moves toward the bottom of the cone. To compensate for this, gradually move the arm more slowly as necessary to apply more paint to the surface. A guide may be used, as in **6-4** where the base tone is being sprayed. This is a difficult technique that you may be able to achieve only partially. (See finished cone, **6-8**.)

Exercise 4: Sphere

Develop similar value relationships with the sphere, as established earlier with the cylinder and the cone. However, in this instance use circular arm movements. First develop the lower base tone by setting the adjusting screw at a point where simple on/off applications of spray can be used to gradually build up a dark value.

A continuous circular movement through the base tone area will produce an even "ring around the ball" effect. You may wish to limit your efforts to this acceptable technique because you prefer it or because of your present skill level. To achieve the more difficult floating crescent effect, you may wish to try the following methods:

a. As shown in the diagram **(6-1)**, use arm movements that converge on the base tone.

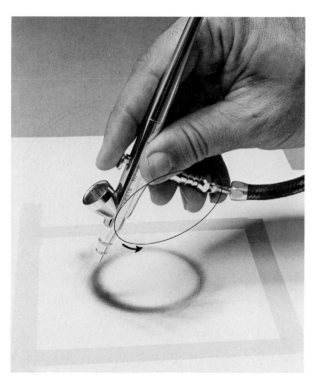

6-5

6-6 Anne Woo. Student work, project 7, cube.

6-7 Arlene Manougian. Student work, project 7, cylinder.

6-8 Mari Omori. Student work, project 7, cone.

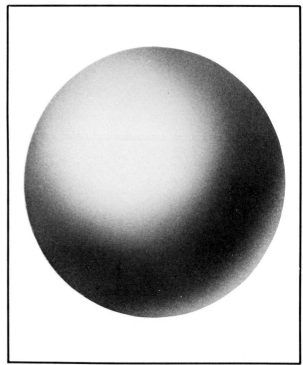

6-9 Dianne Porter. Student work, project 7, sphere.

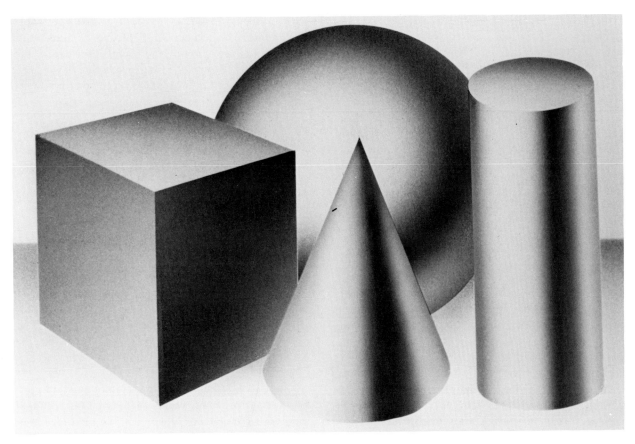

6-10 Ben Balke. Student work, project 7, variation one.

b. Move quickly as you pass over the borders and then slow your arm movements as you pass through the center area of the base tone.

c. Spray closer to the board as you spray the center area of the base tone and move away as you approach the borders **(6-5)**.

When the base tone is completed, the other tones can then be completed (see **6-9**).

Project 7, Variation 1
Basic Form Variations

This variation offers the opportunity to experiment with other approaches to rendering basic geometric forms (**6-10** shows one possibility). Review project 7 before beginning. Be sure to apply the light/shade theory presented earlier in this chapter and include a broad value range within the contours of each object.

Consider the following variations.

1. Basic forms with cast shadows.

2. Other simple or complex geometric forms, forms with cutaway sections, or hollow forms.

3. A still life that includes at least three basic forms and cast shadows.

4. Opaque applications.

5. Other palettes. State on the back of the board the palette used. Consider the following colors either separately or in combination: black and white only; black, white, and palette-mixed or premixed grays; monochromatic, analogous, or complementary hue variations. If more than one hue is used, you may wish to use warm and cool colors on opposing planes to accentuate the illusion of form.

6. A different light source(s) than that assigned in project 7 with different value relationships. However, be sure such changes contribute to the illusion of form.

7. Airbrush with accompanying brush or drawing techniques.

8. Rendering surface characteristics such as reflective qualities, texture, or type of material.

The Relationship of Basic Forms to Objects

Our interest in the function and beauty of certain qualities of objects sometimes limits us from responding to them formally as artists. For example, it may be difficult for the artist to recognize that the complexities posed by detail, surface reflections, and color may be dealt with through simple ways of interpreting the subject. It is important to recognize basic forms in objects because you can then see beyond detail to simplicity and clarity. This recognition also allows you to anticipate simpler methods to complete your work. For example, the use of friskets is simplified when you can anticipate fewer or simpler steps of masking in response to inherent basic forms. You can learn to recognize the way basic forms relate to each other and combine to make a complex object.

Try to select objects that are within your ability; attempts at rendering overly complex or detailed objects could prove to be quite frustrating at this point. Details such as interior lines, surface embellishments, highlights, or cast shadows often require additional techniques and tools. Although these special effects are discussed in chapter 7, some use of brushes or drawing tools may be necessary at this point. If so, review the introduction to chapter 7 and the section on painting and drawing tools before beginning.

Groups of objects in space

Rendering more than one object or rendering objects in a setting involves more complex applications of drawing and painting skills. Because of this, attention to preparatory steps is even more important than when single objects or forms are rendered. Any still-life arrangement can include many complex possibilities. Preliminary studies should be included when groups of objects are rendered. Remember, at the final stage you should concentrate on applying the skills of spraying.

Complex airbrush rendering involves extensive applications of content already covered in this book. It also involves fundamental drawing and design skills. You may wish to review other chapters or sources if you require more information in the areas listed below.

1. *Composition and perspective.* Keep in mind that with groups of objects, the sum of the parts does not necessarily make a whole. In complex rendering, try thinking of the full composition rather than focusing on individual objects. In depicting the illusion of objects in space, provide the visual information the viewer needs. Consider visual principles of perspective such as location or position on the picture plane, size, relationships, foreshortening, converging lines, degree of detail, value contrast, and intensity (bright/dull) or hue (warm/cool) color variations. Where appropriate, also consider systems of perspective such as linear or aerial perspective. Establish figure ground relationships with sufficient clarity. Determine how objects relate to the surface on which they rest, and how they relate to each other in terms of light sources and reflected light.

2. *Masking.* For artists who are used to beginning projects without extensive forethought or study, masking may be a frustrating process. As complexity increases, however, carefully thought out sequential masking steps save time and prevent mistakes. In projects involving complex rendering, you may wish to use various kinds of masking devices. Try to use the easiest or quickest masking techniques that will adequately do the job.

3. *Color.* When unifying the color in your composition, you may wish to consider traditional methods such as color schemes, value or color intensity keying, or the simple repeating or balancing of color. It is sometimes difficult, however, to unify the color in complex rendering because color application usually involves a series of separate steps using masks. This problem is complicated when masked areas are adhered to the painting surface (as with friskets). This adhesion inhibits cross-referencing with adjacent color areas. Overspray in these areas adds to the problem. As a result, the colors may be too dissimilar, too similar with minimum variation in intensity or value, or too dark. You may need to remove the mask at least partially to see color relationships. Prepared swatches of the colors on the areas hidden by the mask can also be used to solve this problem.

4. *Surfaces.* If you are progressing through the projects in a step-by-step manner, you will find it easier to limit indications of texture, pattern, or the reflective qualities of materials. However, at this point in your development with the airbrush, you may find it hard to resist trying some of the special effects skilled airbrush artists do so well. If so, review chapters 7 and 8. Before you begin on the final work, practice the techniques you plan to use.

6-11 Bob Zielonka. Student work, project 8, clothespin.

6-12 Arlene Manougian. Student work, project 8, lipstick.

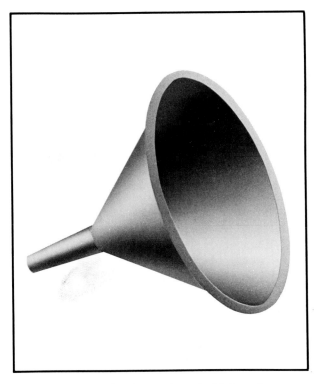

6-13 Jeanne Meyer. Student work, project 8, funnel.

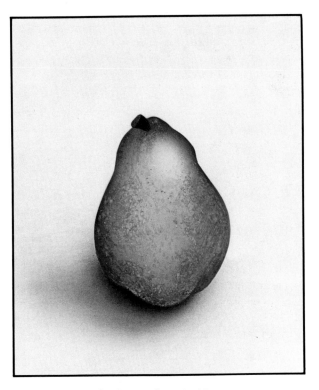

6-14 Gloria Vigil. Student work, project 8, pear.

5. *Craft and retouching.* The careful planning and preliminary studies suggested earlier will help you with the greater level of skill required in complex airbrush rendering. The slow and deliberate processes that lead to good craftsmanship are also useful in retouching damaged areas or errors. Plan to include some cleanup and retouching time at the end of your project.

Project 8
Rendering Simple Objects

This project has the same restrictions as project 7, with these exceptions.

1. Instead of geometric forms, four objects are rendered that visually correspond to the forms used in project 7.

2. The rendering should be derived from actual objects, not from photographs or memory. Before beginning on the final work, consider the preliminary steps suggested earlier in this chapter. Make detailed preliminary drawings that clearly establish value relationships. Note that even though the drawing is from direct observation of the objects, it will probably be necessary to alter areas to create a better illusion of form.

3. Apply any of the color spraying methods explained in project 6. Four possible subjects are shown in **6-11** through **6-14**.

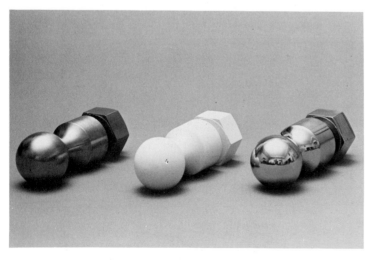

6-15 Of these three surfaces, the white coupling ball provides the best model, having a surface free of unnecessary reflections.

Project 8, Variation 1
Guided Rendering of a Complex Object

On an 8- by 10-inch board, used horizontally, render the trailer coupling ball in illustration **6-15**. Use the following procedures. The photo sequence demonstrates the steps you will follow.

Preliminary considerations

1. *Subject.* As before, have the light source in the upper left and forward of the subject. Have the subject in three-quarter position, tilted slightly forward to expose the three major plane areas. Although the linear rendering closely reproduces the subject, some of the values should be modified for clarity and to emphasize form. Draw the subject correctly in two-point perspective and have the values follow the light/shade theory presented earlier in this chapter.

2. *Masking.* The step-by-step frisket procedures in this lesson are presented to demonstrate how a carefully worked out sequence can save time. As described in chapter 4, prepare your frisket, apply it to your board, and transfer the line contours of illustration **6-16** to your board.

3. *Palette.* Because project 7 demonstrates rendering with transparent washes, this project emphasizes the use of opaque applications of black, white, and premixed grays. Number 2 and no. 3 premixed grays are suggested.

Frisket and painting sequence

The recommended frisket and airbrush painting procedures are similar to those listed earlier in this chapter under "Sequence for the Finished Work."

Render each area by working back and forth between the value areas which have been designated. While the friskets are still in place, compare each value area with the value swatch you have prepared for this purpose. Try to obtain a uniform warm or cool cast throughout the rendering. Remember that sprayed areas will look cooler if you finish with a sequence of light values over dark, or warmer if you finish with dark values over light.

To spray the base tone black, use the technique

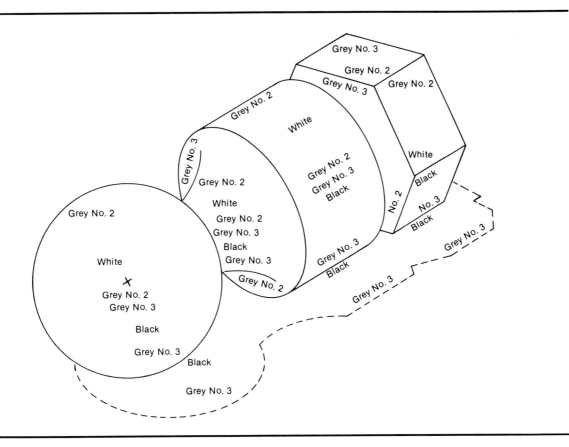

Grey No. 3
Grey No. 2
Grey No. 3 Grey No. 2
Grey No. 2
White
Grey No. 3
White
Grey No. 2
Grey No. 2 Black
Grey No. 2 Grey No. 3
White Black No. 2
Grey No. 2 No. 3
Grey No. 3 Black
Black
Grey No. 3 Grey No. 3
Grey No. 3 Black
Grey No. 2 Grey No. 3
Grey No. 2
White
X
Grey No. 2
Grey No. 3
Black
Grey No. 3
Black
Grey No. 3

6-16

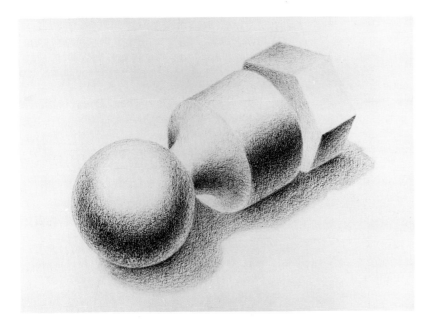

6-17 Thomas Stein. Student work, project 8. Soft graphite pencil.

6-18

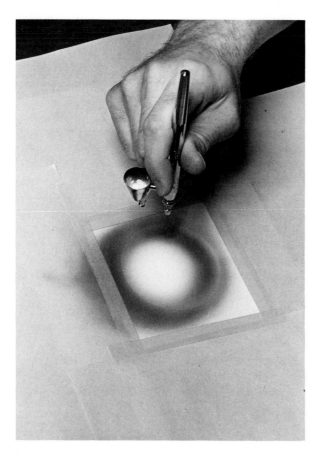

6-19

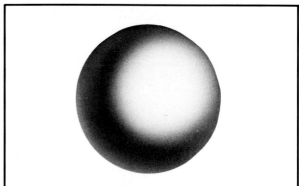

6-20

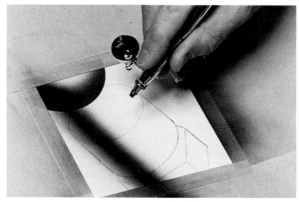

6-21

recommended in exercise 4 of project 7. The overspray of this step darkens both the reflected light and the halftone areas on both sides of the base tone of the sphere (**6-18**).

The reflected light is made more opaque with no. 3 gray. Number 3 gray is also used to complete the halftone above the basetone. Number 2 gray is used on the quarter tone area around the highlight. Do not get overspray on the highlight area. Complete the highlight with white (**6-19, 6-20**).

The cylinder is sprayed in the same way. Be sure the area above the center of the cylinder becomes white. Complete the basetone by spraying toward the reflected light. Be sure that overspray does not make the reflected light area too dark (**6-21, 6-22**).

The curving hard-to-soft edge of the cone's neck is rendered by cutting a mask of .005 mil acetate. This mask is large enough to extend well beyond the frisket opening. Both the positive and the negative shapes are used.

The cone is rendered by exposing the full frisket area to be sprayed. As shown in the photograph, the acetate mask is anchored at one end and raised about 90° on the other. A hard-to-soft edge is created by spraying from the back (**6-23 to 6-25**).

The other mask is used in a similar way to create the base of the cone behind the neck. Number 3 gray covers the top, and no. 2 gray is used on the bottom.

The three outer facets of the nut are completed individually. The friskets are replaced as each facet is finished. Spray at the angle indicated for each facet and for the inside plane of the nut (**6-26**).

When the nut is finished, all friskets should be removed from the object but left on the background. Evaluate the rendering to see if there are any inconsistencies in the relationships of the value areas. Retouch (spray) any areas that need to be modified.

To render the shadow which is cast by the trailer coupling, place a fresh frisket over the entire coupling, precisely following the object's outer contours.

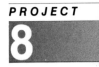

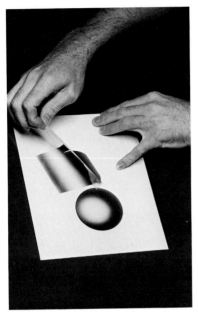

6-22

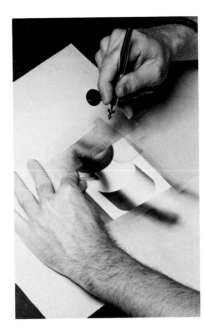

6-23

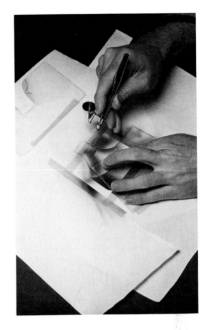

6-24

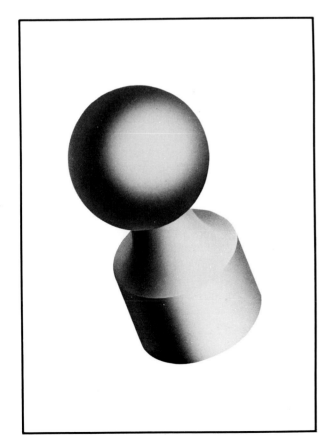

6-25

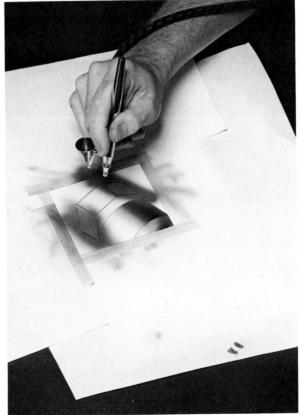

6-26

PROJECT

8

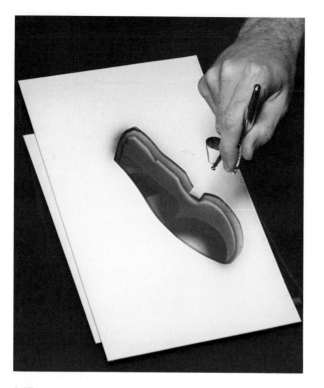

6-27

From a piece of .005 mil acetate which is larger than the board, cut out the shape of the cast shadow. To make it rigid, mount the acetate mask on a board which is larger than the mask opening.

Suspend the mask about ¼ inch above the area to be sprayed. Spray the shadow from about 8 inches above and perpendicular to the surface, to establish a soft edge. Spray black into the areas close to the bottom contours of the object. Then use no. 3 gray to paint a gradation on the diffused outer edge (**6-27**).

Project 8, Variation 2
Rendering of a Complex Object

On an 8- by 10-inch board, render a complex object. Use frisket masks. This project is divided into two parts.

Part 1: Preliminary Steps

1. *Subject.* Select an object that can be interpreted as a combination of basic forms. The object may actually be separate parts that are in some way

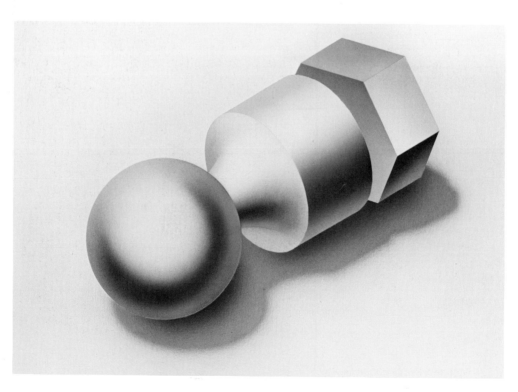

6-28 Chester Przelomiec. *Coupling Ball.* Courtesy of the artist.

6-29 Ray Fagundes. Student work, project 8, variation two.

6-30 Ray Fagundes. Student work, project 8, variation two.

connected to comprise an object. Work from an actual object, not a photograph.

2. *Light.* Use a carefully established and constant light source.

3. *Preliminary drawing.* Make a detailed preliminary drawing that clearly establishes value relationships. Use a drawing medium, such as a no. 6B pencil, that will allow a broad value range between black and the white of the drawing surface **(6-29)**.

4. *Masking.* Write on a separate sheet of paper the areas of friskets to be removed, the sequence of frisket cutting, and which friskets will be reapplied to the surface after spraying.

Part 2: Painting

1. *Palette.* Use opaque applications with black and white or black and white with palette-mixed or commercially prepared grays.

2. *Techniques.* Emphasize airbrush techniques. However, brushes and drawing tools may be used where appropriate to render detail.

3. *Optional.* You may wish to include cast shadows, ground or background planes, or other figure/ground relationships **(6-30, 6-31)**.

Project 8, Variation 3
Rendering a Still Life

Your approach to this project should correspond to your particular interests. If your interest in airbrush painting includes vocational objectives such as illus-

6-31 Jeanne Meyer. Student work, project 8, variation two.

6-33 Ray Fagundes. Student work, project 8, variation three.

tration, you may wish to interpret your subject in terms of a theme, story, or product. If you are interested in fine art uses of the airbrush, you may wish to interpret this lesson as a formal still-life study or as an opportunity to apply particular conceptual or design implications (see **C-5, C-6,** color pages). At the end of chapter 8 is provided a step-by-step example of a still life that demonstrates rendering various surfaces.

This project is divided into two parts.

Part 1: Preliminary steps

1. *Subject.* Select at least three objects that include forms or combinations of forms you feel

◄

6-32 John Garber. Student work, project 8, variation three.

confident in rendering. You may wish to spray your subject white so that the forms can be seen more clearly. Select a setting where the subject will not be disturbed and the lighting will remain constant.

2. *Preliminary drawing.* Make a detailed preliminary drawing in full value that is either 8- by 10-inches or the same size as the finished painting. Use a drawing medium, such as a no. 6B pencil, that will allow a broad value range between black and the white of the drawing surface.

Part 2: painting

You may wish to work somewhat larger than the 8- by 10-inch format used in preceding lessons. The use of airbrush techniques should be emphasized; any combination of techniques, tools, and media or uses of color covered in earlier assignments may be applied to this project as well. Use at least three hues.

PART TWO
SPECIFIC

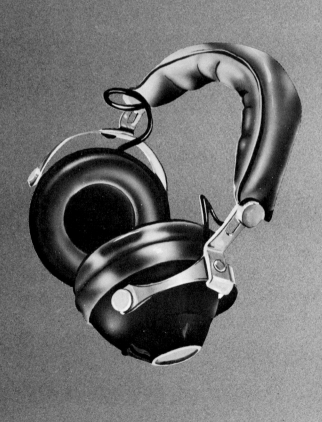

The following six chapters cover selected techniques and uses of materials. The information is geared toward those who have some familiarity with airbrush painting fundamentals. These pages also explore the ways spray is used by different kinds of

APPLICATIONS

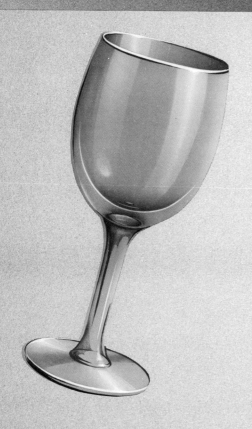

artists. These specially selected techniques are presented because they are frequently used or have additional, broader applications for the art fields, tools, or subjects with which the airbrush is used.

There are many technical uses of spray. Techniques for creating various effects are presented in chapter 7, the rendering of surfaces in chapter 8, and mixed-media possibilities in chapter 9.

Art and art-related fields in which spray is used are discussed in chapters 10 through 12. Uses that emphasize communication are presented in chapter 10. Retouching, which continues to be an important application of airbrush painting, is presented in chapter 11. Finally, those fields which emphasize expressive and decorative uses of spray are discussed in chapter 12.

Chapter 7 **Special Techniques**

Special techniques extend the limits of airbrush painting beyond the basic techniques. These special techniques create many of the exciting effects seen in airbrush painting. At times, when applied without proper consideration of the broader implications of form, space, color, and composition, these techniques may seem flashy or gimmicky.

These special techniques may not integrate well with your work. Uniformity of imagery, therefore, is an important consideration if many of the special techniques described in this chapter are to contribute effectively to a unified composition. Compatibility of materials is another factor to consider. When selecting special techniques, you may wish to note the nature of the supports and the properties of the pigments, dyes, binders, vehicles, and other components (solvents and extenders, for example) being used.

Airbrush Painting with Other Painting Processes

The use of airbrush painting does not have to be dominant, extensive, or even visually apparent in order to be an important factor in a work. You may find numerous uses for airbrush painting in works that emphasize other processes, such as drawing, brushing, photographic, or printing processes. Therefore, an important use of spray is to achieve effects that cannot be achieved as well as through other processes. In **7-1**, for example, spray was used for flat and gradated areas on the drawing. The rendering was completed with a small brush and some airbrush painting to soften edges.

Although most of the projects in this book emphasize the use of spray, most of the techniques can

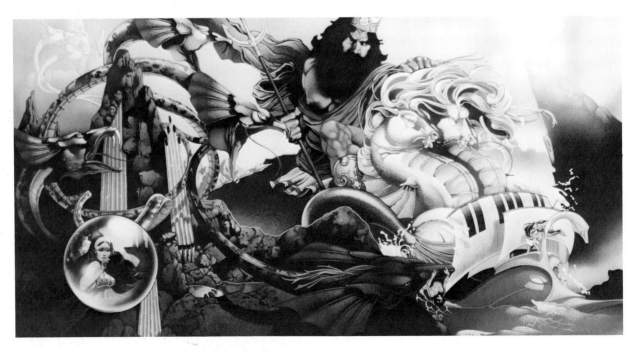

7-1 Robert Rodriguez. *Ulysses: A Greek Suite.* Acrylic polymer on canvas, 35½ by 18½ inches. Courtesy of the artist.

be used effectively in limited ways. The following are only two examples of these special techniques. The techniques described elsewhere in this chapter may suggest other limited uses of spray.

Underpaintings and backgrounds

Airbrush painting can be used to establish an underpainting for other processes. Through airbrush painting, areas can be covered fast and alterations can be made quickly. For example, a sprayed underpainting or background may serve to provide atmospheric effects. These may coordinate with more contrasting applications of drawing, brushed painting, or printed areas. In animation, a sprayed background may relate beautifully to the solid color areas of transparent overlays.

Uses in different stages or in completing parts of paintings

When compatible or identical media are used for spraying and brushing, airbrush painting can be used to complete areas that require special spray effects. When spray processes are used only in small areas or at various stages of the painting, special attention should be given to integrating the sprayed areas with the rest of the painting.

Transparent Supports

Transparent supports of either glass or plastic are usually smooth and nonporous. These surfaces, therefore, should be painted with media that will properly adhere, that can be modified to adhere, or that can be specially prepared. Aqueous media are usually used in renderings. Specially prepared acetate can be purchased to restrict beading. The specific areas to be sprayed can be prepared the same way as are glossy photographs in retouching (see chapter 11).

Special solutions that reduce the surface tension of liquid media can be purchased in art stores. If it is necessary to spray on glass or heavy plastic for display, sign painting, or fine art purposes, a medium such as an acrylic latex (which uses a lacquer thinner solvent) can be used.

In animation, the airbrush is used for the backgrounds on which the cells are overlaid and on the cells themselves. Technical renderings utilizing trans-

parent overlays are used in such areas as mechanical, industrial, architectural, and medical illustration (see **C-7**, in the color section).

In these kinds of rendering, the airbrush can be used on overlay sheets to illustrate cross sections or cutaways, to create ghosting effects that give the appearance of transparency and to make additions. With the transparent overlay, it is possible to retain the original photograph or rendering intact and show one or more alterations in sequence or in layers.

Subtractive Techniques

Subtractive painting refers to the process of removing rather than adding paint to a surface. Care should be taken in using these techniques so that desired areas of the painting or painting support are not damaged.

Abrasive methods

Sandpaper can be used to remove layers of paint from a surface. Media such as acrylic polymer that will not respond well to regular sandpaper are usually easily removed with wet-and-dry sandpaper. Although it is sometimes possible to achieve interesting effects, it is normally difficult to control this process well enough to use it as a painting technique.

With the use of the air eraser **(7-2, 7-3)**, it is possible to work into areas with good control. This

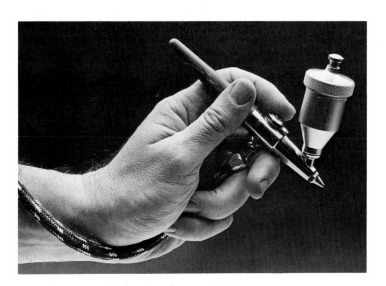

7-2

tool is a miniature version of the sandblaster; it uses a fine abrasive powder rather than sand. The air eraser can also be used to roughen painting supports so that they will better accept media. Smooth plastic and glass, for example, can be given a tooth that allows appropriate media to adhere to them. When using this tool, always remember that the blasting material spreads throughout the working area after hitting the painting surface. Goggles and a respirator should be used.

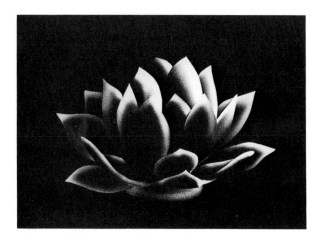

7-3 Lulu Wetmore. *Scratchboard, 1982.* This technique involves using an air eraser and a fast cutting compound to expose the white ground of scratchboard.

Regular or abrasive erasers can be used to remove or partially remove lightly sprayed areas. A power eraser (used in **7-4** with an eraser shield) removes paint more easily and quickly but must be used carefully or it gouges the surface. Sandpaper attachments can also be used in this tool.

Liquid methods

The proper solvent or vehicle of a medium (whichever will reliquefy the dried material) can be used in the airbrush to work back into the medium or through it. For example, minute amounts of water, with carefully controlled pressure, will cut through thin layers of designers' colors, exposing the support and producing a muted line, dot, or area that is different from areas sprayed with color **(7-5)**.

As described in chapter 11, a moistened cotton swab can be rolled over a surface to remove paint. This technique works best on glossy surfaces covered by thin layers of paint. There is an interesting mixed-media variation to this technique. If the underpainting is of acrylic polymer and the rest of the painting is of a remoistenable medium such as designers' colors, subtractive techniques with water and a cotton swab (or other wiping material) are easy **(7-6)**. Being able to work back to the underpainting may allow for a greater range of experimentation on the painting because corrections and modifications can be made

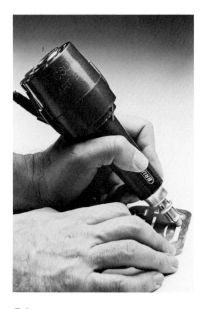

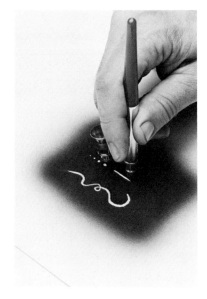

7-4 7-5 7-6

quickly by simply working back to the acrylic under-painting.

When using these techniques, it is sometimes best to overexpose the support or lower layers so that working back into the area with additional spraying can produce the exact effect desired. For example, isopropyl alcohol, either full strength or diluted, can be used to remove thin layers of acrylic tempera. This process is difficult to control, so the easiest technique

7-8 Daniel Smith. Student work.

7-9 Samvong Sarkdavisarek. Student work.

is to remove more tempera than necessary, rinse the alcohol off with water, and then work tempera back into the exposed area with spray.

Bleaching is another way to remove or diminish the color of most transparent water media. Regular household bleach can be used; however, there are available color removers for dyes on regular surfaces and dyes that have been applied to film. Special bleaches or reducers are available in photography stores for use on negatives, prints, and trans-parencies.

Texture

Texture is often discussed as being real or implied. Real texture refers to the actual tactile quality of a surface; i.e., smooth, rough, nubby. Implied texture usually refers to a visually perceived texture that is different from the actual tactile quality of a surface. For example, smooth plastic wall panels may be treated to look like rough grained wood or coarse burlap. In **7-7**, note the contrasting implied textures of the stippled background (applied with a gravity-feed airbrush), the wood grain of the guitar, and the glossy, highly reflective surfaces.

The airbrush can be a useful tool in producing or emphasizing both types of texture. Sharp-angle spraying can be used to heighten most textured sur-faces because the spray will collect most heavily on one side of the raised part of the texture **(7-8)**. Simi-

7-7 Mick McGinty. *Music Television.* Acrylic, 38½ by 25 inches. The stippling in the background of this painting was achieved with a gravity feed airbrush to produce large dots that look like spatter. Note the contrast between the stippling, wood grain on the guitar neck, and gloss of the highly reflective surfaces. Courtesy of Willardson and White and the artist.

larly, repeated sharp-angle shooting from different sides of rough surfaces can result in multicolor effects. As an interesting variation, some surfaces can be temporarily formed and then sprayed, as when paper is crinkled, sprayed from one or more directions, and then reflattened.

Implied texture can be produced in a number of ways; the following are common examples. Lightly sprayed areas produce a slightly grainy texture. When the medium is thickened and the air pressure reduced, larger drops of spray produce an effect called stippling (seen in **7-7**). Screens produce a patterned textured effect, especially when sprayed with different colors or at different angles. Additional effects can be achieved when screens are sprayed, slightly offset, and sprayed again with a different color **(7-9)**.

The exercises in projects 9 and 10 encourage experimentation with a broad range of textures and small patterns. The technique of spraying over stamped (elementary printmaking) surfaces is also discussed in project 10.

Overlays with varying degrees of transparency or opacity may be used with any of these techniques to establish the exact amount of variation of texture desired. An important principle here is that textured or patterned surfaces prepared by various means (such as those suggested in these pages) often have an unfinished or flat appearance lacking in subtlety. Sprayed overlays can transform these areas into beautifully enriched surfaces.

Project 9
Texture and Pattern

There are two parts to this project. In each exercise, all surfaces should be white before spraying, the sprayed colors should cover all of the white surface, and the spray should be used to exaggerate the visual effect of each technique. Select one of the following formats.

1. Each exercise may be completed on an 8- by 10-inch board.

2. The exercises may be completed on smaller boards of at least 3¼ by 4¼ inches and then individually mounted on an 8- by 10-inch board.

3. Or, when completed, the four exercises of each group may be mounted together on one 8- by 10-inch board.

Part 1: implied texture

In the first two exercises, various degrees of stippling can be achieved by air pressure, changing paint thickness, and partially unscrewing the spray regulator (if your airbrush has one).

Exercise 1: stippling Divide the first board evenly into three horizontal bands. Evenly apply yellow over the whole surface. Cover the top band and stipple red over the bottom two-thirds, creating an orange halfway between the two hues sprayed. Finally, cover the top two-thirds and lightly stipple blue over the bottom third of the board, creating a neutral area where none of the hues predominates **(7-10)**.

Exercise 2: spattering Combine the use of stippling and spattering with a brush (as with a toothbrush) using various hues to create a richly textured surface. Spatter by running your thumb over the bristles and flicking paint to the surface **(7-11)**.

Exercise 3: screening (micro masking) Using at least three pieces of screen, netting, or other types of mesh, build up successive overlays with contrasting hues and/or values. With at least one of these, try using two spray applications: first, spray through the screen and then slightly shift it so that the mask slightly offsets the area already sprayed; then spray again with a contrasting hue or value to create an offset, relief effect **(7-12)**.

Exercise 4: wrinkled paper Wrinkle a piece of light- to medium-weight paper that is larger than the board to which it will be attached. The paper should have approximately ½-inch of relief to it. Attach it to a surface with a looped masking tape placed on the paper's underside. Using two to four different hues, spray across the surface from opposing directions at an acute angle. Flatten when dry, attach a board, and trim **(7-13)**.

Part 2: textured supports

So that the dramatic effects of angled spraying can be shown, the real texture in these exercises should not exceed a thickness of ⅛-inch. Where necessary, these surfaces should be sprayed white before they are sprayed at an angle. The white surfaces should be sprayed from the side at an acute angle and across the whole board. Additional colors may be sprayed from other sides.

Exercise 1: textile prepared with gesso Prepare a piece of rough textured cloth with either

7-10 Ray Moskowicz. Student work, project 9, stippling.

7-11 Carol Matsumoto. Student work, project 9, spattering.

7-12 Susan Roller. Student work, project 9, screening.

7-13 Randy Strong. Student work, project 9, wrinkled paper.

7-14 Samvong Sarkdavisarek. Student work, project 9, textile prepared with gesso.

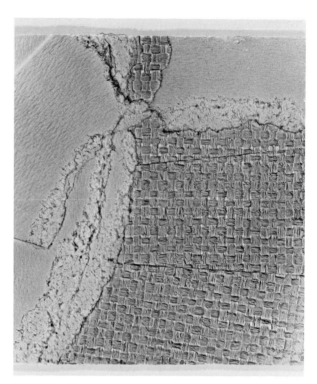

7-15 Niska Flammer Cheffet. Project 9, texturized collage.

7-16 Carol Matsumoto. Student work, project 9, texturized support.

7-17 Michelle Portesi. Student work, project 9, texturized support and found objects.

gesso or another white ground. Accentuate the visual effect of the texture by spraying at an acute angle with one or more spray applications. Mount the finished piece on one of the boards **(7-14)**.

Exercise 2: texturized collage Similarly, accentuate the texture of a collage of medium-textured surfaces **(7-15)**. Various pieces of watercolor paper present one possibility.

Exercise 3: texturized support On one of the boards, texturize the surface with a viscous material such as acrylic modeling paste **(7-16)**. You may wish to experiment with acrylic medium combined with materials such as sand, sawdust, cornstarch, spackle, asbestos, or various types of grains. When dry, continue as in the previous exercise.

Exercise 4: texturized support and found objects Using a similar material and technique as in exercise 3, embed at least three objects that have textured surfaces **(7-17)**.

Spatial Relationships

Airbrush painting lends itself well to creating the illusion of space. Whether the problem is one of suggesting deep space or of presenting figure/ground relationships, airbrush artists can produce these effects because of the degree to which art elements can be manipulated and, correspondingly, because of the degree to which transition and contrast can be controlled.

Most of the ideas in this paragraph are included in what is commonly termed aerial perspective (selected techniques that create the illusion of atmospheric conditions). Precise color and dark/light relationships can suggest spatial positioning. For example, a blue-violet transparent layer of spray over a distant mountain may make it appear farther away, or objects positioned in the background can be rendered with contrasts in hue but minimal variations in value and intensity. Also, darker values often recede while light values seem to advance. There is generally a broader light-to-dark value range with near forms and a more restricted range with forms that are farther away. Texture is also more apparent on foreground surfaces. There is usually more contrast in foreground areas than in distant areas. Spray can be used effectively on foreground as well as background areas to diminish contours or contrasting areas for the purpose of creating better transition from one

position in space to another. Many of the techniques described in the next section can also be used to create the illusion of space.

Miscellaneous Uses of Tools and Media

Tools

Many interesting effects can be achieved by combining spray with common art tools and techniques. The following list reviews some of these techniques. Each can be of value when used separately, adjacent to airbrushed areas, or when applied under or over airbrushed areas. However, notice that with many of these techniques, some spray overlay is necessary to counter coarseness or contrast. Spraying, therefore, is necessary for establishing the exact surface quality desired. When spray is applied over these areas, note that the opacity of the sprayed color is a key factor in determining how much paint to apply.

Lines of liquid media can be easily ruled with two techniques. (1) A raised edge (bridge) can be used with a sable brush to render lines of different thicknesses or lines of varying thickness. Hold the edge at an angle with one hand. With the other hand, hold the metal ferrule of the brush next to the raised edge and then lower the brush to the surface at slight angles **(7-18)**. The paint should be diluted enough to flow and spread. For a variation on this technique, place a finger instead of the ferrule of the brush next to the edge. A brush or airbrush can also be guided in the manner shown in **7-19**. (2) In addition to their use with ink, ruling pens and compasses can also be used with such media as designers' colors and liquid frisket.

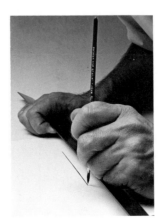

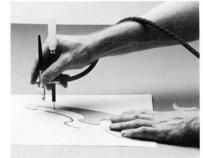

7-19

◀ 7-18

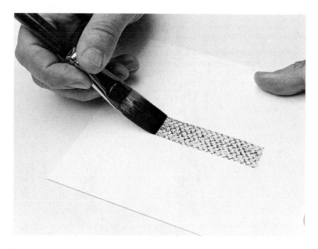

7-20

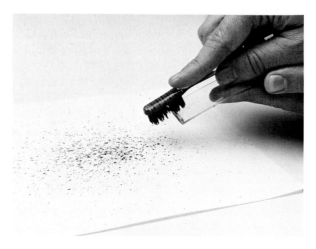

7-21

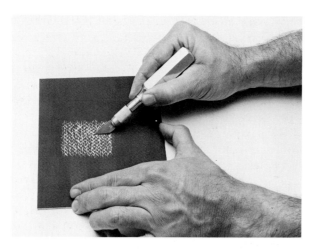

7-22

Drybrush techniques provide an interesting contrast to smooth, airbrush applications. To drybrush, simply use a spare amount of thick paint on a brush and then slowly drag the brush along the painting surface **(7-20)**. Practice first on scrap paper to be sure that the right amount and thickness is on the brush. This technique works best on supports that have some tooth or texture. Also experiment with varying the angle of the brush to the surface and how quickly the brush is drawn across the surface.

Spattering is a very simple technique achieved either by flicking a brush loaded with medium toward the painting surface or by picking up small amounts of paint with a coarse bristled brush like a toothbrush and then pulling your thumb or other tool backward over the bristles so that they throw the paint onto the painting surface as they shoot back into position **(7-21)**. With either technique, practice first to be sure the amount of spatter can be somewhat controlled. This technique can provide larger dots and a more uneven dispersion of paint than stippling with the airbrush.

A thick buildup of transparent glazes can be achieved with a medium such as acrylic gel. The quality of surface depth created with this process can provide an interesting complement to the flatter surface quality produced through spraying. A more exaggerated effect can be gained with the mixed-media process of combining thin, transparent layers of spray with thick layers of clear or toned polyester resins.

The effects produced by the spatula, painting knife, or other tools that can be used to build up thick layers of paint can be heightened with the use of angle spraying. In project 9 this technique was exaggerated with a material such as acrylic modeling paste. However, most paint can, to a certain degree, be treated in this way to gain the degree of real or inferred texture desired.

A knife may be used to scrape down to the color of the painting support. This is a common technique used with transparent watercolors. A variety of tools can be used for this purpose, depending on the effects desired **(7-22)**. Remember that this technique works best with thin layers of medium and that once the surface is scraped, additional transparent washes can be applied to reduce contrast and texture or to alter the color of the exposed area.

The relationship between drawn and airbrushed areas can add to the illusion of space or form. An alternating sequence of spraying and applying media

by other means can develop carefully controlled form or spatial relationships. For example, hatching techniques alternated with light airbrush applications can subtly control the illusion of forms existing in space. Similarly, atmospheric conditions can be rendered with alternating sequences of brushed and airbrushed applications to create receding landscape forms. Or, more complex transitions between figure and ground can be achieved in rendering images like cloud forms **(7-23)**. In this instance a subtle, close figure/ground relationship must be developed using a combination of techniques that may include movable masks such as torn paper.

The best effects normally can be achieved when smooth transitions are established from one form to another. This difficult technique is useful in rendering

7-24 Elaine Yung. Student work.

subject matter that includes varying or complex figure/ground relationships: for example, water, foliage, gaseous material (such as fire, smoke, mist, or haze), distant landscape forms, or out-of-focus background subject matter.

Simple stamp processes Various materials and tools can be used to stamp textures, patterns, and images that can then be coordinated with spraying to produce interesting effects **(7-24)**. This simple form of printmaking may look a bit coarse by itself. When coordinated with either underpainted or overlaid layers of spray, however, the effects can be quite subtle. They may provide a variation to the evenness of the spray, complimenting other areas of the painting. Experiment with: (1) miscellaneous tools such as brushes, erasers at the ends of pencils, and household gadgets; (2) re-formed materials, such as wadded paper, folded cloth, or crinkled foil; (3) organic materials, such as leaves, grasses, or twigs; or, (4) prepared stamping tools made out of potatoes, erasers, cardboard, or wood.

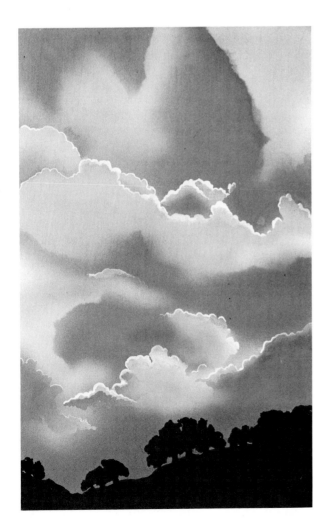

7-23 Linnett Moreno. Student work.

Miscellaneous uses of media

In some situations you may find it useful to try less frequently used methods of spraying.

1. Try spraying on surfaces of varying degrees of wetness. You could add other compatible media when using this technique.

2. While a sprayed surface is still wet, work into it with various tools; after the area dries, spray into it to create subtle effects. Try this technique with very thick as well as thin layers of paint.

3. With water media, try various materials such as salt, alcohol, and powdered paint or pigment. These can be applied to wet, sprayed surfaces to achieve unusual effects.

4. When spraying with acrylics, a matte surface can be developed by lightly spraying high above the surface so that the paint partially dries and becomes more viscous. This beading effect works best in a warm, dry room with the airbrush or air gun set to make a very grainy or stipple spray.

Project 10 examines some of the techniques discussed in this section. Project 10, variation 1 combines some of these methods with techniques that were introduced in earlier sections of the book and shows how the small-area applications that yield dots and lines can be used to gain precise effects. Variation 2 simply suggests creative applications.

Project 10
Miscellaneous Uses of Tools and Materials

For the exercises in part 1, prepare four 8- by 10-inch boards. Smaller borders may be masked off; however, the minimum dimensions of the compositions in this project are 3¼ by 4¼ inches. Boards smaller than 8 by 10 inches may also be prepared and then mounted on the larger 8- by 10-inch boards.

Part 1: brush and drawing techniques

Exercise 1: brush techniques Create a rich and varied surface by experimenting with any combination of brush and airbrush techniques **(7-25)**. Consider dry brush, thick, transparent to translucent glazes, spattering, stamping, and wax resist.

Exercise 2: hatching and limited space control Using hatching and cross-hatching techniques with a pen and a black, permanent ink, hatch either a specific area **(7-26)** or areas throughout the composition **(7-27)**. Spray the whole composition lightly with white, counting the passages over the surface and noting the amount of spray used. Repeat this sequence at least five times or until the full area has been covered with hatching. Do not spray over the last hatching of the sequence.

7-25 Tom Fritz. Student work, project 10, brush techniques.

7-26 Tom Fritz. Student work, project 10, hatching and limited space control.

7-27 Joni Bunker. Student work, project 10, hatching and limited space control.

Exercise 3: receding landscape With this and the following exercise, the subject matter is only incidental to the objective of producing a specific spatial quality. Using a brush, paint horizontal areas across the width of the board, including landscape contours on the top edge. Begin close to the top with the first section. Paint each area at least 1-inch from top to bottom, and to a point that is lower than the section that will follow. Start with a light gray and use at least four different grays in progressing to black on the last layer. Spray the lower part of each section a gray, one or two shades lighter than the brushed-on gray. Make a gradation from the bottom of the painted area to just below the upper edge.

Repeat these alternating sequences of brushing layers and spraying progressively down the composition **(7-28).** Make sure the paint to be brushed is mixed well and that it it thick enough to cover the surface evenly.

If too much contrast remains between areas, you may wish to spray over the whole composition lightly with highly diluted paint. Similarly, a gradation from the top border down will accentuate the illusion of deep space. An extremely diluted color can also be used for this purpose.

Exercise 4: clouds on clouds Cover your board with a no. 2 or 3 premixed gray, then brush in cloud forms using first white and then other values. Airbrush areas in which even gradations are appropriate first with white and then with other values. Work back and forth between brushed areas and airbrushed transitional areas. Use only your achromatic palette in this exercise. The use of the torn paper masks is suggested. This is a very difficult exercise; two possible approaches can be seen in **7-29** and **7-30.** Collect photographs before beginning and try making a composition that combines the images from different photographs.

7-28 Ron Miller. Student work, project 10, receding landscape.

7-30 Victor Herrera. Student work, project 10, clouds on clouds.

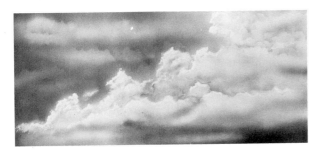

7-29 Wai Tak Lai. Student work, project 10, clouds on clouds.

Part 2: stamping textures and patterns (optional)

Prepare four 3¼- by 4¼-inch pieces of illustration board. After completing the following exercises, mount them on an 8- by 10-inch board so that there are ½-inch borders around and between each section. In each of these exercises, simple prints or stamps are made with various materials. They are applied over the surface using at least two colors. After completing the stamping process in each of the following exercises, spray a gradation of a middle value color over the work. You may wish to use a different hue on each exercise. The gradation should be fully opaque at the very bottom and evenly gradate to a very light transparent wash at the top. You may wish to change media when printing and use a printmaking ink or even an ink pad.

Exercise 1: miscellaneous tools Use one or more tools that are normally used for other purposes and can be used for stamping. Consider such tools as the heel of a brush, the eraser end of a pencil, and household gadgets. For example, if the heel of a brush is used, apply small amounts of slightly thickened paint and then press the brush down on the surface so that the bristles spread and the heel of the brush touches the surface. Through repeated use, a textured or patterned area is gradually established.

Exercise 2: reformed materials Experiment with materials that can be altered to produce an overall effect. Try stamping wadded paper or plastic, folded cloth, creased or crinkled foil, or possibly a similarly altered screen or mesh material.

Exercise 3: organic materials Develop an interesting surface with such objects as leaves, grasses, twigs, hair.

Exercise 4: the prepared stamping tool Design your own printed shapes by cutting, gluing together, or in some way preparing your own printing tool. Consider a potato or some other vegetable, erasers, cardboard, wood.

Project 10, Variation 1
Dots and Lines with Guides

This series of exercises is an extension of project 4. As in project 4, this involves small-area spraying. Most of the exercises should be completed by developing areas slowly with small amounts of spray.

Rule nineteen light lines, ½-inch apart, across the width of an 8- by 10-inch board. On the back of the board, number the horizontal lines 1 through 19 from top to bottom. Dr. Ph. Martin's black synchromatic dye is recommended for this project. Whenever feasible, position masking devices so that spraying will cover up guidelines.

Line 1 Lines using a raised edge (bridge) Each of the following two lines should be of the same value. To limit overspray, spray from a vertical position and continue spraying with the tip close to the board. Place a straight edge parallel to the line you wish to make. Tilt the straight edge or in some way raise it high enough so that the ridge on your spray regulator or another convenient part of the airbrush can rest on the edge with the tip about ½-inch from the surface. On line 1, spray a continuous line ¹⁄₁₆-inch wide. You may wish to retrace your line to make it darker.

Line 2 On and above line 2, spray a line ⅛-inch wide by working back and forth with a ¹⁄₁₆-inch line **(7-33).**

Line 3 Using a bridge with a sable brush On line 3, create a straight line approximately ¹⁄₁₆-inch wide with a sable brush. Also, with the bridge and a ¹⁄₁₆-inch-wide line, soften and reduce the contrast of the brushed line with spray. Airbrush back and forth and broaden the line to about ⅛ inch. As a variation on this technique, use a ruling pen to create the line.

7-31 Ethel Todd. Student work, project 10, organic materials.

7-32 Cindi Morton. Student work, project 10, prepared stamping tool.

7-33

7-34

7-35

Line 4 Similarly, with the bridge or freehand, paint a series of dots of different sizes between ¹⁄₁₆- and ¼-inch wide. Then, with airbrushed overlays, reduce the contrast of the edges.

Line 5 The straight edge as a mask To create a sharp line, straddle line 5 with two flat metal or plastic straight edges of equal thickness that are ¹⁄₁₆- to ⅛-inch apart **(7-34)**. If necessary, hold the edges down with tape, weights, or one hand, while gradually developing a gradation from black at the left border to the white of the board at the right border.

Line 6 To create a diffused line, straddle line 6 with two metal or plastic straight edges of equal thickness ¹⁄₁₆-inch apart. Raise the edges ¹⁄₁₆- to ¼-inch from the surface. In doing so, be sure that the material supporting the edges is at least ½- to 2-inches behind the opening between the edges **(7-35)**. Applying equal amounts of spray at different angles will create a diffused line.

Line 7 Combine the technique of lines 5 and 6 and use one flat edge (⅛-inch below line 7) and one raised edge to create a line that is sharp on one side and gradated on the other **(7-36)**.

Line 8 Cut one piece of light cardboard with a line that includes many curves. Use a very sharp knife and make the edge as clean as possible. Straddle line 8, placing the pieces ¹⁄₁₆-inch apart and raising them as for line 7. Spray **(7-37)**.

7-36

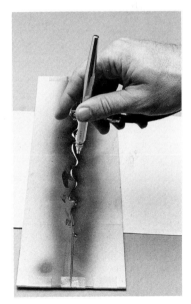

7-37

Line 9 Taping Place two strips of drafting (or a similar type) tape ¹⁄₁₆-inch apart on line 9. Gradually build the value to black without allowing any paint to seep under the tape.

Line 10 Using the same taping technique as used on line 9, straddle line 10 with a thick-to-thin line that has multiple, simple to complex curves, varying from ¹⁄₁₆- to ¼-inch apart **(7-38)**. Complex

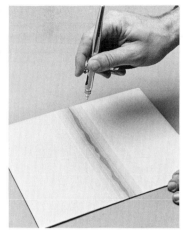

7-38

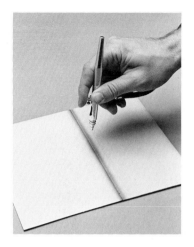

7-39

7-40

7-41

7-42

7-43

curves can be made by cutting drafting tape into narrower straight strips, and curving them, or by using a crepe type, 1/16-inch wide vinyl tape.

Line 11 Place a strip of tape on line 11 and gradually develop a black line that evenly gradates 1/4-inch out from the line to the white of the board (one side of the line will be sharp, the other gradated). This exercise requires very even arm movements. It is best to stand when doing this type of exercise. Ironically, to reduce overspray, overspray can be used to create most of the gradation: develop the gradation by aiming directly at the edge of the tape and spraying close to the board **(7-39).**

Line 12 This exercise produces a curved line that is sharp on one side, gradated on the other. By combining the techniques used on lines 10 and 11, tape a line that has a series of curves above and below line 12. Produce a gradated line 1/4-inch wide and see how uniform you can make the gradation throughout the line **(7-40).**

Line 13 In the same way as on line 9, place two strips of drafting tape 1/16-inch apart on line 13. Then cross the line using 1/16-inch-wide vinyl tape. Begin at the right border with a 1/16-inch strip and cross the line with tape 1/16-inch from the border; increase the space by 1/16 inch each time the tape crosses the line. From right to left, the spaces will therefore measure 1/16, 1/8, 3/16, 1/4, 5/16 and so on **(7-41).** Gradually develop a gradation from black at the right border to a gray or the white of the board at the left border.

Line 14 Straddle line 14 with two pieces of drafting tape that are precisely 3/16-inch apart. Then, carefully place a 1/16-inch strip of vinyl tape down the middle of this space. Using the same measurements as for line 13 and a very sharp knife, cut (by pressing, not slicing) this center piece of tape **(7-42).** Leave the 1/16-inch piece at the right border and then remove all of the remaining 1/16-inch sections. In doing this, try to avoid cutting into the board. Gradate in the same way as for line 11.

Line 15 Liquid frisket Straddle line 15 with two strips of drafting tape 3/8-inch apart. Using a ruling pen (the type of pen found in drafting sets), make two freehand curving lines that straddle line 15. The lines should vary between 1/16- and 1/4-inch apart. Fill in the space between the tape and the ruled line with liquid frisket and a soaped brush **(7-43).** When dry, spray over the open space creating a series of vertical gradations. Remove the frisket.

7-44

7-45

7-46

Line 16 Straddle line 16 with two pieces of drafting tape ¼-inch apart. Above line 16, using the same measurements as for line 14, create the same broken line with the ruling pen and liquid frisket **(7-44).** If you make a mistake, simply let the liquid frisket dry and rub it off. Then below line 16 make a continuous line. Spray over the open space and then rub off the liquid frisket.

Line 17 Decorative uses of miscellaneous masks (optional) Straddle line 17 with two pieces of drafting tape that are ½-inch apart. In this space, place a series of found materials that create a linear pattern of dots and lines **(7-45).** For example, try a necklace chain, tacks or screws placed upside down, paper clips, or nails. After masking off the rest of the whole board, reduce air pressure and then slowly build up the area by holding the air-brush 15- to 18-inches above the surface. This allows the spray to gently fall to the surface.

Line 18 (Optional) Straddle line 18 with a series of small stencils no more than ½-inch wide that broadly correspond to lines and dots. Either spray them solid black or create various effects with gradations. Try circle and ellipse guides, eraser shields, or any other available small stencils.

Line 19 (Optional) Straddle line 19 with the same or similar stencils and placements used for line 18, but raise most of them to create a soft edge **(7-46).** On practice paper, experiment with different

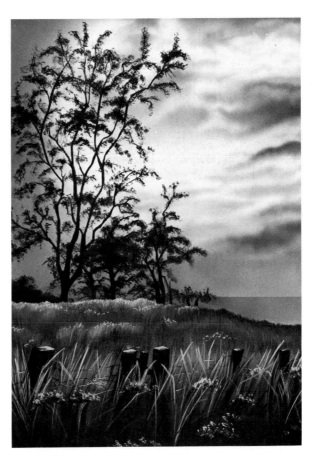

7-48 June Santospirito. Student work, project 10, variation two.

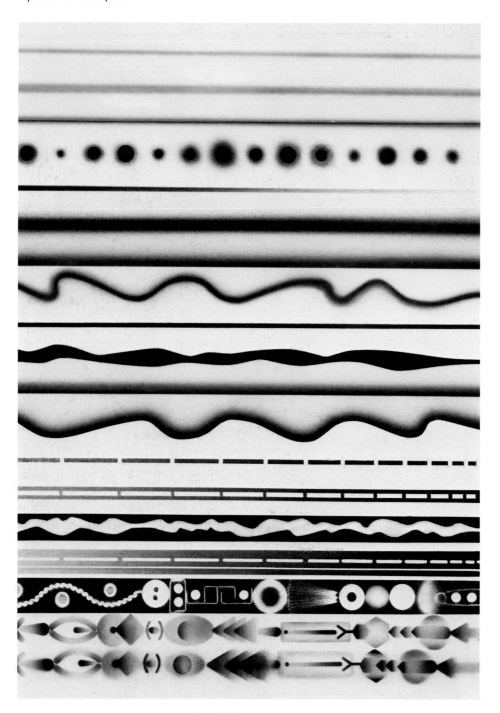

7-47

heights for each size of stencil used so that the diffused quality of the edge can be controlled. There may only be subtle differences between lines 18 and 19. Illustration **7-47** shows the completed project.

Project 10, Variation 2

Apply selected techniques from projects 9 and 10 to a composition of your choice **(7-48).**

Chapter 8 **Rendering Surface Qualities**

The airbrush, especially when combined with other tools, can be used to create unusually realistic surface qualities **(8-1)**. This usually involves combining spray with some of the techniques discussed in chapter 7. Especially important are alternating sequences between spraying and drawing or brushing (see **C-8**, in the color section).

Preliminary Considerations

Selection of subject matter

It is normally best for the beginner to work directly from actual objects. If that is not possible, you may have to work with substitutes such as photographs. Whenever possible, it is also important to select subject matter with surfaces that exemplify the particular qualities you wish to render. Begin with objects that are easy to draw.

Positioning and lighting

Position the subject so that important attributes of the subject are both easily seen and well composed. The lighting should be carefully manipulated so that the values that reveal form correspond as much as possible to those you will use in your rendering.

Preliminary drawing

Do preliminary drawings to work out any problems posed by rendering the subject. This helps resolve problems to the degree that you then can concentrate on masking, media coordination, and spraying.

The linear part of your drawing should correctly place objects in space (linear perspective), even though you seek to emphasize surface qualities. Correspondingly, do not overlook the importance of value as it is used to show contrast. Value is used to establish light/dark composition and figure/ground

8-1 Charley White III. *Harley-Davidson*. Watercolor, 30 by 20 inches. Courtesy of the artist.

relationships, too. In establishing form, determine how the six value areas described in chapter 6 relate to different surfaces. For example, are they reduced to two value areas, as in the rubber top of an eye dropper, or do they become more complex, and/or fragmented, as in the side of a chrome cylinder?

It is especially important for those not experienced in rendering surfaces to work out problems or specific approaches in preliminary studies. It is seldom appropriate merely to copy what you see: draw according to what you know, according to conventional methods, and according to aspects of what you

see. Subjects to be rendered are seldom perceived in a state that can be directly transferred into a good rendering.

For example, they may be too dark or light, awkwardly proportioned, or the wrong size. Your subject may also pose compositional problems or include distracting details or misleading reflections. It may be necessary to depict the subject large enough that there is room to establish clearly the characteristics of the surfaces to be rendered. Correspondingly, it may be necessary to apply or translate the methods of rendering form (presented in chapter 6) and the conventions used to render surfaces suggested in this chapter. In preliminary studies you can solve these problems so that the final work does not appear awkward or contrived.

Color

Consider first the local color of the subject. Then consider factors that modify or substantially change this color (e.g., light and shade, the reflective qualities of the surface, and adjacent colors that reflect onto the subject). Also consider whether the natural local color of the subject should be modified.

For example, you may have to lighten the value of a dark object so that a broader range of values can be used to reveal form, or textural or reflective qualities. You may simply make a list of key attributes of the subject or of how you want the subject to appear. Then you may use this list to critique the work either as you develop the imagery or in the final stages of airbrushing.

Properties of media

Pay close attention to media that combine well with spray to produce particular surface qualities. The size limitations of this book do not allow detailed discussion of this area. However, some specific examples may be useful here.

1. Opaque gouache, such as designers' colors or acrylic polymer, may work well as the grounds on which surfaces are rendered. They may also be useful in rendering dense or coarse textures.

2. Inks and markers are especially useful in creating contour edges.

3. Wax-based pencils (such as Prismacolor pencils) are often used to render reflective surfaces and to modify the light and shadow of planes.

4. Transparent overlays sprayed over other media are possible with dyes (where permanency is not a factor) and watercolors. These materials retain most of the qualities of media applied to lower layers.

5. Pastels or chalks applied directly or with spreading or blending tools can be used to create smooth to coarse textured areas. As a specific example, a cotton swab, powdered pastel, and a thinner (like alcohol or rubber cement thinner) can be used to create interesting background effects. With broad strokes, loosely structured patterns and textures can be created. These complement the smooth surfaces rendered with the airbrush. Before you begin the final work, experiment with the properties of specific media. Test combinations and examine the effects of any overcoats (such as spray fixative) over all the materials that will be used.

Combining spray with brushed or drawn areas

Techniques that are often used to create surface effects should integrate, to the degree you desire, with sprayed areas. Although there is no set way of combining spray with other techniques, consider the following sequence.

1. After any opaque layers of paint have been applied, boldly develop brushed or drawn areas.

2. Airbrush back into these areas to establish light and shadow, necessary gradations, and spatial positioning.

3. Reestablish any drawn or brushed areas that have been sprayed too heavily.

4. Repeat the sequence as needed.

Masking

When considering masking sequence, remember that the rendering of surfaces often includes the use of tools in addition to the airbrush. For example, brushing at the edge of frisketed areas may result in ragged contours where the brushed paint creeps under the frisket.

Retouching

Craftsmanship is important in airbrush renderings that capture the essence of surface qualities. Always reserve time to touch up your work and to establish the exact qualities of clarity and precision required.

Selected Surfaces

Because of space limitations, it is not possible to show how a broad range of surfaces and materials is rendered. Six types of surfaces are discussed. With each, points to consider in rendering a specific material are listed. The content presented in chapter 6 is essential to understanding the more specific information on surfaces in this section. The surfaces are discussed here in the same value area terms that were used to discuss the rendering of form.

Matte surfaces (rubber)

The local color dominates in this type of surface. It is opaque and often includes a limited value range of only two distinct value areas **(8-2)**.

1. Even, strong light sources produce a muted, soft-edged highlight area.

8-3 Jim Wilson. Student work.

2. The lightest tone may be the value of a quarter tone or halftone. Or, because of the restricted value range in the object, these two areas may be restricted or absent.

3. Base tones may not be clearly distinguished because of the reduced value range of this material.

4. Reflected light areas may be absent or minimized because secondary light sources are not strong enough to show on this material. The base tone, therefore, may reach the edge of the object away from the light source.

5. Cast shadows on the object should normally be shown with minimum contrast. However, sharper cast shadows projecting off the object may be used to complement any lack of contrast on the object.

Smooth satin surfaces (opaque plastic)

Notice how the local value and hue of plastic dominates **(8-3)**. The colors are usually simple (not too many variations within planes) and opaque. The colors often look nonorganic and artificial. Depending upon the degree of matte or gloss, each of the value areas on the object may be gradated evenly over planes or may collect into areas of reflected light that have specific borders.

1. Highlights tend to be less concentrated than on polished surfaces and not as bright.

2. Quarter tones are, or are close to, tints of the local color. With some plastic surfaces, notice how these lighter tones are virtually nonexistent.

8-2 Tom Fritz. Student work.

3. Halftones are the local color of the object or light shades of this hue.

4. Base tones are shades of the local color and retain some of the local hue even in the darkest areas.

5. Because of the dominance of the local color, reflected light areas may not develop warm or cool variations of the local color.

6. Look closely at cast shadows to see if they include the local color of the object.

Highly polished metal surfaces (chrome and steel)

With metals that are of a particular color, the color of each reflection must be altered. Chrome is a white metal (**8-4**). With gold, notice the warm tones of yellow, orange, browns, and olive greens. In stainless steel notice that there is a bluish tone in some of the value areas (**8-5**), and there is also more of an overall grayish quality than with chrome. Also notice that the edges between value areas on stainless steel are normally more diffused than those on chrome.

Interpret chrome and steel as reflecting their surroundings somewhat like a three-dimensionally formed mirror. Render them in a crisp and clean manner; do not overwork them. In doing this, it is often best to retain the color of over half of the painting ground.

As with all surfaces, the reflections conform to the contours of the object. Notice how these contours change as objects get very close.

Consider how the reflections can be selected and arranged to correspond to the areas which depict

8-4 Craig Mauss. Student work.

8-5 Frank Cummings. Student work.

form. On polished surfaces, each of these form value areas may be repeated to a lesser degree. For example, notice that on a chrome cylinder there may be a number of dark lines of varying width that correspond to base tones. Also notice on cylindrical forms how lines move lengthwise, whether the object is placed horizontally or vertically. The following methods will help best portray exterior surfaces in bright sunlight. Logical adjustments can be made when rendering chrome indoors or without bright sunlight. These techniques should be reversed when concave surfaces are rendered.

1. Notice how highlights concentrate. On exterior, horizontal planes, especially, notice how large the dominant highlight is. Strong highlights overcome any lines or colors underneath them.

2. On horizontal surfaces, the quarter tone is a cool-blue, light-sky reflection.

3. Halftone areas are the darker part of the sky or other middle tones picked up from the reflecting subject.

4. Base tones tend to collect into very strong contrasting bands. With exterior surfaces, the dominant

base tone band is the horizon. Notice that strong bands like these do not quite reach exterior edges because of light reflected from other areas.

5. On lower planes on which reflected light is seen, note the warm earth tones. Form can be emphasized where there is a strong contrast between the warm and cool of reflected light and quarter tone surfaces. Notice, however, that this up-and-down, warm-cool relationship changes to a right-and-left relationship when a cylindrical object is changed from a horizontal to a vertical position.

6. Strong exterior cast shadows allow more contrast than those produced by lesser interior lighting.

Transparent surfaces (glass)

Two representative characteristics of glass are (1) the high contrast between value areas and (2) the way glass distorts material placed behind it **(8-6)**. Render glass as though it is clean and polished; overworked glass tends to look weathered or like worn plexiglass. Clean glass has a lot of contrast. If glass has on its

8-6 Brad Merville. Student work.

surface any substance that stops or refracts light, there is less contrast. Do not overemphasize gradations when rendering glass. There is a dominant up-and-down, vertical direction to most glass reflections. Emphasize what happens at edges of glass and at the places where the glass has greatest thickness (from the viewer's position). Show the linear quality and the thickness of the glass edges that define shape and form.

Handle carefully those areas where glass is thick; e.g., the base of a wine glass or the handle of a vase. Light and dark areas at edges or in thicker areas of glass tend to overlap (cross over) each other without mixing. For example, notice the light and dark lines on the rim of a wine glass.

Consider working on a toned ground. Allow much of the ground to show. Lines or edges that pass behind or through glass are distorted; this effect contributes to the illusion of transparent materials. Layers of glass can be distinguished with slight tonal changes.

1. The highlights on glass are 180 degrees apart where light reflects off similarly contoured edges of a plane (as with the highlights that are opposite each other on the rim of a wine glass). Highlights closer to the viewer tend to be stronger than those in back. Highlights tend to overpower everything underneath them. Therefore, darks and contours stop short of highlights.

2. Quarter tones are used sparingly and may either be reflections with specific contours or gradated areas that contribute to the illusion of a plane.

3. Halftones tend to show as the toned ground seen through layers of glass. If shadow areas are rendered on the glass, they should be used sparingly and only where specifically needed.

4. Base tones also may show only as the tone of the ground seen through either larger areas of glass or areas with simple planes. However, at edges and where there are thicker layers of glass, darker tones are often present that correspond to base tones.

5. Reflected light shows either in the areas close to edges where the toned ground is allowed to reestablish itself or as light-toned reflections, possibly of a different color, that come from a strong secondary light source.

6. Cast shadows tend to be transparent, especially in areas where light passes through fewer layers or glass of less thickness.

Translucent surfaces (frosted glass with an outer glossy surface)

Observe the degree of transparency or translucence of materials **(8-7)**. Distinguish between glossy and matte translucent materials. For example, the inner surface of an object may be frosted and the outer surface smooth with some gloss. Translucent materials with matte outer surfaces are rendered as are opaque matte surfaces.

The greater the translucence, the more there is diffusion of light passing through the material. Objects behind such materials are less distinguishable. On translucent material of a light value, there is less contrast in reflections and other light dark variations. In observing the translucent quality of frosted glass, notice how this material virtually eliminates the image of objects or the effects of light reflecting off objects placed behind it.

1. Highlights are usually bright but may not contrast with surrounding values because of the overall light tone of most frosted glass. On the other hand, a strong highlight on a smooth, dark, translucent surface will show marked contrast. Most surface reflections should be shown with defined edges but not strong contrasting values.

2. Quarter tones, halftones, base tones, and reflected light usually show only minimally. However, on dark material, quarter tones may show clearly.

3. Cast shadows may show some of the translucent quality of the object. Especially notice where some light shows through fewer layers or layers of less thickness.

8-7 Jim Wilson. Student work.

8-8 Larry Peterson. Student work.

Coarsely textured surfaces (cork)

After any opaque colors have been applied, airbrush in the major planes of coarsely textured surfaces like cork **(8-8)**. The planes of coarsely textured surfaces should normally be rendered in the same manner as described in chapter 6. Notice how the contrast between planes is reduced with dense, coarsely textured surfaces such as fur or shag carpeting. Then draw or brush in the textured areas using a little more contrast than will be apparent in the end product. Especially note the effects of light on planes that the main light source touches. Do not copy an actual cork but look at many corks and then decide how the particular qualities of this kind of surface may be exaggerated to read well in a rendering.

Reestablish value areas with slow, carefully developed applications of spray. Reestablish any drawn or brushed areas that have been sprayed too heavily.

1. The planes on which highlights occur on forms usually are not well defined or bright. These planes retain some of the local color of the object. Notice that the coarse texture functions as a low-relief area. In cork's small crevices, for example, the side perpendicular to the major light source picks up the light and the side away from the light is in shadow. The side of the small crevice area that catches the light should be retouched toward the end of the painting process. The relief quality of this surface will then be distinct.

2. Quarter tone and halftone areas normally show more local color. The degree of texture here is determined by the contrast of combined quarter tones and halftones.

3. Coarse texture is minimized in the base-tone area, especially in dark-value areas.

4. If there is reflected light, it, too, shows texture. With coarse texture, the side of the texture away from reflected light determines the major color value of the entire textured plane. If the reflected light is next to a base tone, the reflected light and base tone both can be used to show texture.

5. The degree of texture will influence the edge of the cast shadow. The rougher or more varied the surface, the more the edges of cast shadows will be diffused. With strong cast shadows, the edges close to the object may show some of the actual texture of the object.

Surfaces with implied texture (wood grain)

After any opaque colors have been applied, render implied textures with an appropriate tool such as a brush, pencil, or pen. Because spray (and some overspray) will follow, you may wish to show strong value contrast in distinguishing the grain. Respond to the particular structure or properties of the subject. With wood grain (8-9), notice that the grains do not cross and that they did not grow in an even, rigid pattern. Notice how the positive and negative lines vary in thickness and how, on large, flat planes, the grain tends to form uneven shapes that become fairly circular around knots. After airbrushing, reestablish any areas that have been sprayed too heavily.

The particular real texture of the surface should be considered separately from the implied texture. For example, very smooth, glossy surfaces have brighter highlights and greater contrast between value areas. The reflections off a glossy surface tend to be over, or to cover, the implied texture more than the lights and darks on a duller surface. Matte surfaces or surfaces that do not reflect strong light tend to show more grain.

1. Some of the grain can normally be seen in the highlight.

2. Therefore, a little more grain can normally be seen through the quarter tone.

3. The local color of the wood and the grain show most clearly in the halftone.

4. Because the base tone is usually applied with a value that is close to that used on the grain, the grain tends to show in all but the darkest area.

5. The grain often shows more clearly in the reflected light unless the secondary light source is strong.

6. Within cast shadows that fall on the object, the grain will show if this value area is not too dark.

Project 11
Rendering Materials and Surfaces

Prepare four 8- by 10-inch illustration boards. Smaller formats may be masked off on these boards or you may wish to work on smaller boards (minimum size 3¼ by 4¼ inches) that are mounted on the 8- by 10-inch boards after they have been completed.

Exercise 1 Render a plastic or rubber object that has a matte or satin surface.

Exercise 2 Render a highly polished metal object. A chrome object is suggested.

Exercise 3 Render a transparent, glass object that is on a toned ground. The object may be tinted.

Exercise 4 Render a coarsely-textured object such as a sponge, cork, or rock.

Exercise 5 (optional) Render a smooth-surfaced wood object that has an observable grain, or render an object that includes translucent material.

Exercise 6 (optional) Render other objects with other surface qualities.

8-9 Victor Herrera. Student work.

Project 11, Variation 1
Rendering Materials and Surfaces in a Still Life

Create a still life of at least three objects that include different materials and different reflective qualities. In composing these objects, consider not only how they can be effectively composed but also how their different surfaces can be realistically rendered (see **8-10** and **8-11**. See also **C-8** in the color section).

8-10 Jeanne Meyer. Student work.

8-11 Wai Tak Lai. Student work.

Project 11, Variation 2
Guided Rendering of Materials and Surfaces in a Still Life

On a board with similar proportions to illustration **8-25**, render the still life shown in illustration **8-12**. Use the following procedures.

 1. Select objects for their surface qualities, sizes, and variations in form **(8-12)**. Carefully position them and set up the lighting so it generally corresponds to the value system used in chapters 6 and 8.

 2. Make a drawing on paper (vellum was used here) with precise use of guidelines and other guides. Apply graphite to the back of the drawing and transfer it to a board **(8-13)**.

 3. Make a value drawing so that precise value areas can be more accurately established in the final painting.

 4. Devise a system for removing friskets. The diagram indicates one possible sequence **(8-14)**.

 5. Remove the frisket from the first area to be sprayed.

a. In this case, the horizontal friskets are removed from the light bulb threads, the hardest area. The highlight is left covered.

b. The threads are airbrushed and then brushed **(8-15)** to establish the hard edge of the reflections. Then the edges are sprayed to soften them.

c. The small friskets on the highlight are removed, lightly sprayed, and then brushed for proper contrast.

 6. Work on frisket area no. 2.

a. In **8-16** this area is the cap of the bottle. The local value is brushed in, then the light areas on the ridges are drawn with a ruling pen.

b. Some of the ruled lines are then sprayed to tone them down and establish a greater illusion of volume.

 7. Frisket area 3.

a. The glass of the bottle and eye-dropper is sprayed.

b. Lines are ruled to represent glass thickness and the edge of reflections **(8-17)**.

 8. Frisket area 4.

a. The frisket for the light bulb is cut with a compass and blade. It is then removed, leaving intact the frisket for the highlight.

b. The bulb is sprayed.

c. The highlight frisket is removed and the highlight is brightened with white paint.

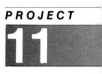
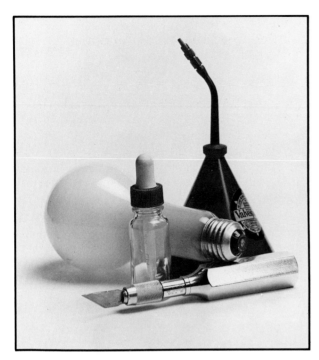

8-12

8-14

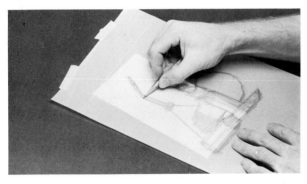

8-13

8-15

8-16

8-17

8-18

8-19

8-20

8-21

8-22

8-23

9. Frisket area 5.

a. The frisket on the rubber of the eye-dropper is removed.

b. The surface quality of the rubber is captured with essentially two values **(8-18)**.

 10. Frisket area 6.

a. A technical pen and brush are used to render the detail on the label **(8-19)**.

b. The edge between the can and the threads of the light bulb is cut with a swivel knife **(8-20)**.

c. In spraying the base of the can, care is taken to avoid making it as dark as the actual object. The original can was too dark to show value areas well.

d. The spout of the dispenser is sprayed with small value areas so that the same range of value used on the base can be used in this area.

 11. Frisket area 7.

a. The knurled pattern on the knife **(8-21)** and the neck and base of the valve spout on the can are drawn with a technical pen.

b. After spraying white on the highlight area of the knurled parts, black is sprayed on the base tones and quarter tones **(8-22)**.

 12. Frisket area 8.

a. The middle sections of the knife with the dark base tone are cut and sprayed. The bottle reflects on the top of this area.

b. The three planes of the knife handle are cut and sprayed separately. The thread reflections on the top plane are cut and sprayed separately **(8-23)**.

c. The ellipse between the knife blade and handle is cut and sprayed.

d. The knife blade is cut and sprayed in two steps.

 13. Frisket area 9.

a. Cast shadows. After frisketing around the perimeter of the still life, a soft cast shadow is sprayed **(8-24)**.

 14. Final retouching.

a. Edges are sharpened and details are clarified in value transition areas (especially where planes change).

b. A final evaluation is made of contrast in highlight areas.

 15. The final still life can be seen in **8-25**. It measures 8 by 10 inches and was executed in gouache.

8-24

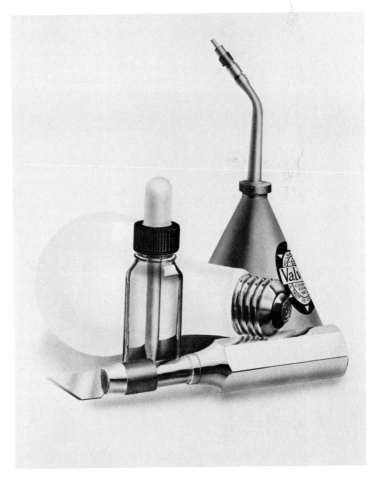

8-25 Chester Przelomiec. *Surfaces Still Life*. Courtesy of the artist.

Chapter 9 **Mixed Media**

Artists often find that various combinations of media best suit their needs. You may need materials that counter such limitations as fugitive colors, bleeding or staining characteristics, cracking, poor binding properties, or the slow drying characterisics of another material. Or you may select a material for such desirable properties as transparency, opacity, flexibility, viscosity, or durability. You may also respond to the particular function at which a material excels. For example, you may need a material that will create bas-relief or textured areas, produce fine lines, develop deep glazes, function as a glue for collage, stain, print, photo transfer, or fulfill any of a number of other tasks.

Miscellaneous Uses of Tools and Materials

Properties of media

Depending on how permanent a painting should be, compatibility of materials can be an important factor in mixed media. This is especially important for the fine artist who is concerned with permanence.

1. The traditional fat or lean principle is useful when oil paints are used: oils may be used over water-based paints but can cause problems when paints with nonfatty binders are placed over them.

2. Bleeding (staining) is sometimes a problem when paint is sprayed or brushed on water-soluble dye colorants. For example, an opaque gouache sprayed over transparent dye watercolors may cause color bleeding.

3. When paints with weak binders (such as designers' colors) are used, cracking and chipping can occur when heavy layers are built up.

4. Note the permanence of the colorants you use. You may develop problems in combining the permanent palette of one medium with the fugitive colors of another. Over a period of time the fugitive colors

may fade, thus creating bad juxtapositions with the more permanent colors.

5. Note the strength, flexibility, and wetness (where buckling is a factor) of the binders used both in painting and cementing media. For example, in some situations you may wish to add a strong binder such as acrylic medium to a paint like designer's colors. Or, you may want to use a wheat paste glue such as Yes glue (best) or library paste to adhere paper to a board, but white vinyl glue to attach one board to another.

Contrasts in value, hue, intensity, and texture

Contrasts that result when one medium is placed next to another can be minimized with spray. For example:

1. Areas can be unified simply by making gradations that move between contrasting areas. This is especially useful for collaged areas.

2. Flat transparent layers can be sprayed over contrasting areas to unify them.

3. A medium like the ink of a photograph reproduction can be unified with painted areas with a combination of superimposed brushed and sprayed applications that copy the qualities of the photograph.

4. Contrasts in texture or other surface characteristics between media areas can usually be minimized with light, subtle spraying, first on the coarser areas, and then over both areas.

5. Contrasting space and form indications can also be unified with one of the above methods.

Retouching

Many of the retouching techniques described in chapter 11 have important implications for mixed media. Airbrush artists interested in mixed media should review chapter 11 and note carefully how many retouching techniques and underlying principles have potential application for mixed-media use.

Spraying sequence

Spray may be used most effectively in mixed media if its sequential relationship to other media is understood.

1. Consider which opaque areas should be sprayed first.

2. As described earlier, decide to what extent spray should be used over other media to alter contrasting characteristics of art elements (especially those of color).

3. Examine sprayed areas (especially those sprayed too heavily) and determine: (1) if the effects of media in underlying layers should be reestablished; (2) if spray and other (brushed, drawn, printed, etc.) media sequences should be repeated; and (3) if additional media should be introduced.

4. When working with photographs and other collage or assemblage media, recognize where parts can be sprayed before they are attached to other surfaces or forms. It is often possible to delay gluing or connecting parts until the work is virtually finished. This method can substantially save masking time.

Airbrushing and Specific Media

Although airbrushing is not always specifically mentioned, the following information is pertinent to the use of airbrushing with mixed media.

Painting

Often a background is airbrushed in one medium to provide a base for other painting media. For example, sprayed acrylic polymer may serve as an underpainting for oil paints, while sprayed designers' colors could provide an excellent backround for transparent watercolors. Sprayed backgrounds are commonly used by graphic designers and illustrators before other media are used on the supports or on separate overlays.

Drawing

An important asset in using spray with other media is that spray can be applied subtly and gradually to the degree necessary to create a desired effect. For example, when used with fine line drawing media, it is possible to use spray in a manner that complements delicate line qualities (See **C-10** in the color section). Spray, then, can be used in the way that artists combine transparent watercolor and drawing. On the other hand, opaque layers of spray can be used to reduce the effects of drawing, to partially reestablish the ground of an image, or to paint entirely over a drawing.

The following examples provide some ideas for using spray with drawing media.

1. The even and uneven line qualities of inks used with such tools as pens, brushes, quills, reeds, and sticks may provide an interesting contrast to even spray applications. For example, the hatching technique introduced in project 10 is an interesting way of controlling the position of drawn areas in space.

2. The graded areas produced with charcoal, pastels, and chalks may be enriched with either underpaintings or spray overlays applied at a greater distance than normal. Because these drawing materials are loosely adhered, be careful not to blow particles loose with the airbrush or air gun. Likewise, if the surface is too wet, these materials may disperse.

3. Water-resistant media such as wax crayons can be coordinated easily with spray because an exact amount of resist effect (beading) can be achieved with spray. Note that heavy applications of hard, wax-based pencils may also resist water media.

4. Graphite also has resist characteristics. Because pencils come in such a broad range of hardnesses and can be used in a very controlled manner, it is an ideal medium to use where subtle variations in line and value are needed. Also, in many situations graphite can be used for retouching where darker value modifications are necessary.

5. The subtle lines of silverpoint can be strengthened with the use of transparent watercolor washes over the drawn surface. With the use of light spray this combination can be executed in a subtle manner enhancing the beautiful qualities of silverpoint drawings.

6. Because marking pens are transparent, they coordinate well with more opaque drawing media. Where it is desirable to coordinate transparent media, marking pens relate well to transparent dyes, transparent paints, and inks. Distinguish between watercolor and permanent markers: the watercolor marker inks are water soluble and the permanent marker inks are soluble in xylene, lighter fluid, lacquer thinner, or rubber cement thinner. In addition to the popular self-contained markers, refillable foun-

tain pen markers are available. The colors and clear fluid (cleanser) for these pens may be used in airbrushes. Some brands of permanent markers also market a limited color series of spray cans. When working with markers, try to anticipate bleeding.

Printmaking

As with other processes, airbrush painting can be used effectively to create backgrounds for printmaking. Additionally, spray can be used on the print itself to produce effects not easily obtained through printmaking. For this purpose, a compatible painting medium can be sprayed or inks used in printmaking can be diluted and used with the single-action or the larger double-action airbrushes. (In **9-1** several media were combined with photo techniques to produce an illustration that was then color separated and reproduced using offset lithography.)

In combining airbrush painting with printmaking, artists commonly counter the sharp contrasts normally found in prints. A number of printing techniques can also be used to do this. An advantage of spray, however, is that it can be used after the print has been pulled.

When prints are made from multiple plates, from more than one printing element, or from repeated printing of the same plate, alternate spraying and printing can produce unusual effects. Through this technique, figure/ground and spatial relationships can become quite complex.

9-1 Cindy Marsh. *Curves*. Mixed media, 20 by 30 inches. Courtesy of EMI/Liberty Records.

9-2 Phillip Zubiate. Student work.

Collage

Often there are abrupt contrasts within artworks involving collage. At times these can be diminished with spray. Spatial positioning is also a problem that can be met either with general spraying, which tends to neutralize contrast, or through subtle applications of spray around or in and out of the collaged area. (Illustration **9-2** uses airbrush with collage techniques.)

The airbrush is a marvelous tool for preparing collage material or for altering existing material. The colorant used in collage material is usually different from that used in painting media. For example the colored tissue paper used by many artists normally includes fugitive colors, some of which will bleed into succeeding media layers. By preparing your own material you are assured of better color matching and permanence.

Altering existing collage material is easier before it is glued because masking time can be saved. With this technique, dark/light, color, and texture variations can be quickly rendered while the collage piece is moved back and forth between the painting area and the artwork for comparison.

Photography and xerography

Whether photography is used directly as in collage,

through a photo-transfer process, or through a machine copying process, it can be a key source of imagery for artists who used mixed media.

Airbrush painting can be used with numerous photographic techniques and light-sensitive materials. Two photo-transfer techniques that produce reverse images will be suggested here. Both work best with inexpensive pulp papers (such as newsprint) that do not have glossy finishes. The first technique only partially transfers the ink. For a solvent, the transparent base for oil-based silk screen ink works best. Solvents such as denatured alcohol, lighter fluid, or rubber cement thinner can be used instead. The solvent is applied to the back of the photograph, which has been laid face down on the white support. The back of the paper is then rubbed gently with a dull tool. Because the solvent has loosened the ink from the paper, it transfers to the new support. This technique can be used on paper. It does not build up an edge.

The second technique is acrylic transfer. This technique can produce an exact reverse image of the photograph. Depending on the number of coats of acrylic medium applied, the transfer will have a noticeable degree of thickness. There are two basic methods.

1. Coat both the front surface of a photograph and a firm painting support with acrylic medium. While both surfaces are still wet, carefully join them with the photograph face down. The paper may buckle, thereby making it difficult to smooth the photograph on the surface; however, it is important to flatten the whole area because nonglued areas will not transfer (a brayer is useful). During this process do not allow any of the acrylic medium to dry on the back of the photograph. When the photograph has completely dried, wet it from the back with a sponge or brush and rub off the paper. All of the paper should be removed. Paper residue that will not rub off can be removed carefully with isopropyl alcohol and a cotton swab. This technique should be used only on smooth surfaces that will withstand rubbing and wetting; smooth surfaces prepared with acrylic gesso work very well.

2. Coat the surface of the photograph with four to six coats of acrylic medium, allowing each coat to dry between applications. Immerse and soak the photograph in water and then rub off the paper. The resulting transparent sheet can be used separately or adhered to a support. It will achieve its full toned range only when it is placed over a white backing.

The image is not reversed. The surface has the same gloss as acrylic medium, so there may be some beading of paint sprayed over this image.

Xerography utilizes electrostatic forces to form an image. Although this process is similar to photography and even though, as used by artists, it usually includes copies of photographs, it is distinguished from photography here because of the implications it holds for airbrush painting.

Collage material can be copied through xerography, recomposed, and then copied again. (In **9-3**, photocopied images were used as collage materials.) Spray can be used effectively before, between, and after copying. Copying can change the color and texture by shifting hues, reducing or increasing intensity, and altering value range. These changes may serve to unify a composition. However, if they produce awkward juxtaposition, retouching with spray can create the necessary modifications. Also, the inks tend to resist water-based media and the layering of ink causes a slight relief that can become more apparent after spraying.

With the proper machine it is possible to work

9-3 June Santospirito. Student work.

9-4 Leo Monahan. *Paper Tiger.* Paper sculpture and airbrush, 20 by 30 inches. Courtesy of the artist.

with a heat-transfer process. This allows you to transfer the copy of an image to a support that may be more appropriate for spraying.

Textured, bas-relief and three-dimensional surfaces

Spray can be used in works that include various degrees of three-dimensionality **(9-4).**

1. The even quality of sprayed layers may allow these three-dimensional forms to be viewed with minimum distortion.

2. Spatial positioning can be achieved with spray when color (especially value) is used to heighten or diminish the illusion of dimension. You may wish to review the principles of aerial perspective in other sources before trying this. Generally, however, advancing color characteristics are contrasting areas,

lights, intense colors, and warm colors. Receding color characteristics are low in contrast, middle gray to dark, low in intensity, and cool.

3. Minute variations of value and color intensity can be made on these pieces. This allows the artist to establish fine distinctions when integrating two- and three-dimensional surfaces.

4. The illusion of greater coarseness or depth can be gained by spraying at an angle relative to the surface, rather than from straight above.

Use only the necessary degree of relief. Thicker layers of paste are prone to cracking and chipping and may not integrate well with flat areas. It is often best to build up thick layers gradually to retard cracking. An acrylic binder works best for this purpose; try the one that is used in commercially prepared modeling paste or the painting medium used with acrylic polymer. It is best to use a firm board with modeling paste. If thick layers of gouache are used to create texture, the addition of acrylic medium will produce a more flexible paint.

The binder also works well when materials such as aggregates (sand, perlite) or small objects are mixed into or embedded on top of it. If you build up paper surfaces, use flexible materials such as rice or tissue paper. Also, be careful in protecting these surfaces, especially sculpture, assemblage, and other three-dimensional structures which are not usually framed (see **C-11**, color section).

Project 12
Experimentation with Various Mixed-Media Techniques

Prepare at least four 8- by 10-inch illustration boards. If you wish to work on smaller sizes, mount them on the 8- by 10-inch boards after they have been completed. Experiment with various mixed-media techniques. A different technique should be emphasized on each piece of illustration board. Explain on the back the specific techniques that were used.

Project 12, Variation 1
Drawing, Collage, and Painting

Create a single work that utilizes drawing, collage, and painting **(9-5)**. Select collage materials first, so that a corresponding size of illustration board can be selected. Although both brush and drawing techniques are suggested, extensive use of the airbrush is required. Use at least one photograph.

◄
9-5 David Olsen. Student work, project 12, variation one.

Chapter 10 **Uses in Illustration and Graphic Design**

For the layperson, some of the areas covered in this chapter (especially illustration) are representative of airbrush art. Even though these categories overlap, they are useful. They allow a variety of airbrush applications to be presented in an orderly manner. For example, the terms *illustration* and *rendering* are both used. Illustration is a broader term and refers to general representational imagery. Rendering an image demands greater accuracy and adherence to dimensional specifications.

Illustration

Basic areas of illustration

In illustration, the airbrush is used to capture the essence that communicates something important about a subject. Specific fields of illustration include:

- Cover illustrations (books, magazines, record albums, booklets, brochures, containers).
- Advertising illustrations where the intent is to sell products or communicate ideas.
- Book illustrations or editorial illustrations for periodicals, depicting narrative content or objectively rendering subjects.

Fashion illustration

The airbrush traditionally has been used (especially in newspapers and magazines) with work that includes the human figure and with separate illustrations of accessories such as hats, shoes, hosiery, and handbags.

Cartoons and caricatures

Cartoons are drawings that satirize a subject or action. Caricatures are deliberately distorted interpretations of subjects (normally persons). They usually include an exaggeration of the subject's features,

10-1 Peter Palombi. *That's Why You're Overweight.* 21 by 21 inches. Courtesy of Eddie Harris.

mannerisms, peculiarities, defects, or other characteristics. Both usually employ stylized, linear imagery with simple, flat and gradated applications of color which are well suited to airbrushing. (A graduating student promotes his abilities in **10-3.** See also **C-12** in the color section.)

Animation

With the use of a pegboard for registration, a series of cells (usually .005 acetate) is placed over a background. Each is photographed in order. The airbrush is used for the backgrounds **(10-4)** or on the transparent cells.

10-2 Dave Willardson. *Stereo Sweetheart.* Dyes and inks, 20 by 24 inches. Courtesy of the artist.

10-3 Tom Fritz. Student work; a self promotion illustration by a graduating student preparing to enter the field.

10-4 *The Fox and the Hound.* © MCMLXXXI Walt Disney Productions.

Advertising Design

The designer often needs to integrate, clarify, or alter various components of his or her work. This may include using the airbrush on backgrounds, in lettering, and in small spot illustrations. The airbrush may be effectively used to create a flat or graded background color. Airbrush painting may also produce the illusion of three-dimensional chrome lettering. It may create a decorative design that complements the message of an advertisement.

Lettering

The clarity and precision possible with the airbrush can help to make readable letters. (See **C-13** in the color section.) These factors also contribute to the relation of letters to their grounds and to each other. Letters can be rendered to appear precisely positioned in space or on a plane, or may be made to float. They may appear flat or three-dimensional.

Posters

Posters normally combine lettering and a design or illustration. Since they are intended for posting in various public places, they may vary in size from a small placard or bill to a large billboard. The airbrush is especially well suited for creating surfaces for poster design. (See **C-14** and **C-15** in the color section.) Large and even flat or graded surfaces can be created easily. Contrast can be controlled to produce imagery that can be perceived at a distance.

Advertising displays

Display work can involve two-dimensional surfaces, relief, or three-dimensional constructions. In this area, airbrush work is usually prepared for a particular type of setting, such as a window display.

A common display technique involves two-dimensional cutouts which are arranged with the degree of depth desired. The airbrush can be used not only in preparing the imagery on these surfaces, but also in creating or intensifying figure/ground spatial relationships. For example, the contrast between planes can be increased or reduced to exaggerate or limit the illusion of three-dimensional space in a manner consistent with aerial perspective. The airbrush

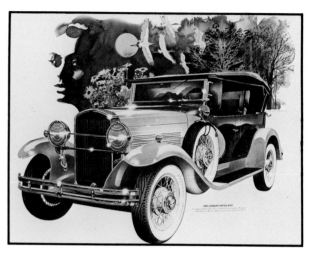

10-5 Paul Melia. *1929 Jordan Speed Boy.* Courtesy of the General Tire and Rubber Company.

can be used to depict cast shadows, creating a greater illusion of depth.

Technical Rendering or Illustration

The airbrush is frequently used for design presentations and in educational, promotional, and advertising materials where it is necessary to objectively describe various subjects **(10-5)**. In each of the related areas discussed in this section, accuracy may be important. Structure, function, relationships, or such visual characteristics as form, color, and texture must be communicated accurately. To do this, a knowledge of the subject is desirable. So is the ability to work closely with non-art personnel to whom the work will be submitted or who may be supervising the project.

In each of the areas described here, the subject may not exist or may not exist in a position or form that can be visualized. In these situations, it may be necessary to construct an image from plans, ideas, or parts of the subject. To do this, the artist may have to work closely with personnel in the fields involved (engineers, medical doctors, etc.).

Where the subjects to be rendered do exist and can be visualized, the illustration may be used to present a clear view of the subject or to delete misleading details or obstructions. The illustrations may also present the subject in an aesthetically pleasing, dynamic, or easily understood way.

The ability to render surfaces can be especially important in technical rendering. Consider the following distinctions:

- The different colors and reflective qualities of metals such as chrome, aluminum, brass, and stainless steel.
- The satin, semigloss surfaces of enamels, porcelain, opaque glass, and opaque hard plastic.
- The transparent or translucent surfaces of glassware, plastic tubing, and the thin membranes of organic tissue.
- The matte or textured surfaces of leather or vinyl upholstery, rubber hoses or tires, the side of a brick building.
- The pattern of the implied texture on woods, polished stones (like marble), the surface tissue of skin or an organ (such as the heart).

Representing various views

Described here are some common ways to illustrate subjects.

Cutaways The subject is rendered to look as though it has sections or layers removed so that interior areas can be observed **(10-6)**.

Cross sections The subject is rendered to look as though it has been cut all the way through. This illusionary cut is usually on the major axis of the subject or perpendicular to it.

Vignetting A vignette normally shades off gradually at the borders of a work. However, the term "vignette" also can be used to describe the technique of isolating a subject by spraying surrounding areas. The effect in vignetted areas may be to reduce contrast in the outer, sprayed areas, or may be to lighten, darken or alter color hue, or intensity.

Ghosting Internal areas that are not normally visible to the eye are sometimes rendered as though the viewer is looking through almost transparent outer layers **(10-7)**. Because these outer layers are slightly indicated, the inner areas are not rendered quite as clearly as they would be if they were exposed.

Exploded views The components of complex objects are rendered separately in the same scale. Although the parts are separated, they have alignment and proximity so they appear ready to be positioned properly to form the complete object.

10-6 Rolls-Royce RB.211 Turbofan (used in the Lockheed Tristar 10-11). Courtesy of Rolls-Royce Limited.

10-7 Richard Leech. Yamaha snowmobile. Watercolor, 20 by 40 inches. Courtesy of the artist.

10-8 Richard Leech. Yamaha motorcycle advertisement illustration, 25 by 35 inches. Courtesy of the artist.

Mechanical rendering

It is possible, with the airbrush, to create descriptive renderings that show mechanical parts clearly and show how parts relate to each other. In these works misleading details can be eliminated while precise details of the subject can show fine distinctions to the viewer. A combination of line drawing and airbrushing may be used **(10-8, 10-9)**.

In mechanical or other technical renderings it may be necessary to represent with accuracy:

- How the parts of the subject are distinguished or spatially positioned.
- Precise measurements.
- The material the subject is made of or how it is finished.
- The function of parts.
- The order of assembly or how parts fit into each other.

Industrial design (product illustration)

Skill in rendering surfaces is important in industrial design **(10-10)**. The form of an object usually must be rendered to show the material it is made of and the reflective qualities of its surface. The object is visually depicted so that it can be a part of a presentation or display.

Architectural and interior renderings

Broad planes that closely relate to geometric forms and simple surfaces make architectural rendering well suited to airbrush techniques **(10-11)**. This is also true of the large background areas that are often a part of these renderings. Airbrushed areas are usually combined with brushed watercolor and gouache, ink, or wax-based color pencil in detail areas.

Biological, medical, and natural science illustration

Studies of nature and the physical world are required in such fields as botany, zoology, medicine, physics, and geology. Artists in these fields may present clear views of natural subjects **(10-12)**. They may also be called upon to interpret, recreate, or develop imagery for the viewer of subjects that (1) cannot be directly observed (as with internal organs), (2) exist differently in nature, or (3) do not exist in the form depicted. For example, the interior tissue of a living organ is normally hidden inside the body. When it is exposed for viewing, it may be damaged or in some other way altered. Even if we could see it undamaged, it might not have the color, delineation of parts, form, and texture necessary for viewing, study, and understanding **(10-13)**.

10-9 Richard Leech. Valve illustration for Masoneilan International. Watercolor, 20 by 30 inches. Courtesy of the artist.

10-10 Gene Allison. *Cap on Faucet.* Gouache, 11 by 14 inches. Courtesy of the artist.

10-11 David Kimble, artist. Courtesy of Los Angeles Bonaventure/Westin Hotels.

10-12 Ray Moskowicz. Student work.

10-14 A stencil is being used to create a wallpaper pattern for a stage set. Courtesy of Theater Department, California State University at Northridge.

Related Uses

Stage or set design

Sprayed surfaces are used in preparing sets for theater, concerts, films, and TV. Small- or regular-size air guns normally are used because of the large scale of these sets. The following are typical applications:

- Large, uniform, flat or graded areas, such as those of interior or exterior architectural planes.
- Large, gradated areas, such as those of the sky or the clouds in the sky.
- Combined uses with the brush or other tools, as with the illusion of such surfaces as weathered wood.
- The illusion of shadows or light shining on planes.
- Patterns with repeated stencils, as when the effect of wallpaper is created **(10-14)**.

10-13 Linnett Moreno. Student work.

Exhibition design

The uses of spray in exhibition design are similar to those of stage or set design. Common examples are seen in art galleries and museums, science and historical museums, and the displays in government and educational settings. Realistic dioramas prepared for natural history museums, for example, employ both airbrushes and air guns to render the natural habitat of birds or animals **(10-15)**.

Project 13
Professional Directions

Review the material about art fields in chapters 10 and 12. Complete a project which is representative of one of these areas. Variations 1 and 2 are examples of two approaches to this assignment.

10-15 Duncan Allison Spencer. *Waterhole Habitat—East Africa.* Acrylic polymer, 55 feet high, 100 feet across the front. Courtesy of the Los Angeles County Museum of Natural History. The animals in this large diorama are real, though a little distorted by the wide angle lens used to photograph the scene. The sky was created using a modified air gun which can produce the large stippled pattern necessary for atmospheric effects. (Detail.)

Project 13, Variation 1
Still Life with Contrasting Materials (Product Advertisement)

Select at least three objects with different materials and surfaces. In composing these objects, consider not only how they can be effectively composed but also how their different surfaces can be realistically rendered.

At least one of the objects rendered should be interpreted as the central product in an advertisement. Before beginning your painting, complete a series of preliminary studies to find a combination of relationships and effects that will best present the product.

Project 13, Variation 2
Transparent Supports (Cross Sections)

This project gives practice in techniques for mechanical, architectural, or medical illustrations. Using a photograph of a building, a machine, or a human form, render an interior section on an acetate overlay. Assume that the purpose of rendering is to describe the functioning of an interior.

1. Use an 8- by 10-inch sheet of .005 mil acetate and an 8- by 10-inch black-and-white photograph.

2. Mount and clean the photograph in the manner described in chapter 11.

3. Use a clean sheet of regular acetate or acetate specially prepared for spraying. With the unprepared type, the areas that will receive media can be prepared in the same way as glossy photographs (see chapter 11). Handle the acetate carefully to avoid marring it with fingerprints.

4. Place the sheet of acetate evenly over the photograph and tape it at the top border so that the tape attaches to the illustration board and to the acetate only where the acetate overlaps with the photograph's border.

5. Special care should be taken when working on acetate. Frisket knife marks will show, as will the marks left by drawing tools that have been applied too heavily.

6. Acetate scratches easily and paint applied to this surface will chip, especially when heavy areas are built up.

7. Protect the finished piece with a cover.

Chapter 11 **Retouching**

It is often appropriate or necessary to alter graphic material in one way or another with modifications, additions, deletions, corrections or restorations. Many tools can be used for retouching, but for effects involving precision, clarity, and matching, the airbrush is a proven and useful tool.

The changing of values is probably the most common application of retouching. With achromatic or chromatic applications of a painting medium, the light and dark relationships of a work can be altered to create precise value relationships. Similarly, hue and intensity changes can be used to create precise value relationships, and more precise color relationships. The intensification or reduction of the illusion of three-dimensional form often requires very subtle changes. The airbrush is especially suited for this.

For example, it may be necessary not only to intensify a highlight or deepen a shadow, but to do it in the precise manner that allows a form to integrate naturally with its surroundings. Forms may need to be simplified for a clearer description of an object.

The airbrush can also be used to modify the illusion of texture. For example, it may be appropriate to apply smooth, transparent layers to an area that appears too rough. Retouching may be needed to create an apparently rougher texture. For this, try one of the techniques described in chapter 7, Special Techniques. Each of the preceding elements may control the spatial relationships within a work. Through retouching, figure/ground relationships and other spatial qualities can be depicted precisely for continuity of imagery, better transition from one area to another, or for positioning in space.

Retouching and Nonphotographic Processes

Techniques for coordinating the airbrush with other processes are covered more extensively in chapter 7. For the purposes of this book, however, retouching is interpreted as a somewhat different process because it retains the look and feel of the original work. In most instances, the objective of the artist is to minimize or disguise evidence of retouching. The following suggestions provide introductory ideas and techniques.

1. In retouching, always determine the degree of optical or chemical compatibility necessary between the material sprayed, the existing material to be retouched, and (where applicable) the masking material used. For example, the surface to be retouched may peel when tape or friskets are used, or the oil-based paint or ink originally used on a work may not be compatible with water-based media sprayed over it.

2. Color matching may be difficult when the retouch medium is different from that used in the original work. When it is necessary to change from one commercial brand to another brand of the same medium, the hues, blacks, grays and whites can be quite different.

3. Later in this chapter, it is explained that in photo retouching, alterations are usually completed on glossy or relatively non-water-absorbent surfaces that can be wiped clean of mistakes. In less ideal situations it may be difficult to correct errors where the surface to be retouched is absorbent, old, worn, or of a coarse texture. If this is the case, it may be necessary to retouch with a very slow, gradual build-up of layers that eventually achieve the desired result.

4. For fine artists, permanence is normally desired, especially where transparent applications are used; these modifications may show the result of fading very quickly. The fine artist should use colors designated as relatively permanent in a line of good quality, transparent watercolors or other appropriate painting media. For the graphic designer preparing work for reproduction, this may not be an important factor. The best medium may be nonpermanent watercolor dyes.

5. *Uses in painting.* Transparent retouched areas

often integrate well with areas executed with a brush. Try to retain some of the qualities produced by brushing. As explained in chapter 7, the textured or patterned areas produced by brushes can be beautifully altered with the airbrush.

When retouching over acrylic polymer, errors can be wiped off quickly when the paint is still wet. Dried, very thin layers of acrylic polymer applied over thick layers can be carefully removed with isopropyl alcohol and a cotton swab (quickly wash off the alcohol so that it will not loosen lower layers).

With acrylic-polymer paintings that will be placed under glass, designers' colors can be used as the retouch medium. This change in medium may be helpful to the artist because designers' colors are easier to work with, especially in detail areas.

6. *Uses in printmaking.* The inks commonly used in printmaking can be diluted and sprayed. The larger single- or double-action airbrush is suggested for this medium. Also, the greasy resistant used in lithography, such as tusche, can also be diluted and sprayed. There are numerous applications of airbrush retouching in printmaking. In most instances, logical applications can be worked out simply by reviewing the properties and limitations of these processes. For example, the limited value range in photoserigraphy can be varied and extended with retouching. Liquid frisket can also be used to make alterations on prints, especially on studio proofs where the artist is experimenting with variations. Also, the sometimes abrupt contrast caused by the use of dissimilar plate materials in collagraphs can be subtly controlled by airbrushing these areas on the final prints with either flat or graded applications.

7. *Uses in textiles.* Batik, tie dye, and other processes can be retouched with either single- or double-action airbrushes with the same dyes used in creating these works.

8. *Uses in xerography.* There is a limited dark/light or color range in the copying processes that utilize electrostatic forces to form an image. It may be appropriate to extend this range through retouching, especially when the copy is used with other materials that have a broader hue, intensity, or value range.

9. *Uses in mixed media.* Although airbrush painting and mixed media are covered in chapter 8, it should be briefly noted here that airbrush retouching can counter problems common to mixed media. These problems usually occur when there is a visual contrast between different materials or processes and

when that contrast produces unsatisfactory relationships in value and color, in spatial positioning, or in the illusion of texture and form.

Photo Retouching

Photographs are usually retouched to prepare them for reproduction in a publication. However, there are other photographic uses of the airbrush. The photographer may retouch his or her photographs for exhibition or restoration. The fine artist may use retouching techniques to modify a work which uses a photograph. This section introduces the basic principles and techniques of this process, since they contribute to an understanding of common uses of the airbrush. Retouching is done on black and white negatives and prints, color prints, and color transparencies in such fields as:

- Mechanical and technical illustration
- Newspapers and other news media
- Product and advertising design
- Architectural rendering
- Portrait and portrait restoration
- Illustration

To understand the need for photo retouching, one must understand the limitations of the photographic process. Photographs are taken under varying light and other conditions. The camera can be expected to see only so much; it cannot always record subjects in proper emphasis, detail, clarity, or in proper relationship to other parts of the subject. The camera often records extraneous details or misleading juxtapositions of imagery. Alterations can be made in a photograph to provide the desired consistency, clarity, or compositional changes. It is because of such considerations and because of the demands of particular printing processes that so many photographs are retouched.

Success in retouching is dependent upon skill with using and maintaining the airbrush and upon other fundamental abilities. It is important for the artist to recognize problems in form, value relationships, and surface qualities. With color retouching, a basic understanding of color is imperative. Success in retouching is also dependent upon skills in coordinating the airbrush with the brush, drawing tools, and friskets and other masks.

Planning

The photograph to be retouched should be carefully studied. Establish the intended use of the retouched photograph. Uses might be advertising, portraiture, education, or representation of aesthetic ideals. Consider what aspects of the photograph should be emphasized or deleted, what should be clarified or described better, and what areas could be made less confusing. Keep in mind the intended handling of the retouched photograph. For example, if it is to be reproduced, note whether or not the range of values to be used is consistent with reproduction possibilities or limitations.

Preparation

Most photographs used in retouching are printed on 8- by 10-inch single-weight glossy stock. However, it is best to use unferrotyped, double-weight glossy paper because it does not show marks as easily, allows better paint adhesion, and the emulsion does not tear as easily when friskets are removed. It is best to have at least two prints: the print to be retouched and the comparison print. If only the original print is available, it is usually best to copy it photographically and then complete the retouching on the copy print. To ensure that the copy print is as close as possible to the quality of the original, it should be photographed with a large format negative; less enlarging from the copy negative will produce a better print.

Mounting Prior to retouching, it is usually best to mount photographs on mounting or illustration board that allows a 1½- to 2-inch border around the photograph. This border facilitates handling and can be removed when the retouching is completed. Any important information located on the back of the photograph should be transferred to the back of the board before the mounting process begins. If exact placement is desired, guide marks should also be placed on the board at this time. Handle the photograph carefully when mounting to avoid cracking or creasing.

The two most common ways of mounting are with rubber cement and by dry mounting. When using rubber cement, apply even, thin coats to both surfaces. After both surfaces are dry, apply the photograph to the board using the "U" method: let the center of the photograph touch the board first and then carefully roll down the sides **(11-1)**. Guide marks

are useful, to show where the center of the photograph border should meet the board. The photograph is smoothed from the center out with the hand or a roller such as a brayer. Excess rubber cement should then be removed.

When it is necessary to be precise in mounting photographs, place two pieces of scrap paper on the prepared surface with their edges meeting in the middle of the photograph. Place the prepared photograph to be mounted in its exact position and then alternately remove the two pieces of scrap paper, allowing the photograph to adhere to the prepared surface as the scrap paper is removed **(11-2)**. If it is necessary to remove a photograph mounted with rubber cement, dissolve the cement, as the photograph is being separated, with rubber cement thinner or bensol. Apply the thinner with a brush or a small oil can.

11-1

11-2

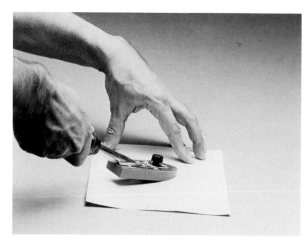

11-3

11-4

Dry mounting is normally the preferred method. It requires the use of dry mount tissue and an iron, a special dry-mounting iron, or a dry-mount press.

1. Cut dry-mounting tissue either to the same size or slightly larger than the photograph.

2. Place the photograph face down on a clean surface. Place the tissue on top. Tack it in the middle by holding a tacking iron (or the edge of another type of iron) momentarily against the tissue and then release it slowly by removing the iron up and away at an angle **(11-3)**. Use this procedure so the iron will not buckle or roughen the surface of the photograph.

3. Trim any excess tissue from around the edges of the photograph.

4. Position the photograph face up on the board. Lift up a corner of the photograph and tack the tissue to the board **(11-4)**. Then do the same with the adjacent corner.

5. After placing a clean sheet of paper over the photograph, dry mount the whole surface **(11-5)**. To melt the tissue, heat of approximately 225 degrees Fahrenheit should be applied for about 10 seconds.

When mounting one photograph over another, or when the photograph is to be mounted on a larger surface, it may be desirable to reduce the thickness of the edges. There are three common approaches for doing this.

1. With regular, straight-edged photographs or photographs with contours, cut straight through the paper; then sand the edge from the back where there will be overlap **(11-6)**. Use light sandpaper and sand only toward the edge, being careful not to fold back the edge.

11-5

11-6

2. With the second technique, the photograph is torn while holding it upside down on a flat surface. With this method it is best to hold the photograph up to the light and lightly draw the line to be ripped. Be sure that the line is far enough away from areas you wish to retain so that you will not rip into them. Fold with one hand down the area to be mounted. Then tear the excess area off by ripping toward the piece to be retained (thus producing a beveled edge under the photograph's edge) **(11-7)**. Sand the edge to make the bevel uniform.

3. The third technique is similar to the second except that the contours to be followed are cut partially through the front of the photograph with a sharp knife before the paper is torn. This, of course, allows a more precise edge when it is necessary to closely follow the contour of a photographic image. With this technique it may be necessary to hold the photograph face up when tearing.

Rubber cement does not adhere well to slick surfaces of glossy photographs. A painted surface will allow the rubber cement to stick; so, before mounting, prepare the area to be glued by lightly brushing or airbrushing the glossy surface with appropriately colored paint.

Before mounting, the white edges of the photograph paper can be darkened with a brush and paint of the proper value. Apply the paint to the edge with the face of the photograph up so that excess paint is deposited on the back when the brush is drawn across the edge **(11-8)**. If a heavy bead of paint is deposited on the back, it can easily be smoothed with your finger or a brush.

Surface preparation Remove foreign matter such as grease, oil, or fingerprints from the surface of the photograph with a cotton swab and rubber cement thinner or talcum powder. Acetic acid or saliva may also be used but may buckle the paper. This process also serves to give the surface the slight tooth that allows the paint or dye to adhere better. A simple tool for this purpose can easily be prepared in the following manner.

1. The end of a round, wooden brush handle provides a convenient, thin dowel. Shave the point off the end and sharpen it.

2. Flatten a small wad of sterilized long-strand cotton. Place the handle in the center of the cotton wad and fold the cotton over so that it envelops the handle **(11-9)**.

11-7

11-8

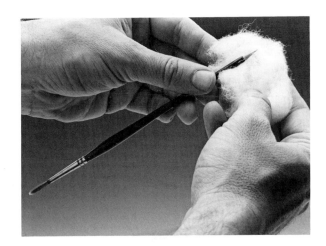

11-9

11-10

11-11

3. Twirl slowly and roll the cotton around the handle. Move the finger and the thumb down gradually as the handle is rotated **(11-10)**.

When moistened, this tool is useful not only in preparing the photograph but also in removing thin layers of paints or dyes **(11-11)**. Because these materials can be removed easily in this manner, it is possible to simplify the use of masks and stencils when working with photographs. However, this method should not be depended upon to remove thicker layers of medium.

Special problems and specific techniques A rough surface on the photograph is often the result of erasing that has loosened the paper fibers. Painting then causes the fibers to stand. To correct this, rub the resulting nap with a piece of cotton after the paint has thoroughly dried.

Dark sections and detail or texture areas can be bleached with a solution such as Spot Off or Farmer's Reducer, which can be purchased in most photographic stores. This solution should be diluted with water according to the directions on the label and applied in a circular motion with the cotton swab described above. When the photograph is bleached to the degree desired, immediately apply a fixer without a hardener or hypo (sodium thiosulfate) with a similar motion to stop the bleaching process and also to remove the brown stain. Finally, wash the surface with clean water.

Retouched areas that have yellowed because of age can be cleaned with benzol and then bleached by airbrushing with hydrogen peroxide.

Waterspots are difficult to cover by airbrushing. The best method usually involves wiping off the af-fected area with a knife and then retouching the area with an airbrush.

At times it may be necessary to temporarily alter a photograph. Temporary changes can easily be made on frisket paper and then removed when it is necessary to reestablish the original work. Clear acetate overlays, which cover the whole surface, can also be used for this purpose. When using this technique, the acetate can be prepared with the same method described earlier for glossy photographs.

With photographs that are to be reproduced, the specific printing process that will be used should be recognized as a factor before retouching. For example, for newspaper reproduction it is necessary to use more contrast and a simplified palette of black, white, and two grays. Less contrast is necessary with other processes such as offset and fine-screen, half-tone printing.

Special distinguishing traits or descriptive qualities of the product or client should be noted in retouching. A logo, trademark, distinguishing feature, or special attribute may be clarified or emphasized through retouching.

A brush should be used for highlights and selected dark areas. Consider using the brush both early, where subsequent sprayed layers will mute contrast, and later, where maximum contrast can be achieved.

Specific applications

Modification Retouching may involve emphasizing, minimizing, clarifying, or applying other slight alterations to what already exists on the photograph.

For example, it may be necessary to delete halftones, intensify highlights, darken shadows, emphasize form, sharpen an edge, or bring out a detail. A machine part may be retouched to emphasize the three-dimensional quality of its form **(11-12, 11-13)**, to clearly show how it is put together, or to show to advantage a company name or trademark. The distracting reflections on glassware or on other reflective surfaces of a product might be simplified to make them read better.

Vignetting effects may be appropriate in simplifying a composition and focusing the viewer's attention on a subject. An object in a photograph could be retouched by spraying it with a flat opaque or transparent layer of paint and then overlaying drawn outlines. With this technique, a particular machine part can be isolated and more clearly described.

Adding, removing or correcting Retouching with an airbrush may be necessary to remove, add or significantly change parts of a photograph. In figures **11-14** and **11-15**, the airbrush was used to fill in the areas

11-12, 11-13 Gouache, 8 by 10 inches. Courtesy of William F. Litschert, Litschert's Airbrush and Photo Retouching School.

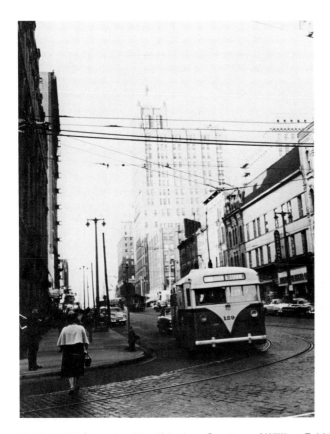

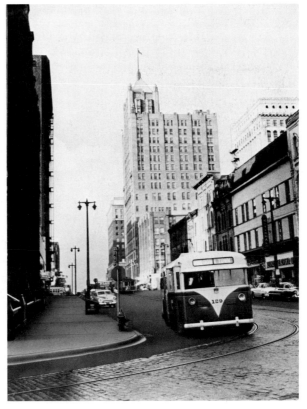

11-14, 11-15 Gouache, 8 by 10 inches. Courtesy of William F. Litschert, Litschert's Airbrush and Photo Retouching School.

where people, poles, wires and a car were removed from the original photograph. Modifications made the buildings darker and clearer. In **11-16** and **11-17**, the artist effectively used bleach, dye, and airbrush for the few alterations.

If a photograph is used for a different purpose than that for which it was taken, it might be necessary to remove a figure, writing, the side of a product, or an object that is inconsistent with the setting of the subject. Because of the printed format for which a photograph is to be used, it may be necessary to lengthen or widen the photograph.

At times it is necessary to make temporary revisions or show alternatives. For this, with the use of transparent overlays, it is possible to add to or revise parts of a photograph without actually changing the original. It may be necessary to show the interior of a machine with a ghosting or cutaway technique. See **11-18** and **11-19**, which show many regular retouched areas and cutaway sections of a motorcycle drive shaft.

Restoration Retouching may be used to repair cracks, tears, abrasions, or weathered areas. Photographs that need to be restored are often in poor condition and should be handled with care. If the photograph is to be mounted, note that the surface texture of the area to be restored should be as flat as possible. With older photographs it is also good to

11-16, 11-17 Tim Wild. Untitled. Bleach, dye, and gouache, 9⅜ by 6⅜ inches. Courtesy of Wild Studio. In photo retouching, it is important to note that the airbrush often is used in limited areas.

Most of the areas of this photograph were retouched by hand with bleach and dye. An airbrush was used on some of the larger areas to adjust the tone and to simulate the texture of the photograph.

11-18, 11-19 Gene Allison. Yamaha drive train. Gouache, 18 by 24 inches. Courtesy of Chiat/Day Advertising.

11-20, 11-21 Gouache restoration, 8 by 10 inches. Courtesy of William F. Litschert, Litschert's Airbrush and Photo Retouching School.

note the particular weathered quality, grainy texture, or other qualities that the retouched areas may have to match.

Montage A montage of photograph parts can be created utilizing the rubber cement mounting techniques mentioned earlier. The photographs should first be traced on tracing paper as they are to appear in the montage. Using the appropriate technique, cut or tear out the photographic parts, prepare the edges, paint the glossy areas where they will overlap, and glue.

Mount the pieces using the tracing guide prepared earlier. A montage may be the best way of combining such imagery as: airplanes, where a single in-flight photograph would be impossible; architecture, where the problems of scope, position, and angles might rule out a single photograph; or a subject such as "modes of transportation" in which the different types of vehicles depicted are in different environmental settings.

Color Generally, the same principles that have been applied to black and white retouching also apply to color retouching. The key difference between the two is that the use of hues and the greater use of transparent media create added challenges. When converting a black and white photograph to color, color retouching is often completed on light sepia prints because the regular black-and-white print does not respond well to transparent color.

Color dyes are usually used where it is necessary to preserve the underlying form. Before applying dyes, note that small areas that may become too dark when color is added to them can be scraped back with a sharp knife to expose a lighter tone. This lighter area can then be retouched with transparent dye to achieve the proper value and intensity of the desired hue. Dyes should be diluted to the desired level and built up gradually with the airbrush, a sable brush, or a cotton swab (see **C-16** and **C-17**).

Chemical toners commonly used in photography can also be used over the whole photograph or on a restricted area. When only parts of the photograph are to be toned, lacquer is applied to the rest of the photograph as a mask and is removed later with lacquer thinner. Rubber cement can also be used for this purpose. Airbrush retouching can then be applied where desired.

Gouache colors are necessary where large areas need to be lightened and where extensive revisions or corrective retouching are necessary.

11-22 John Garber. Student work, project 14, variation three.

Added skills and special care are required for color retouching of large-format transparencies. For these, use transparent dyes.

Photo retouching projects

Photo retouching is usually introduced within the context of the vocations in which it is used; often an important objective is the development of skills that can be used in prepared work for reproduction. Although these considerations are important, the following projects emphasize previously learned airbrush skills which may be used now for retouching photographs: (1) skill in rendering close value transitions and subtle form variations; (2) rendering combinations of surfaces and forms; and (3) establishing figure/ground and spatial relationships.

In the retouch projects, use the following steps.

1. *Planning.* Use at least two copies of the photograph; a second print is retained so that comparisons can be made between the original and the retouched areas. The use of retouching in these assignments does not include reproduction considerations; therefore, a full range of value and value contrast variations may be used. Begin by noting areas to be retouched; distinguish between areas to be corrected and areas to be modified.

2. *Preparation.* Mount the photographs properly on a centered 8- by 10-inch area of a 12- by 14-inch piece of illustration board. Cut off the 2-inch border when the assignment is completed. Prepare the photograph surfaces properly, then mask off the photograph border with drafting tape. Prepare colors to match the warm or cool tones of the photograph. Be sure to prepare the edges properly, where separate pieces of photographs are used in your composition.

3. *Painting.* Except with the last project variation (color retouching), use an achromatic palette of retouch colors. To the degree that your skill allows, develop imagery that looks like better photography rather than like a painting.

Project 14
Photo Retouching

Project 14, Variation 1
Retouching a Black and White Photograph

Retouch an 8- by 10-inch or larger photograph. The photograph should include many areas which need retouching. Ideally, the photograph would include areas which would be retouched by adding, removing, and correcting. You may want to select a photograph which also needs to be restored, or restore areas that you have purposely damaged.

Project 14, Variation 2
Using Parts of Retouched Photographs

Using at least three parts of photographs, develop a composition of your choice. Any selection of techniques already introduced in this book may be applied to this assignment. The transitional area between the photograph and the illustration boards should be retouched to minimize any contrast between the two surfaces.

Project 14, Variation 3
Complex Montage

Create a montage using a minimum of five separate pieces of photographs that, when combined, cover all of the 8- by 10-inch composition. Retouch both the photographs themselves and the transitional areas between the photographs. The completed composition should be unified and have the appearance of a continuous photograph.

Project 14, Variation 4
Color Retouching

This project has two options; both require the use of dye watercolors or transparent watercolors.

 1. Convert an 8- by 10-inch, black-and-white photograph into full color.

 2. Retouch an 8- by 10-inch color print.

Chapter 12 **Fine Art, Craft, and Production**

Fine Art Uses

Airbrushes and air guns offer many possibilities in areas outlined in this chapter. Not only are many uses of spray discussed here, but the works shown also demonstrate a broad range of techniques, skills and media. Some of these artists are innovative in responding to ways of using spray, new directions in art, changing conditions, or unusual materials. Other artists demonstrate a mastery of already established uses of spray.

Spray processes can be used in most fine art areas in which traditional liquid media are used. Their use is dependent upon the imagery or surface quality desired and the artist's skill and understanding of techniques.

The areas in which spray is used by fine artists overlap, and thus are difficult to categorize. The following list, therefore, is not intended to be complete.

1. Painters who employ special effects often use spray. Photo realists, for example, use the airbrush to render the reflective qualities of surfaces **(12-1)** or the particular look of materials. The airbrush can also be used to create the illusion of collage or even assemblage materials. (See **C-18** and **C-19** in the color section.) Some artists who use these trompe l'oeil techniques are capable of representing the finer qualities of subjects so realistically that they often appear, even at close range, to be real objects or appear to have actual spatial dimensions.

2. Artists who use spray with other kinds of tools or mixed media often include spray because of its ability to integrate with other processes or to retouch problem areas. For example, there is often a

12-1 Don Eddy. *Private Parking I*. Acrylic on canvas, 48 by 66 inches. Courtesy of the Nancy Hoffman Gallery, New York.

degree of undesirable dissimilarity in the pieces used in collages. These areas can be retouched so that the color, textures, or form relationships work more harmoniously.

3. Sprayed surfaces are ideal for paintings that include the study of color, light, or optic phenomena. This is because spray can be applied evenly with a smooth texture. (See **C-20, C-21** in the color section.) For these reasons, three-dimensional or bas-relief surfaces are often sprayed, as well.

4. Because spray can be used precisely to repeat the contours of a broad range of materials, artists often use it with common masking devices as well as unusual masks such as organic materials. (In **12-2** masks were used to achieve an assemblage effect; only a few areas include actual pieces of string.)

Craft Uses

Airbrushes and air guns are used in traditional craft areas to provide a color coat or to condition or protect surfaces. Spray is applied for simple flat or graded areas or for more complex decorative uses. Each of the craft areas described in this section has applications that range from production work to traditional craft to fine art. Production work refers to the construction or finishing of products for uses such as sales, display, or reproduction. Although production work may demand only elementary airbrush skills, some applications may require difficult techniques.

Textiles

Dyes that are later made colorfast with heat or chemicals can be sprayed onto textiles to produce qualities not easily attained through other methods. The dye should be selected according to the fiber material used. Uses vary from wall hangings to soft sculpture to designer-quality fashion designs.

Production uses include various applications in preparing clothing, such as T-shirts, or fabrics used in interiors, such as drapery or upholstery.

Ceramics

Large-barrel airbrushes and small- to medium-sized air guns are used to spray ceramic glazes **(12-3)** and stains onto ceramicware. The larger air tools are nec-

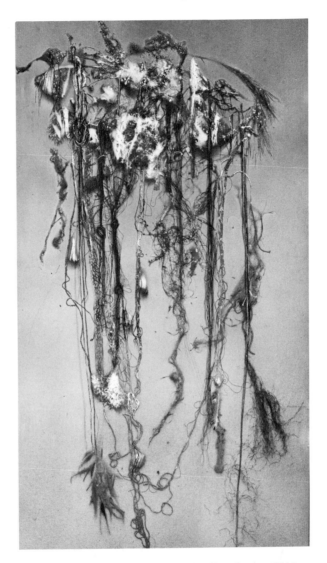

12-2 Sylvia Glass. *Weaver of Webs.* Acrylic polymer, 49¾ by 21¾ inches. Courtesy of the Todd Gallery, Phoenix, Arizona.

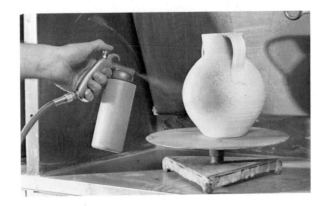

12-3

12-4 Carl Caiati. *Badger Star Bus*. Courtesy of the artist.

12-5 Molly. Firemen's helmets. Acrylic lacquer. Courtesy of Philip Orlando and Bob Gino, Orlando Gallery, Sherman Oaks, California.

essary because the media used are heavy-bodied and because the particles in them are relatively large as compared to particles in most paint media.

Glazes contain abrasives that wear out the tips of regular air tools. Because of this, it is advisable to use a special glaze gun available from larger ceramic supply firms. Production uses include simple coatings on pots or tiles and more complex applications of stains on figurines.

Wood

Air guns are frequently used to apply varnishes, lacquers, and other finishes to wood. Although much of this work simply involves even applications of spatter or flat transparent layers, greater skill is required when subtle gradations are used decoratively. This is especially true when wood objects are stained with gradated sprayed layers in a manner that visually accentuates their relief or three-dimensional quality.

Production uses of air guns include furniture, cabinetry, paneling, and musical instruments. For example, the bodies and necks of guitars are frequently sprayed in a manner that allows value gradations to complement outer contours.

Leather

Dyes, inks, stains, watercolors, and finishes can be applied over dampened or dry leather. Although other methods are sometimes used (dipping, brushing, or daubing), sprayed applications with an airbrush, pressurized container, or an atomizer allow uniform layering and blending. Production uses include areas such as upholstery, boots, handbags, saddles, and clothing.

Production

Airbrush painting has many production uses other than those that closely relate to traditional craft areas. The following represent a sampling. **Some of the uses in this section normally employ media which should not be inhaled. Be sure to use a respirator in these situations.**

Automotive and related finishing

Cars, vans, surfboards, boats, motorcycles, helmets,

12-6 Nansea Scoble. *Queen Triggerfish*. Courtesy of the artist.

and other objects related to recreation or transportation are frequently decorated with spray **(12-4, 12-5)**. Large airbrushes and small- to medium-sized air guns are normally used with lacquer.

Food decoration

Cakes, pastries, ice cream, and confections are sometimes decorated with food coloring. Cake decorators use gravity-feed airbrushes because they must spray with a low pressure that will not damage or blow away delicate frosting.

Taxidermy

The craft requirements of taxidermy can be quite demanding. Animals, especially fish, can be rendered with amazing realism with lacquers sprayed through the airbrush (see **12-6**). Although airbrushes of different kinds and sizes are used, the most common is the large double-action airbrush because it can produce some detail with lacquers.

Glass painting

Acrylic lacquers are used to paint glass. Sprayed applications are especially important in situations where a uniform degree of transparency or translucency is required. Paint may also be sprayed onto glass surfaces that have been etched or carved, and vitreous paints, which are fired in a kiln, may be used on glass.

12-7, 12-8 Courtesy of Touch of Glass, Woodland Hills, California.

12-9 Margie Jervis and Susan Krasnican. *Circumference.* Sandblasted glass, 4⅞ by 12¼ inches. Courtesy of the Corning Museum of Glass, Corning, New York.

Glass etching or carving

Special air tools, such as the small airbrush-like Paasche air eraser and the larger Paasche abrasive gun, are used to cut into glass and create designs. This sandblasting process is achieved with abrasives of different cutting strength, such as pumice powder for slow cutting and aluminum oxide for fast cutting. Various tips are available for different spray patterns. (**12-7** and **12-8** show a stencil being made and sandblasted to cut a pattern into glass.)

Designs can be created by uniformly etching the surface as you would with an acid etching material. A higher relief effect can be achieved by carving more deeply into the glass with either heavier or successive layers of abrasive material (**12-9, 12-10**). An interesting variation is glass etching on flashed glass. In this technique, the sandblasting material cuts through a layer or layers of thin colored glass that have been fused to a thicker base sheet of glass. With these processes, masking materials must be used that will resist the abrasive materials. **Use appropriate respirators and goggles to avoid inhaling abrasives or getting them in eyes.**

Cartography

Airbrushes are used to make maps and charts. For example, the small, double-action airbrush is particu-

12-10 Don Dailey. *Grassland.* Sandblasted glass (carving), 11½ by 7⅞ inches. Courtesy of the Corning Museum of Glass, Corning, New York.

larly suited for some of the detailed gradations that are useful in representing topographic surface features such as hills and mountains.

Flocking

Flocking is a fabric fiber available in various lengths. Flocking air guns are used to obtain suede to velour-like surfaces. The support must be prepared with an adhesive material before flocking. In art-related fields, this process is used primarily for decorative purposes as with banners, signs, and three-dimensional displays. Flocked surfaces are not usually very durable, and should be used primarily indoors.

Miscellaneous decorative uses

A broad range of objects that are often sprayed includes toys, dried flowers, fishing lures, and novelties or holiday decorations. The single-action airbrush is often used in model building to spray enamels or lacquers.

12-11 Peter Heinz and John Fitzpatrick. *Fuchsia*. Etched and carved glass, six by sixteen inch center area in larger panel. Courtesy of A Touch of Glass, Woodland Hills, California. The center area of this piece was carved using a sand blaster. The glue chipping on the background was accomplished by etching the surface and applying a coat of animal glue. When the glue dries, it shrinks, releases from the surface and chips some of the glass away with it.

PART THREE

TOOLS, MATER

ALS AND MEDIA

Information on tools, materials, media, and the studio are discussed in the following chapters. Although some of these topics have been introduced in earlier chapters, they are more thoroughly covered here. The material in this section and the appendixes is provided for reference.

Chapter 13 **Painting Media**

Selection of appropriate painting media requires basic understanding of various media properties. This chapter provides the introduction you will need. The following questions may be helpful when selecting media.

- Is the work intended for preliminary studies, reproduction, or continuous viewing?
- Will the work be protected from weathering, sunlight and extremes of temperature?
- What degree of transparency or opacity is required in the work?
- What will be the nature of the ground on which the medium will be applied?
- What painting techniques or combinations of media will be used?
- Are there qualities (such as precision) that are required by the planned imagery?
- What will be the physical properties of the finished painting's surface?

Dyes

Dyes are soluble colorants. Because of this they are different from pigments that are insoluble. Dyes are used as stains on such surfaces as paper and they are absorbed into materials like textiles and inert pigments (for example, lake colors are made from a combination of soluble dyes and inert pigments).

Dyes are sprayed in graphics, photo retouching, and related areas with what are commonly referred to as watercolor dyes. Watercolor dyes are used in situations where transparency is needed but permanency is not required. These aniline dyes are coal tar products and flow easily through all types of airbrushes. Food colors are dyes used in the decoration of cakes and other foods.

For photographic print and negative retouching there are such products as Spotone, which includes six retouching colors for black-and-white negatives, and toned and black-and-white prints. For color re-

touching on negatives, prints and transparencies, there are such products as Kodak retouch colors.

Fabric dyes can be sprayed, although other techniques are used more frequently to color fabrics. Some of the subtle and precise techniques of airbrushing can be applied to textile design. These dyes are normally made permanent with either steam heat or chemical methods.

Paints

All paints consist of one or more pigments and one or more binding agents. Depending on the type, paints may be diluted with a vehicle which may be the same as the binder, or with a diluent or solvent such as water, or a volatile solvent such as turpentine. Paints often contain additional ingredients to provide special qualities.

Artists sometimes prefer to prepare their own paints rather than using those that are commercially prepared. The special requirements of airbrushing re-

13-1

ferred to throughout this book suggest the use of media prepared by experts. For instance, paint used in spraying is often diluted beyond normal levels. The finer quality paints desirable for use in airbrushing require proper selection, precise measuring of ingredients, and careful preparation.

Pigments

Fine-quality artists' paints are important for use in the airbrush because the pigments should be very finely ground. In an airbrush, the opening between the needle and tip is very small. The size of pigment particles is a factor in how well the spray can be controlled.

The correct proportions of pigment and other ingredients in airbrush paint are important, too. The paint must have enough binding agent and solvent or diluent. At the same time it must have enough pigment that the color will be sustained even when the paint is diluted for spraying.

Pigments and color hues For limited palettes, choose a coordinated group of pigments that will produce a broad range of colors when mixed. As you are confronted with specific color problems you may find it difficult to develop the needed colors within the confines of a limited palette.

Commerical paint colors offer the artist a broad range of pigments. Some of these colors may be simply combinations of other colors in a brand line. Others may include pigments that produce colors you cannot duplicate using other pigments. For example, a limited palette of designers' colors may include only two reds such as cadmium red pale and alizarin crimson. But a line such as the Winsor & Newton designers' colors includes seventeen colors between scarlet lake and magenta.

Transparent and opaque colors Painting media and pigments have specific qualities of transparency or opacity. With opaque colors, you may create a solid ground, cover already established areas, or simply apply colors opaquely. Transparent colors can create complex colors through layering and the utilization of mixed media. Sprayed layers of transparent colors can also modify the results of brushing and drawing, as in rendering transparent glass.

Precautions With most spraying, some spray will get into the air. It is important to note that some paints contain toxic pigments (titanium and cadmium, for example). Take precautions even if you spray moderate amounts of paint. Use an appropriate face mask and work in a well-ventilated space (see chapter 18).

Problems Painting media vary substantially in their degree of permanence. Some colorants fade fairly quickly, especially in direct sunlight, and are termed fugitive. Colors that are highly colorfast are termed permanent. Some brands will indicate the degree of permanence on their labels or in their brochures.

Some pigments will bleed through upper layers. This is a common problem when color overlays are attempted on watercolor dyes or on water soluble dyes. Bleeding can be limited by spraying reworkable fixative before spraying succeeding layers. Also, opaque whites are available that inhibit bleeding.

Pigment dispersion can be a problem. Your pigments may not have been thoroughly dispersed when manufactured. Already diluted paint may have settled out, or, if you are working from dried cakes, the painting media may not be properly reconstituted. Even quality paints should be carefully diluted and blended when being prepared. As the paint is being diluted, work the diluent in with a stiff bristle brush and a circular grinding motion.

Binders

The binder in paint is the material that protects and holds pigment and other particles together. It allows pigment to be applied evenly and to adhere to the painting surface. Many of the distinctions between paints are based on the kinds of binders used. The binder in oils is linseed oil and the binder in water miscible acrylic is acrylic polymer. Binders vary substantially in such characteristics as durability, resistance to weathering, strength, and flexibility. In airbrush painting, the kind of binder used is important for a number of reasons.

1. Viscosity is the resistance of a liquid to flowing. Each binder has a higher degree of viscosity before it is diluted for spraying and before its coloring strength is diminished.

2. Thicker and more viscous media tend to clog more easily. Therefore, they may require larger airbrushes that allow less detail.

3. Some binders can be easily diluted, reconstituted, or dissolved. For example, gouache and watercolors can be dissolved with water. Water, of course, is plentiful and expense is normally not a

factor in its use. By running water through the air-brush, some dried or partially dried material can be removed. On the other hand, although acrylics mix with water, dried material must be dissolved with a different solvent such as a denatured alcohol or scraped loosed (as with a reamer). Media that are diluted or dissolved with volatile solvents have additional problems. Volatile solvents add to your expenses and may create a health hazard when sprayed.

Diluents and volatile solvents

Diluents dissolve or dilute paints and are therefore miscible with them. For example, gums or acrylic polymer binders may be used with some water-based media, with water serving as the diluent. A combination of xylol, toluol, glycol, or ketone solvents may be the diluent in an acrylic lacquer.

A solvent is something that will dissolve another substance. A volatile solvent is an organic liquid that easily evaporates and is used to thin or dissolve oils, synthetic resins, and lacquers. Volatile solvents are used as diluents, cleaning agents for wet media, or dissolving agents for dried paint. In addition to being usually flammable, volatile solvent fumes may have an undesirable odor and irritating or toxic qualities that are increased through spraying. **When spraying volatile solvents or the media in which they are used, be sure to use a proper air mask and to work in a space with *excellent* ventilation.**

Be sure you know the proper diluent for your painting medium before you begin painting. Of the materials that may thin media, only one may be used for painting. For example, turpentine may be used as a thinner in diluting oil media for painting. Various other solvents that will *dissolve* oils, for cleaning, should not be used for dilution. It may be possible to use an inexpensive paint thinner for flushing an air-painting tool after spraying oil media.

With other media, a different material may be needed to dissolve dried paint. With designers' col-ors, water is used as a paint vehicle, for cleaning wet paint, and for dissolving dry paint. With acrylic polymer, however, water is used for the diluent and for cleaning wet paint, but a volatile solvent such as alcohol or acetone must be used to dissolve dried paint.

Information in this area is usually provided by the companies manufacturing specific kinds of paint. If not, you may have to find this specialized information in other sources. For example, the *Detzler Repaint Manual* (see the bibliography) provides information on finishes commonly used on outdoor vehicles.

Other components of paint

Additional ingredients may also influence the use of paint for spraying. These ingredients may add to the bulk and therefore reduce the amount of pigment and binder contained in the paint. Their effectiveness may be diminished by the thinning necessary for spraying. They may be of little or no use when the medium is sprayed rather than spread. Although a thorough discussion of these materials is not necessary here, the following incomplete list of materials that may be added to paints may add to your understanding of the complexity of the paint used by artists.

1. Fillers add to the bulk and texture of most paint.

2. Thickeners may change the consistency of paint, from the thinner paint found in jars to paste media appropriate for tubes.

3. Retarders slow paint's drying and can make a medium such as acrylic polymer easier to handle.

4. Antifoamers are used in materials such as acrylic polymer.

5. Preservatives may be necessary to retard spoilage.

6. Wetting agents or dispersants are added to improve the evenness and spreadability of paints.

Selected palettes are listed in appendix 2.

Chapter 14 **Equipment**

Airbrushes and Air Guns

Various kinds and sizes of airbrushes and air guns are available to the artist. There is a broad range, from professional level to inexpensive airbrushes and air guns appropriate for hobbyists. A range of sizes allows detail as fine as a pencil line or the broad spray pattern necessary for covering large surfaces. Before purchasing an airbrush or air gun, be sure you understand how different kinds work. Understand the different features offered by different brands.

Airbrushes

Airbrushes are either single- or double-action. Single-action airbrushes are operated by pressing down on the finger lever, releasing both air and painting medium. The amounts of air and medium can be adjusted separately. (A large-barrel, single-action airbrush is seen in **14-1**). These simpler airbrushes are used for spray tasks that require less precision or immediate control of spray width and density. This kind is used by artists in various fields who require primarily flat applications and simple gradations. They are less expensive than double-action airbrushes and easier to operate, clean, and maintain.

Beginners with limited technical requirements often start with single-action airbrushes. They are most often used by hobbyists or model makers and in craft-related fields such as ceramics or fabric design. For some spraying jobs, the single-action airbrush can be used to satisfy the same requirements as the double-action airbrush. Single-action airbrushes are designed either with the needle inside or outside of the airbrush body.

Double-action airbrushes are operated by pressing the finger lever down for air and back for medium. Although they are more difficult to use than single-action airbrushes, they allow the control necessary for most graphic design, photo retouching, and fine art work. Double-action airbrushes can also be faster than single-action, especially in areas requiring complex applications. Most double-action airbrushes utilize this independent-action; there is also a fixed

14-1

double-action airbrush which mixes the fluid and air with one movement of the finger lever.

Double- and single-action airbrushes come in large- and small-barrel sizes. (**14-2** shows a small-barrel, double-action Thayer & Chandler A airbrush with a color cup; **14-3** shows a large-barrel, double-action Paasche V L 1 airbrush with a large water assembly jar.) Small-barrel airbrushes are capable of greater detail. Because of their smaller tip sizes, they work best with thinner, less viscous water media such as dyes and paints. They will also accommodate

14-2

14-3

14-4 Photograph courtesy of Kirk Grodske.

gouaches. However, acrylic polymer and media using volatile solvents easily clog in this size airbrush. Although large-barrel airbrushes with their larger tips cannot perform with the same detail as smaller airbrushes, they can provide a larger spray pattern and accommodate more viscous, heavy-bodied media. When these viscous media are appropriately thinned and when stringent cleaning and maintenance procedures are followed, artists can use lacquers, varnishes, oils, ceramic glazes, and acrylics in these brushes.

Some brands of airbrushes may offer more than one tip size in their lines of small- and large-barrel airbrushes. When changing from one tip size to another, it is necessary to change the needle and head assembly (in double-action airbrushes) or fluid assembly (in single-action airbrushes).

Most airbrushes are of the suction (siphon) type. Air passing over the opening for the fluid material creates a partial vacuum that draws the liquid up (or over) to where the air can spray it. In gravity-feed airbrushes (such as the Iwatta model in **14-4**), medium flows from a container on top of the airbrush down to where it is sprayed by the air. This kind of airbrush works on less air pressure and is less likely to clog than a suction airbrush. Still another kind, which utilizes an oscillating needle, is discussed later in this chapter. Many brands offer left-hand models that usually cost a little more.

Air guns

Air guns are larger than airbrushes and cover large areas faster. They accommodate thicker media more

easily than a large-barrel airbrush. Therefore they accommodate a broader range of media, from acrylic lacquers and oil enamels to the thinner media commonly used in the small, double-action airbrush. They normally have a pistol design with bottom-, side-, or top-mounted triggers. The simple, general-purpose air guns may have a top-mounted press-down button instead of the longer trigger.

Air guns have greater air requirements than airbrushes. They may need more air pressure and air volume. The smaller air guns can usually be run on all but the smallest compressors. The larger ones, spraying the most viscous media, may require air pressure as high as 60 pounds per square inch (with a siphon air gun) and, therefore, a larger compressor.

The small (touch-up) air gun that is a little bigger than a large-body airbrush is the kind most often used by artists. It usually has a spray pattern range of ¼ to 4 inches. Larger air guns, of course, produce more spray and larger patterns and are capable of more heavy-duty work. (**14-5** shows one medium-sized and one small air gun.) Air guns are used for broad applications and large-scale work, such as preparation of painting supports, laying in large areas of flat or gradated color, background work, murals, and large three-dimensional forms.

The simple, general-purpose types are used for light-bodied paints and other fluids of similar viscosity. These inexpensive guns are used by hobbyists and artists with simple spraying needs. The low-pressure

14-5

sprayer shown in **14-6** is used for ceramic glazes, fixatives, medium consistency lacquers, varnishes, and enamels. The more complex air guns include additional or more refined adjustments and are therefore more versatile. These include separate air and fluid adjustments and a selection of nozzles for variations in spray coarseness, size, and pattern.

In addition to factors such as kinds of adjustments and size or quality of construction, air guns differ in the following ways.

1. In siphon-feed guns, air passes over the opening for the fluid material and creates a partial vacuum. This draws the liquid up to where the air can spray it. A hole in the liquid container allows the pressure above the liquid in the container to remain constant. In pressure-feed guns, the liquid is placed in an airtight container. Air pressure from the air supply is exerted onto the surface of the liquid and forces it up to where it can be sprayed. This kind of spray gun will accommodate heavier media.

2. Bleeder guns always have the air on, flowing through the gun. The trigger controls the liquid. This kind is often used with the smaller, continuously running compressors that do not have tanks. The more common nonbleeder guns have a valve that stops the air when the trigger is released. This allows much better control of both the air and the painting medium.

3. In addition to nozzles that are designed for various spray patterns, there are two kinds of nozzles for different liquid bodies. Internal-mix nozzles combine medium and air inside the nozzle, while the ex-

14-6 Courtesy of the Paasche Airbrush Company.

14-7

ternal-mix nozzle combines medium and air just outside the tip of the nozzle. The internal-mix type is best for heavy, slow-drying paints and the external-mix is better for light, quick-drying or thinned paints.

Other airbrushes and air guns

The oscillating needle airbrush The Paasche AB (14-7) is a double-action airbrush. It works on a different principle than that behind the airbrushes explained earlier in this book. The air supply powers an air turbine. It causes a needle to reciprocate at a controlled speed up to 20,000 rpm. The needle picks up a small amount of medium at the opening of an adjustable color cup. The cup is attached to the airbrush. The paint then continues out the reciprocating needle to where a small air nozzle sprays the medium off the needle onto the painting surface.

This airbrush is used for the finest detail work. It is much more expensive than other kinds, but with it artists can draw hairlines and create accurate, small-area gradations. It is recommended as a second airbrush for areas that require unusual precision or detail, as in photo retouching, illustration, or special uses in architectural, fashion, industrial, and graphic design. It is not recommended for beginners as a first airbrush. The most common media used in this airbrush are watercolors, gouache, inks, and oils.

Flocking guns This tool is used to obtain suede to velourlike surfaces. Flock is a fine, fiber material that is blown onto surfaces that have first been prepared with an adhesive material.

Air erasers This tool is like a miniature sandblaster that blows a finer aggregate such as slow-acting powdered pumice or fast-acting aluminum oxide. The small eraser has an airbrush body and the larger one has a small air gun body. Various tip sizes are available. (**14-8** shows a Paasche A E C air eraser and a Paasche L A abrasive gun in the foreground and a Speedaire sandblasting gun behind them.)

Air erasers can remove material from surfaces without marring or smudging. In painting, they are useful for subtractive processes, retouching, and cleaning. On other surfaces, such as metals, plastics, and glass, they are used for etching and miniature sandblasting. Air erasers are commonly used by glass etchers, dentists, jewelers, and lithographers.

These tools may not always work with a continuous flow of material. With this problem, use an on-and-off technique. Also use a moisture trap (usually available where airbrushes are sold) to stop the aggregate material from clogging. Depending upon the amount and size of the work to be done, use goggles and a mask. Prepare the painting area to protect it from the overspray of aggregate material.

Airless guns These spraying tools are used by commercial and industrial painters and for household uses. They work by exerting pressure on the medium to create spray. There are two kinds. The vibrator sprayer uses an electromagnetic motor in the body of the spray gun. The motor activates an armature that vibrates, thus pushing a piston rapidly back and forth at a rate of about 120 strokes per minute.

14-8

The piston pushes paint against the tip, causing it to spray out. This paint gun is used for spraying limited areas and for touch-up work. It produces some over-spray.

The other kind of airless sprayer produces pressure with a pump that is separate from the spray gun. Paint is sent to the gun through a hose and sprayed at a very high pressure. This is for larger scale and more continuous painting use. It does not produce over-spray and can handle thicker paint.

Artists working on large surfaces may wish to use these guns. For example, the vibrator gun is useful in a spraying enclosure that is not equipped with an air supply. The regular, high-pressure airless gun, which does not produce overspray, is useful in preparing large painting supports with acrylic gesso in spaces or situations where overspray and particle fall-out are not acceptable.

Airbrush accessories

Cups and jars Depending upon the brand you purchase, your airbrush will come with a color cup, jar assembly, or both. Have a minimum of two containers: one for painting and one for cleaning. Your dealer should have a list of the cups and jars available for your brand and model. Before deciding on the size containers to buy, consider the amount of medium you expect to spray at one time and how often you will change colors.

If you are doing large-scale work and need to change colors frequently, you may wish to purchase a number of large glass jars or aluminum containers. Or, if you will work on small surfaces and frequently change colors, you may wish to use various sizes of the smaller color cups. Beginners may prefer to use jars at first so that they can forget about the problem of an open cup spilling when the angle of the airbrush is changed.

Airbrush holder A simple holder comes with most airbrushes. Better and easier-to-use holders are available. Airbrush holders are useful for protecting the airbrush from damage caused by dropping, for decreasing the incidence of spilled painting medium, and for simple convenience.

Airbrush box Although airbrushes come in small boxes, you may find it more convenient to use a larger container that will hold the tools and materials for your work. These are especially convenient if you prefer to keep the hose attached to your airbrush

during storage. When doing this, always store the air brush and hose separately from other materials and store the airbrush with the protective cap on. Many types and sizes of metal or plastic boxes are available where art, hardware, or fishing tackle supplies are sold.

Kits Various kits are available which include airbrushes and/or air guns plus selected accessories. These sets are arranged either for a specific type of spraying tool or for a particular use. The following list includes specialized uses for which some kits are prepared: automotive and related finishing, stripping, touch-up, hobby, and ceramics. There are also travel kits (with portable pressurized cans) and air eraser/abrasive air gun kits.

Maintenance and repair tools Your need for these tools will depend upon how and how much you use the airbrush, where you do your airbrush work (classroom, commercial studio, home), and on the availability of repair tools at your local supplier. You may find it convenient to put together a maintenance, repair, and small-parts kit so that you can reduce airbrush down time.

The following materials are not necessarily available or appropriate for all airbrushes. Consider your needs before purchasing these items.

1. Small wrenches for removing heads and jar assemblies on some airbrushes and for handling hose fittings; small screwdriver for the adjusting screw; flat-nosed pliers for loosening various airbrush parts; tweezers for small airbrush parts and for picking up friskets.

2. An eyedropper, cooking baster or plastic squeeze bottle with a long snout for cleaning the airbrush. (Fill with water or the appropriate cleaning liquid. Apply to the point on the airbrush where the paint cup or jar is mounted, and spray.) These may be used instead of the extra-large color cup or jar suggested earlier.

3. A cleaning reamer for cleaning and removing solid material from the needle channel and tip; tip-changing tool/three-corner reamer for removing the tip and also reaming the area behind the tip; pipe stem cleaners (small sized), cotton swabs, and bamboo shoots for cleaning.

4. Liquid cleaner for immersing the airbrush and cleaning the parts. These cleaners are of the kind commonly used to clean precision instruments. They usually include detergents and wetting agents that will loosen or dissolve foreign matter. Liquid cleaners

also work well in ultrasonic cleaners (see no. 5). Similar cleaners prepared for pens can also be used.

5. Ultrasonic cleaners for cleaning the airbrush or other small tools. Ultrasonic cleaners are somewhat expensive; however, they should be considered for airbrush classrooms or commercial airbrush studios. They clean by agitation of ultrasonic waves through fluid material (water, water-soluble cleaners, volatile solvents).

6. Lubricants and sealers. The instruction booklet for your airbrush may recommend a lubricant or sealer such as beeswax.

7. Magnifying glass for examining the tip, needle, and other small parts. The linen tester type (8 to 10 powered) works well for detail; however, lower power lenses offer greater depth of field.

8. Extra airbrush parts are a good idea to save trips to the store. It is always wise to keep one or more extra needles and tips. If you have an airbrush that will accommodate more than one size head assembly, you may want to have an alternate available, especially if you plan to use media that differ in viscosity.

Depending on your airbrush, you may find it convenient to stock a needle spring, needle lock nut, adjusting screw, or parts of the air valve assembly, especially the air valve and washer. Your needs may be different. Left-handed artists using the Paasche V L may find that they continuously loosen the finger lever. It can be set with clear fingernail polish on the threads. If it unscrews, bends, and breaks, the finger lever assembly will have to be replaced.

Air Supply

Air supply sources other than those described in this chapter are available. They usually do not work well. Old airbrush books refer to manually operated hand- or foot-powered pumps for spraying in areas where electricity is not available. You may also hear of artists or hobbyists using truck tires inflated at gas stations or the apparatus used to spray insecticides. Such sources usually are not worth the time and effort needed to use and recharge them.

The air requirements of artists vary substantially. A cake decorator may require 4 to 5 pounds per square inch (psi) of air. Normal airbrush use requires between 25 and 35 psi, and some synthetic paints sprayed with air guns may require up to 60 psi.

Your needs probably will not vary to these extremes. Still you should consider the media, tools, and situations in which you will be spraying. Consider both present and future air needs and the requirements of a continuous, even, and correct pressure. Artists with space problems or with specific and limited needs often purchase small, quiet compressors. Artists with a variety of air requirements or additional potential needs often purchase larger compressors.

The ratings on air supply sources help determine which is appropriate.

1. The number of pounds per square inch (psi) indicate how compactly air is compressed. The more air there is packed into a limited space, the higher will be the pressure that is delivered. A high psi allows a heavy-bodied paint to be sprayed.

2. Cubic feet per minute (cfm) refers to two ratings. Displacement cfm is the amount of air a compressor should produce. It is measured by the displacement of the piston or diaphragm and the speed of the pump. Free-air cfm is a more accurate rating. It indicates the actual amount of air that comes out of an air source. Free-air cfm will go down when air pressure (psi) goes up because of the resistance of air buildup working against the compressor. Because of this, free-air cfm ratings are indicated at a particular psi (for example, 2.8 cfm at 30 psi). A higher cfm allows more paint to be delivered in a given time.

Compressors

Compressors utilize a motor and pump to compress gaseous material that, when under pressure, can be used as a propellant.

Compressors are designed to produce a particular cfm at a specific psi. The horsepower (hp) rating is for the motor. For example, a ⅓ hp diaphragm compressor might be rated with a free air cfm of 3.0 at 30 psi.

The voltage ratings are important, too. Most small compressors plug into 110-volt outlets. Larger ones may be wired for 220 volts or easily convert from one voltage to the other; 220-volt wiring is less expensive to run. A motor is single- or triple-phase, depending on the design and amount of windings around the armature of the electrical motor. Most small to medium compressor motors used by artists are single phase; for greater efficiency, the larger commercial/industrial ones (such as the ones that

might be used for an airbrush classroom) are often triple phase.

Not to be confused with phases (electrical) are *stages* in compressors. A single stage compressor has only one size of chamber for compacting air. A double stage has two cylinders of differing sizes. Air compressed in the larger chamber is transferred to the smaller chamber for further compression. Most compressors used by artists are single stage and run on 110 volts, single phase. Larger stationary compressors, normally of 2 horsepower or more, might be double stage. This feature allows the compressor to run more cooly and efficiently. These industrial compressors are used in classrooms, larger studios, or shops.

Compressors may or may not include other features.

1. Artists often select oiless compressors with permanently lubricated bearings for easier maintenance and no oil in the airline. Be sure to service as directed.

2. Air filters should be changed or cleaned as directed.

3. Medium- and large-sized compressors are usually combined with a reserve (storage) tank. This allows air pressure to build up in the tank when the compressor is not being used or is not under heavy use so that pressure can be gradually released as needed. Reserve tanks should be drained of water periodically. The amount of water condensation in tanks varies according to amount of use and the amount of humidity in the air from which the compressor draws.

4. Compressors with tanks have automatic on/off pressure switches. For example, the motor might turn on when the tank pressure is down to 95 psi and then build up to 125 psi before turning off. Compressors without tanks simply turn on when plugged in or via a manual switch. These run continuously while being used. Foot-operated switches or one that is placed in the electric cord can be installed for these compressors.

5. Compressors include valves that control air direction and buildup. Check valves allow air to flow only from the pump. Unloader valves discharge pressure in the air lines so that the compressor does not have to work against pressure when it starts again. There are combined check and unloader valves. **Relief (also called pop-off or safety) valves release excess pressure in the tank.** Compressors without tanks are normally equipped with an air bypass to vent excess air. These air bypasses are factory-set on some brands and adjustable on others.

Additional factors may also contribute to the selection of a compressor. Noise level is important for those who must work in the same room as the

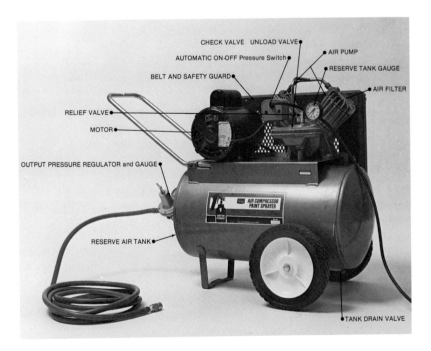

14-9

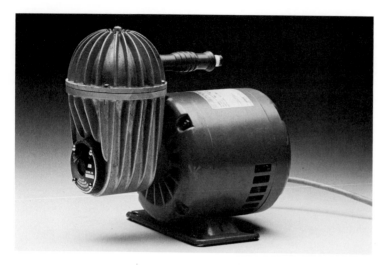

14-10

compressor or close to others whom the noise might disturb. The actual size or weight of air supply equipment may be a factor for artists with space limitations or those who need to move the compressor to different locations. Artists who must have a portable air supply should also note the availability of wheels and handles.

Piston compressors These compressors use one or more pistons to compress air (a 1 hp piston compressor with tank is diagramed in **14-9**). The larger, more durable compressors are piston operated, although piston compressors come in many sizes. These compressors are recommended for artists who need a continuous, long-term air supply; they also meet the greater air requirements of air guns and large-scale work. They may require more maintenance than diaphragm compressors.

Diaphragm compressors These are usually smaller, lighter, quieter and less durable than the piston compressors. They range from $1/10$ to $1/2$ hp (**14-10** shows a $1/4$ hp model). Although the diaphragm can go out, it is easy to replace. The smallest ones are used by hobbyists, with single-action airbrushes. Diaphragm compressors usually are designed without tanks, although some are available with tanks.

Artists should use at least a $1/8$ hp compressor with a small-barrel, single-action airbrush. Use $1/4$ hp or larger compressors for large-barrel airbrushes and heavier fluids. Artists using small touch-up air guns should review their air requirements as stated by the manufacturer. Some state that they can be used with small compressors.

Pressurized containers

Use caution when handling containers whose contents are under pressure. Do not puncture, drop, or otherwise damage pressurized containers.

Carbon dioxide tanks Compressed carbon dioxide in heavy metal tanks is a traditional alternative to air compressors (**14-11**). Tanks offer the advantage of a quiet, clean supply of pressure requiring no electricity. Their disadvantage is the expense and time

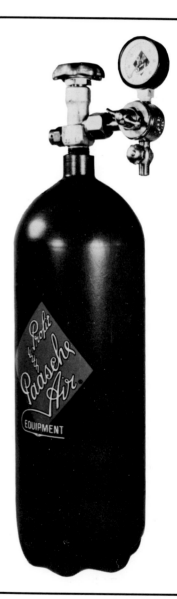

14-11 Courtesy of the Paasche Airbrush Company.

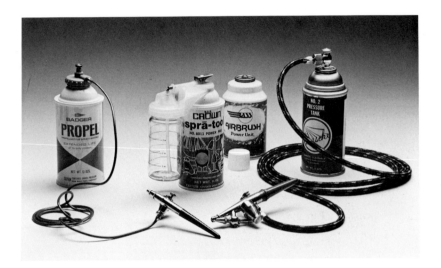

14-12

needed to refill them. Those who use tanks on a continuing basis are recommended to purchase a 15-pound tank that can be exchanged for another refilled tank. Tanks may be purchased and refilled (you keep the same tank), or may be rented (20- or 50-pound tanks) and exchanged for refilled tanks. The tanks must be tested every five years. It is normally best to obtain tanks and get refills from the same supplier. Aluminum tanks are lighter than steel ones.

Welding equipment and supply outlets seem to be the most common source for refills. When looking for outlets in the Yellow Pages, you can also look under the headings of "Gas—industrial & Medical Cylinder & Bulk" and "Fire Extinguishers."

These tanks are outfitted with a regulator and gauge for measuring and controlling the pressure leaving the tank. Get the correct fittings for different tanks (scuba, diving, fire extinguisher) and for different gases.

Other metal tanks When tanks other than carbon dioxide tanks are used, be sure that approved and safe propellants are used and that tank pressure specifications are adhered to.

Pressurized, nonrefillable cans (tanks) Pressurized cans **(14-12)** are sometimes useful in situations requiring portability, speed, and convenience. This propellant source can only meet limited air supply requirements and should be used when other sources are not available. These replaceable tanks are advertized as providing one to two hours of air (propellant) depending upon airbrush size and type of work. They are not recommended for artists needing a continuous air supply. They may be a convenient air supply for hobbyists whose airbrushing needs are restricted to limited spraying (for example, on models or stencils). Kits are available that include an airbrush (be sure to get the one you want when you buy the kit), pressurized cans, on/off air valve, hose, color cup, and jar assembly.

Various kinds of paint that use volatile solvents are available in spray cans. They can be quite useful to the artist or hobbyist with limited and simple uses for spray (flat colors or simple gradations) or a special need for a medium different from that normally used.

Air supply equipment

Hoses Select the proper length, thickness, and hose fittings for your needs. Small, hobbyist, single-action airbrushes sometimes use $\frac{1}{10}$-inch inner diameter (ID) hoses and most artists using airbrushes choose $\frac{1}{8}$- or $\frac{5}{32}$-inch (ID) hoses. The air compressor connections for these two sizes are usually the same; however, $\frac{1}{4}$-inch "pipe" thread sizes between airbrush brands may be different. The air guns used by artists usually use $\frac{1}{4}$-inch ID hoses and $\frac{1}{4}$-inch pipe connections.

Try to determine the best length for your work instead of combining a number of hoses. When a small-diameter hose is used at some distance from the air supply, a heavy-duty $\frac{1}{4}$-inch ID hose may be necessary. This hose will withstand some abuse. Large-diameter hoses are also used to minimize pressure drop.

14-13

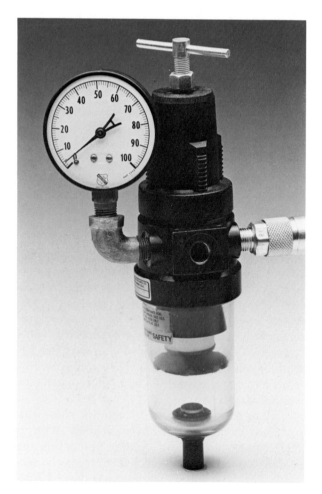

14-14

14-15

Quick connector couplers These fast-release devices **(14-13)** allow you to change hoses quickly and easily. There are many coupling configurations, so it is important that the ones used at one site be matched with the couplings at another site planned for use. Students should keep this in mind if they plan to work both at school and at home.

Teflon tape Leaky air hose connections can be sealed by wrapping strips of Teflon tape around the threads of the fittings **(14-14)**.

Hose adapters Airbrush-to-hose, hose-to-hose, and hose-to-air-supply adapters are available.

F fittings With these attachments to the air line, two or three airbrushes can be run off one air supply source separately or simultaneously.

Gauges, regulators, and filters These may be purchased individually or in combination: gauge/regulator and gauge/regulator/filter **(14-15)**. Your dealer can outfit you with the appropriate sizes or kinds for your needs.

Gauges are used to indicate tank pressure or the regulated pressure that is released to the air tool. Pressure regulators are used to control the pressure to the air tool and pulsating air from compressors without tanks. These valves can be connected at the air supply source or at any point in the air line. Regulators are also designed for carbon dioxide tanks.

Filter/moisture traps collect water that has condensed from compressed air. They also collect oil, dirt, or dust particles that can cause problems when

sprayed. Filter/moisture traps are attached between the compressor and the airbrush. This attachment is important in situations where non-water-soluble medium is being sprayed because the condensed water is incompatible with vehicles used for thinning and may cause erratic spraying. If any foreign material works through the system, it may be spit out the airbrush and damage your work.

Miscellaneous Supplies

Protection from spray

Respirators Respirators are used to prevent the inhaling of harmful particles or fumes. The degree to which particles and fumes are in your breathing space will determine whether you wear a respirator at all, use a simple mask, or wear a respirator that allows only filtered air to be inhaled. Water media that place only particles in the air require masks with a simple filter. Media that include volatile solvents require the additional use of a cartridge that will absorb fumes. (Particle respirators are seen in the foreground in **14-17**; the respirator in the back at the right is for use with medium to heavy spraying; the one at the left is for use with media that include volatile solvents.) Some considerations in purchasing respirators are: comfort, ease of movement, especially in looking down at your work; ease of replacing straps,

14-16 Small in-line moisture trap.

filters, and other parts; ease of wearing glasses or goggles with the respirator.

Goggles These should be used with air erasers or any medium that may irritate your eyes.

Drop cloths Whenever there is heavy spraying in your studio, consider the use of plastic or fabric drop cloths in areas you wish to keep clean.

Air attachments

Blow guns These are useful for cleaning and dusting your studio.

14-17

14-18

Inflator attachments Air chuck, needle, and tire gauge attachments make your air source useful for inflating tires, air mattresses, balls, and toys.

Auxiliary tanks Sometimes a separate portable tank is necessary to provide limited air needs.

Paint preparation

Viscosity cup A viscosimeter may be used to measure the correct paint thickness for spraying media used in air guns. Medium is placed in the cup and then timed as it drains. Thinner is added to bring the medium to the correct dilution for spraying. The viscosity cup includes timing and dilution information.

Paint strainers When preparing large amounts of paint for spraying, you may want to pour the di-luted medium through a strainer to remove particles that could clog the airbrush or air gun. This is especially important with the large quantities of paint used in air guns. Paint strainers that slip over the bottom of the fluid tube of air guns are also useful for stopping solid or undiluted material from entering the air gun **(14-18)**.

Power erasers

A power eraser is essentially a small motor and holder for a long, pencil-like eraser. The spinning eraser is very useful as a cleanup, retouching, or subtractive painting tool. Its effect is different from that of the air eraser; therefore, some artists use both. A variety of erasers with different abrasive qualities can be purchased in art stores.

Chapter 15 **Cleaning and Maintenance of the Airbrush**

Airbrush artists should recognize that the airbrush should always be maintained in optimum condition. A finely functioning tool contributes to better work, more precision, and faster operation. Develop a feeling for how your airbrush works when it is in perfect condition; this will allow you to respond to or anticipate problems.

Cleaning

Improper cleaning seems to be the most common cause of problems faced by airbrush artists. It is important to learn how much cleaning is necessary.

In normal use, spray clean water (or other appropriate solvent) through the airbrush after each painting sequence. This cleans the airbrush and limits the buildup of residue. When airbrushing, keep an extra color cup or water jar assembly near by, so that water (or other solvent) is always available. Never let the airbrush stand uncleaned. Even if it sprays reasonably well, hard-to-clean residue may build up. Do not use hot water in airbrushes that have wax seals in the head assembly.

Occasionally clean the airbrush by forcing air backwards into the jar or color cup. With some airbrushes, you can safely do this by placing your finger in front of the airbrush. Move your finger back and forth to create an intermittent backward air flow **(15-1, 15-2)**. Then remove any particles that have been loosened.

The above method is unsafe with airbrushes that have a protruding needle point, unless the needle is withdrawn. As an alternate, safer cleaning method, squeeze the airbrush tip between the thumb and forefinger intermittently. This method is most apt to work with airbrushes that have crown-shaped font surfaces on the spray regulators.

Keep the color cup clean. Remove excess paint after running water (or other solvent) through the cup. Clean out dried paint with a wet, round-bristle brush.

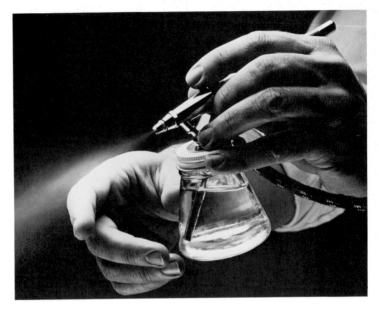

15-1

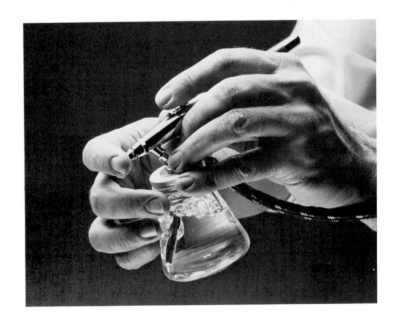

15-2

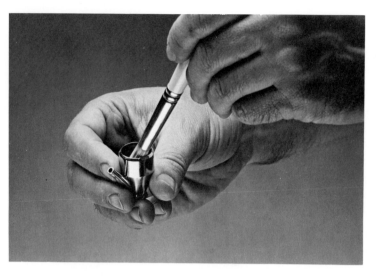

15-3

The small hole on the lid of assembly jars some-times clogs. It must be kept open for proper func-tioning.

After you finish your work, you may want to remove the needle and clean it before storing the air-brush. Remove any excess medium and then place the needle back in the airbrush so that the point is past the finger lever but before the tip. In this position the needle stops the finger lever from popping out and does not allow any residue of medium at the tip to stick to the needle.

Special Cleaning

Special cleaning procedures are occasionally neces-sary. Although the airbrush should stay clean with normal procedures, the following parts may need specific attention on occasion.

The tip A reamer can be used to loosen hardened material at the tip **(15-4)**. Be sure to use the proper size and brand. After inserting, turn it while exerting only a slight amount of pressure. The reamer should be used very sparingly and carefully so as not to flare, widen, or split the tip. Tips with threading should be reamed by turning right to left. Some brands also include a back reamer designed to loosen material farther back along the needle channel.

The needle Stains on the needle can be removed by first placing a pink pearl eraser on a hard surface and then running a needle along it in the direction opposite the point **(15-5)**. Revolve the needle as you do this. Remember that the point can be damaged very easily. Remove loose material from the needle before placing it back into the airbrush.

The color cup or assembly jar For a more thor-ough cleaning of the color cup, try the following pro-cedures. After filling it to the brim with water, place your thumb over the top, press down, and vigorously force water out through the stem **(15-6)**. Repeat this procedure several times. Remove the color cup bot-tom cap if there is one, and clean out any material in this area. Clean out any obstructions in the stem of

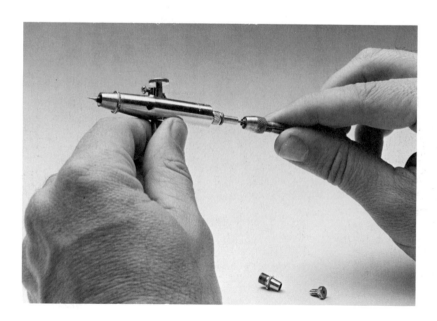

15-4

15-5

the color cup or assembly jar with a flexible wire **(15-7)**. To see if the stem is clogged when the airbrush will not function properly, bypass the assembly jar or color cup by spraying water through a different one or inserting water in the airbursh with an eyedropper.

The spray regulator Do not allow paint to build up on this post. The spray regulator should be removed from small-barrel airbrushes before cleaning it with a moistened cotton swab. Do not damage this part by using a metal implement.

Maintenance

Information for your airbrush is usually in the material accompanying the airbrush when it is purchased.

Some companies also sell inexpensive booklets that include this information. Review this material for any specialized procedures not covered in this section.

The airbrush is a fine precision instrument. Study your airbrush's parts and learn their functions. Once you understand what each part will do and what will happen if something goes wrong, you will be able to respond quickly to problems. If the airbrush is clean, in good repair, and if all parts are in proper alignment or properly adjusted, it should operate correctly. However, if it will not work properly and you have done what you can, send it back to the factory or to a reputable repair service instead of continuing to use a poorly functioning tool.

With the use of the appropriate chart you should be able to assemble and disassemble your airbrush

15-6

15-7

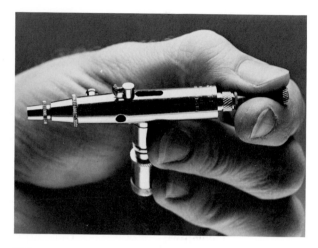

15-8

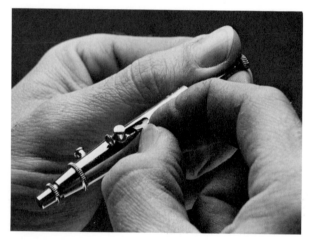

15-9

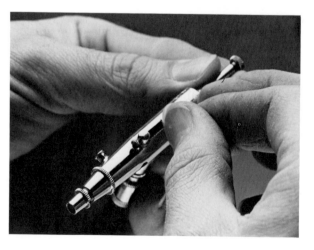

15-10

without too much difficulty. One exception is the finger and auxillary lever, which must be in place before the needle is positioned. The finger lever must fit into the top of the air valve assembly. The auxiliary lever is difficult to replace in airbrushes where it is a separate part. Because airbrush companies may design their airbrushes somewhat differently, this part may be easier to assemble in some models or brands than in others. The following example is given to show how complicated this procedure can be. In such airbrushes as the Thayer & Chandler, this part can be replaced in the following manner.

1. With one hand, hold the needle support back by pulling back on the needle locknut **(15-8)**.

2. With the other hand, hold the top of the auxiliary lever and place it lengthwise along the inside of the airbrush body **(15-9)**.

3. Turn the auxiliary lever back and around to its proper position crossways at the back of the slot **(15-10)**.

4. Hold the auxiliary lever back with your thumbnail and then release the needle support **(15-11)**.

5. Put the finger lever in **(15-12)**.

6. Remove your thumbnail from the auxiliary lever so that the lever makes normal contact with the finger lever **(15-13)**.

7. Make sure the channel is clear by putting the needle in backwards through the channel before installing it in its normal position **(15-14)**.

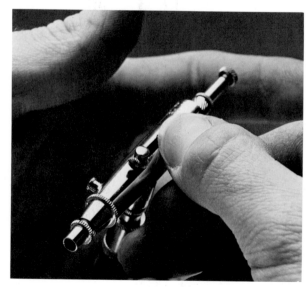

15-11

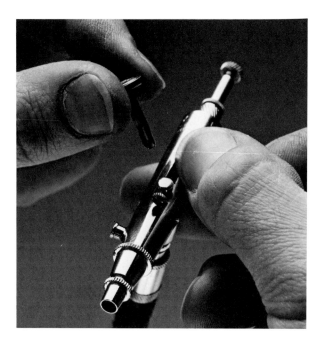

15-12

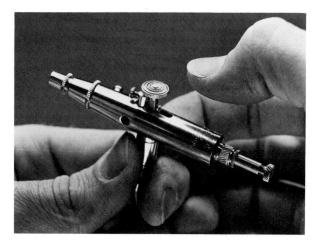

15-13

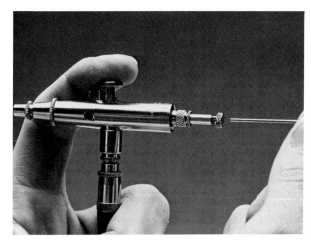

15-14

Before removing the needle in a double-action airbrush, you may wish to follow a simple procedure to stop the finger lever and/or auxiliary lever from falling out of the airbrush body. Press the finger lever down and back against the auxiliary lever and then hold them there with a piece of masking tape **(15-15)**.

The needle

Keep the protective cap on when the airbrush is being stored. Note that with some brands the needle actually protrudes beyond the spray regulator when the needle is in the screwed in position.

Your airbrush needle is precisely shaped for optimum spraying. It is to your advantage to keep it straight and sharp and to retain the length of the fragile point.

The needle can be damaged easily in the process of putting it in or removing it from the airbrush. Use very deliberate movements when putting the needle in so as not to bend it by hitting the back chuck. You may also want to pass the needle backwards through the airbrush past the finger lever to be sure that the channel is clear (the finger and auxiliary lever can become displaced when the needle is removed). A bent needle can damage the tip if you remove it before doing some straightening.

15-15

15-16

If the needle becomes stuck in the airbrush, remove it with pliers **(15-16)**. With airbrushes that have screwed-on tips, this should be done while turning counterclockwise. Be sure that the material causing the sticking has been removed before replacing the needle.

Periodically examine the needle and tip with a magnifying glass to be sure they are not damaged. Consider corrective procedures before replacing damaged needles. The needle can be straightened by placing it on a hard smooth surface at an angle consistent with its taper. While turning, stroke toward the point with your fingernail until any bends are

removed and the needle is straight **(15-17)**. Check the needle again with the magnifying glass before putting it back in the airbrush.

After straightening, needles can be sharpened with a fine-textured honing stone **(15-18)**. Do this only if the needle is in relatively good shape. Sharpen by pressing the front of the needle down with the index finger of one hand and turning from the back of the needle with the other.

The tip

Tips are easily damaged. The force of the needle against the tip can cause it to flare outward, thus enlarging the tip orifice. The needle and tip are designed to fit precisely. This size change, therefore, can limit functioning: as you trigger, the airbrush may spray suddenly instead of allowing you to ease into the spray pattern. The force of the needle next to the tip can also cause a split in the tip. This may cause spattering, a change in the direction of the spray, and a loss in spray pattern precision.

Dents or changes in alignment of the tip are normally the result of careless handling. In addition to altering the spray pattern, this can also cause medium to flow through when only the air is on and it can cause spattering and a change in spray direction.

The tip may be hard to remove (to unscrew or dislodge from other parts). At first, try to move it with a reamer and a gentle turning motion. **(15-19)**. If there is a wax seal, heat the joint. For airbrushes with wax seals, a back reamer turned clockwise may produce more torque. Finally, if all else fails, the tip can

15-17

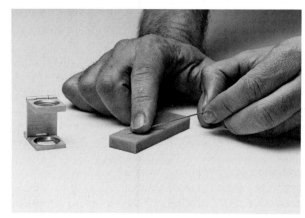

15-18

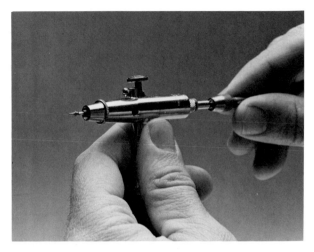

15-19

15-20

be easily removed with pliers **(15-20)**. This, however, ruins the tip.

Sealed and lubricated parts

Care should be taken in using the threaded parts of the airbrush. They strip easily because they are small and because they are often made of soft metals.

Well machined and maintained fittings produce fewer air leak problems. With larger ones, such as hose fittings, Teflon tape can be used to stop air leaks. With smaller ones, petroleum jelly or unheated beeswax can lubricate and limit leaking.

Some airbrushes require tip and head beeswax seals. These seals are already set when the airbrush is purchased. They should, therefore, be resealed when parts are replaced or when they appear to be leaking. After heating the tip with a match, unscrew the tip with a reamer. Apply a small amount of wax to the threads; too much will cause a buildup that can limit spraying. Heat only enough to melt the wax **(15-21)**. Turn the airbrush to promote equal heating around the joint, then screw the part in. Trim away any excess wax that might limit spraying.

Small amounts of oil or petroleum jelly may be applied to a few parts. Note the areas where friction might occur, such as where the finger and auxiliary levers come together or at the friction spot on or connected to the needle support. A little oil on the needle spring is advisable. Small amounts of petroleum jelly can also be applied to the end of the finger lever, the needle, and the valve plunger.

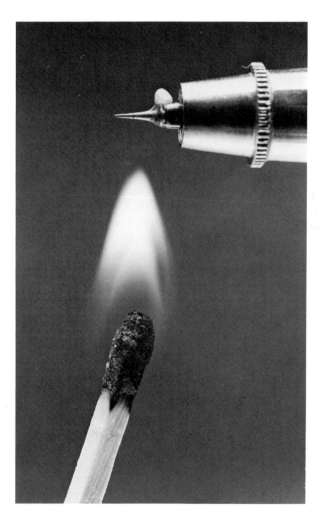

15-21

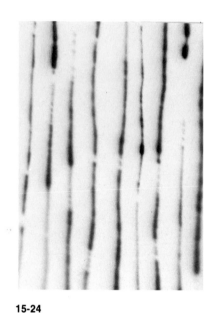

15-22 15-23 15-24

Troubleshooting: Double Action Airbrush

This section focuses on double-action airbrush problems because this kind of brush is used in the projects in this book. This airbrush is also the most common one used professionally. If you use another airbrush or an air gun, this section will still be useful. The basic problems described apply to most air painting equipment.

Grainy spray Grainy spray **(15-22)** and stippling refer to relatively even patterns; however, stippling has heavier dots. Causes may be: (1) thick paint; (2) low air pressure; (3) dried paint on the needle or spray regulator; (4) a bent needle; (5) spray regulator screwed in too far (for airbrushes using a regulator instead of an air cap). The first two causes can be used to create this effect if desired.

Spatter Spatter **(15-23)** is a random pattern of dots of varying size. Spatter can be caused by: (1) a bent needle or aircap; (2) by dried or semidried paint at the tip or on the needle; (3) because there is usually some residue at the tip, allowing the needle to snap back may also cause spattering (as well as a split tip). Keep the airbrush very clean at all times. Run water through it before putting it down. Before spraying your painting, spray on a practice sheet; (4) small parts of residue or improperly mixed painting medium located in the airbrush color cup or jar assembly may also create problems. Try to make sure this residue does not build up. When it does show up

in the color cup, jar, or on your palette, remove it; (5) spatter can also be caused by contaminants in the air lines. Filters between compressors and the hose will stop this problem.

Reduction of spray If, while you are spraying, the spray suddenly or gradually diminishes, either the airbrush was not clean when you began or you are trying to complete too much small-area spraying without cleaning in the midst of working.

Sudden spraying While you are spraying there may be a sudden increase of spray. Or, you may pull back on the finger lever and get no response at first before the spray begins. This normally happens when the buildup of painting medium at the tip restricts or stops the flow. The spray then rushes out when this obstruction has been cleared. Another cue for sudden spraying is a flared tip. A tip will flare out at the point if the airbrush needle is constantly pressed too hard against it.

Restricted spray When the air brush sprays but will not produce the amount of spray it should, consider the following causes; (1) the paint may be too thick; (2) the airbrush may not be clean; (3) the spray regulator may be screwed too far in or out; (4) the air pressure may be too low or high.

Intermittent spray Instead of a continuous spray you may get a repeated on-and-off or sputtering response **(15-24)**. (1) The tip or needle might be dirty (notice the spongy feel when you pull the finger lever); (2) the inside passages of the airbrush may

have one or more small particles clogging them: repeated cleaning may be required to dislodge these particles; (3) air may be leaking at the joints of parts (check any parts that may have broken beeswax seals); (4) there may be a problem in the area of the air valve; there may be a lodged particle, a part may be out of adjustment, or the 0 ring may need to be replaced.

No spray If you cannot get spray when you repeatedly pull back on the lever, it may be because of: (1) a loose needle locknut; (2) the spray regulator is screwed too far out or in; (3) thick paint; (4) too much or too little air pressure; (5) clogging in the stem of the airbrush color cup, or jar assembly; (6) the needle spring is too tight (notice that the auxiliary lever will be loose when this happens). Unless mechanical problems are easily apparent, try spraying water through the airbrush before making adjustments.

No air If there is no problem with the air supply to the airbrush, there may be (1) a clog somewhere in the air channel; (2) a problem with the air valve assembly (such as the valve nut not being screwed in properly); (3) the finger lever may be jammed or worn.

Change in direction of spray Symmetry in the shape of the needle, tip, and spray regulator and in their alignment is important. Therefore, this problem can be caused by: (1) a bent needle; (2) a bent or split tip; (3) a bent spray regulator; (4) worn threads on the spray regulator (to the extent that it moves back and forth).

A problem with these parts can also cause a distorted spray pattern or limited overspray. For example, a dull needle will produce a larger spray pattern and a bent needle will deflect spray to produce an odd-shaped pattern.

Bubbles through jar or color cup (15-25) Air is being redirected back into the jar or color cup because: (1) the spray regulator may be screwed too far out or clogged with paint; (2) the seal may be broken on airbrushes using beeswax at the tip; (3) the head seal is missing; (4) the head is not on tight.

Air leak through the tip If the valve washer is not sealed properly, some air may leak out through the tip when the airbrush is in the off position. This can be checked by standing the airbrush on end and placing a drop of water on the spray regulator. If it bubbles, there is a leak.

Spray cannot be turned off If the finger lever is pressed down and the airbrush emits some spray even though the front lever is not pulled back, the needle is not properly resting against the front of the tip. This may be because: (1) the adjusting screw is in; (2) the needle has been improperly set by the needle chuck; (3) the tip is dirty; (4) a particle is lodged in the tip; (5) the tip is damaged.

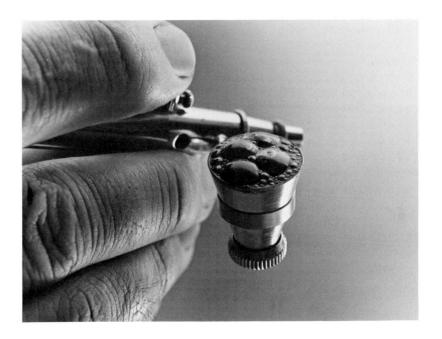

15-25

Chapter 16 **Painting Surfaces and Supports**

Painting supports are the physical material and structure on which painting media are applied. They may be objects with other functions, such as walls, clothes, and vehicles; or they may be specially prepared surfaces, such as a painter's canvas. It is particularly important to use the appropriate support for finished airbrush work.

Sprayed surfaces pose special problems because the uniformity of the sprayed layer shows even minor variations caused by scratches, dents, lint, particles, oil smudges, and other imperfections. This is usually not true with the layers of varying thickness or coarse texture that have been applied with a brush. Because of this, excellent craftsmanship is important in preparing support surfaces and utmost care should be exercised in preserving them.

In some areas where spray is used, the nature of the support may be predetermined. Examples of this are hobby uses, such as model-building; decorative applications, such as cake decoration; fabric design, such as spray on T-shirts; product-related uses, as with vans or surfboard decoration; or commercial uses, such as sign-painting. In these situations, it is necessary to understand the properties of the surface, what the appropriate painting medium should be, and whether any surface preparation is necessary.

In other areas, a specific ready-made support may be appropriate. For example, in some areas of graphic design, cold-press illustration board will meet your limited needs. In such areas as fine arts painting, you may have to select or prepare painting surfaces that meet rigid requirements. With supports that are designed for art uses, factors other than the quality of materials or construction may come into play.

- Is a heavy-duty structure necessary for the support? What about related factors such as rigidity/flexibility, weight, strength, and size?
- What degree of durability or permanence is necessary?
- What adhesive quality is necessary? Is a smooth surface required or is a coarser texture needed?
- Is some porousness desirable?

Support Materials

Spray is applied to a broad range of supports and surfaces in art and art-related fields. Only a limited number of those that are commonly used can be presented in this general discussion.

Papers and light boards

Have plenty of extra paper around for practice. Various white, smooth, and reasonably firm papers or light boards may also be used for student work. For finished work, the most common supports are medium- or heavy-weight cold-press illustration board, three-ply, kid-finished bristol board, and 300-pound cold-press watercolor paper, which is commonly used by watercolorists who do not mind the coarser texture. These surfaces should be heavy enough that they do not buckle under normal use. You may want to note the rag (cotton) content of the grade you select; 100 percent rag content is best but is also more expensive. The degree of rag content can be important in finished work because of long-range permanence and because any yellowing of the surface under transparent layers of medium will alter the perceived color. Over long periods of time, there should be minimal, if any, discoloration of 100% rag content paper.

Fabrics

Fabrics have the advantages of being flexible, strong, and lightweight. Depending upon the size, density, and material of the fiber, they have varying degrees of texture, weight, strength, and absorbency. Imperfec-

tions and coarse textures show through sprayed layers; fine, even-textured materials are suggested unless you wish to show these rougher qualities. Artists working on prepared supports should use good grades of cotton canvas, or better yet, a tightly woven linen. Before purchasing, check these fabrics for imperfections that may show.

Normally it is easier to work with fabrics when they are flat, preferably stretched over a hard surface. This is especially true when the fabric is to be prepared with gesso that will be sanded, if a metal straight edge is to be used (the end may dig in), or if some masking techniques are to be used (the putting-down and pulling-up of tape can warp a fabric surface that is simply stretched over stretcher bars). Natural fabrics such as cotton or linen canvas can be made taut again by wetting the back side and allowing the material to shrink back.

To avoid these difficulties artists may stretch fabric over thin, reinforced plywood or composition board. The finished painting can then be left on the board or removed and restretched over lighter stretcher bars.

Before selecting the medium to be sprayed onto fabrics, be sure you understand the compatibility of one to the other. The colors should be permanent and you should be able to clean the surface after the work has been completed. For example, note which dyes are used on different fabrics and how the dyes can be made colorfast.

Artists work on both untreated and treated fabric (prepared with materials like acrylic gesso). Artists working on untreated fabrics should note the absorbency and texture of their material and recognize how the color of this ground is an influence on overlaid colors. Colors that are absorbed into the fabric may appear dull.

Hardboard supports

Usually, thin plywood or composition board (pressed wood) is used by artists who want a hard surface and a more substantial support. When properly prepared, they provide an even, flat surface that allows easy masking and is free of distractions such as buckling. For artists interested in long-term permanence, it should be noted that boards tempered with oils, such as Masonite, may eventually cause problems. Even so, the medium tempered board (lower in oil content) is frequently used by artists.

Before applying gesso to hardboards, lightly sand the surface. Then wipe the surface clean with a sponge or cloth that has been dampened with isopropyl alcohol or a combination of water and a little vinegar.

Smooth, nonporous surfaces

It is necessary in some art or art-related areas to work on such surfaces as metals, glass, and plastics (acrylics, polycarbonates, cellulose acetate butyrate, styrene, vinyls, etc.). Art stores and paint dealers can provide information on the correct media for specific surfaces of this type. Acrylic lacquer is probably the medium most widely used on nonporous surfaces; however, formulations vary for different surfaces and conditions.

Uses of other paints are too varied to describe in detail here. There are paints and inks for vinyl surfaces; elastometric lacquers may be used for more flexible surfaces; and polyurethane enamels are used to resist chemical impact or abrasive elements that would damage other paints. Animators and other artists working on transparent overlays may use special gouache formulations that can be used over clean, unprepared acetate. They are available in a water-resoluble base or in a waterproof vinyl acrylic copolymer that can be removed with isopropyl alcohol.

Before spraying, learn the proper procedures to clean surfaces (often with isopropyl alcohol), inhibit oxidation, assure proper adhesion, and reduce surface tension. When airbrushing media are purchased, the accompanying written material usually provides this information.

Preparation of the Support

Construction of the support

Throughout this book there has been constant reference to the evenness, clarity, and precision of sprayed surfaces. If you are inexperienced at this, you may wish to consult references on how to work with the support materials you choose. With wood and wood products, review sources on carpentry, woodworking and cabinetry. The following points will help in constructing supports specifically for spraying:

1. Double check your measurements; carefully draw sharp lines; and be sure of your right angles. (See figure **16-1**.)

2. When cutting the support, be sure the blades you use are sharp. Cut with the appropriate side of the support up so that the sharp edge will be on the side to be sprayed. Carefully follow drawn guidelines. Do not rely upon the guides on paper cutters or saws to guarantee precision; and be sure that material is secured tightly before cutting.

3. Use straight and uniform materials to reinforce supports. Canvas stretcher bars should be beveled on the side facing the front **(16-2)** so that stretcher creases are minimized on the canvas. The corners should be mitered, preferably with a tongue and groove cut. Reinforcement of board supports (cradling, **16-3**) increases the strength and rigidity of the support, minimizes warping and impact damage, and provides a surface for attaching framing, hanging or other hardware.

4. Recognize that finishing of joints is important in preparing supports.

5. Materials used to fill in cracks, dents, holes and other impressions on the support surface should be compatible with the material of the raw support and the first layer of medium that will cover it.

6. Minor forming may be necessary on edges, corners, or other contours of supports, especially those which are more three-dimensional.

7. Sanding is usually the final step in forming the support. Select the proper sanding material for the material of your support.

Distinguish between joints that will show and those that will not. Those that will show should be finished so they do not distract. In connecting joints, carefully note the level of joint surfaces, proper angles, and the size of cracks or spaces. For surface areas that will be observed, note any visible materials used to secure the joint, remove any excess glue, and properly fill and sand cracks.

The following is one method of stretching canvas over stretcher bars or boards:

- Mark the halfway point on all four sides of the support.
- Place the canvas face down on a surface with the stretchers or boards on top. Align the canvas so that the weave lines-up vertically and horizontally with the borders of the boards or stretchers.
- Tack the canvas first at the center of each side and then work toward the corners. Complete only a part of each side at one time so that the tacking progresses at about the same rate on each side.
- Use canvas pliers or your hands to stretch the canvas taut, but not so tight that wrinkles develop around the tacks **(16-4)**.
- When the sides of the paintings will be displayed, tack the canvas to the back instead of the sides.
- At corner joints, carefully fold stretched fabric so the visual effects of layers and creases are minimized **(16-6, 16-7)**.

16-1

16-2

16-3

16-5 Masonite scraps make good corner braces for large stretcher bars.

16-4

16-6

Materials used to fill in cracks, dents, holes, and other impressions should be compatible with the material of the raw support and with the first layer of medium that will cover it. The greater the area to be filled, the more you need solid material in the filler. For scratches, a primer surfacer might be appropriate but putty would be necessary to fill a hole. In selecting a filler, consider spreading, adhesive, and sanding qualities. A glazing putty has less solid material and, therefore, spreads more easily than a spot putty used to fill larger areas.

Use enough filler material so that after drying and shrinking there will be excess material to sand off. It is the sanding that matches the filled area with the level of the support.

Allow filler to dry thoroughly before sanding. Because of shrinking, additional layers may be required. It is difficult to use filler material over flexible supports. Because of its high solid content, filler tends

16-7

to crack when bent. On flexible surfaces, it is usually best to use a number of layers of a ground material like acrylic gesso (or gesso with added acrylic gel or medium to make it even more flexible).

Minor forming may be necessary on edges, corners, or other contours of three-dimensional forms. For example, you may want to sand the sharp edges and corners of a composition board support so that they are slightly rounded. This gives a more even transition from the front to side planes. Sanded edges and corners will not damage easily.

More substantial shaping may be necessary with three-dimensional forms. Heavy fillers or putties may be used to re-form damaged areas. You may start with cutting tools, rasps, or files; to finish the surface for spraying, you will probably have to use power or hand sanding tools.

Sanding is usually the final step in forming the support. Select the proper sanding material for the material of your support. Regular garnet paper is appropriate for wood, wet or dry paper is best for materials that will clog, and emory paper is used on metals. To remove and roughen surface material evenly, it is usually best to sand in one direction and then cross-sand. To develop a scratch-free surface, begin with heavier weight papers and then work down to the finer grades for the smoothness or tooth you wish.

The support surface

Grounds are the surfaces over which the painting is applied. The ground may be the material of the support or another intermediary substance, between the support and the painting medium, that prepares the support surface.

These undercoats may be unnecessary on some supports and in some situations. Artists working on papers, light boards, and fabrics may not need to use undercoats for their grounds. They may plan only limited, short-term uses for the work; the surfaces may be protected in another way; or the material of the support may be compatible with their painting medium. In planning the ground you will use, consider the following points.

1. Decide on the degree, if any, of absorbency appropriate, and determine what the effect of this quality will be. Also note any problems of adhesion on a nonabsorbent material. On the other hand, recognize that a material like raw cotton fabric may soak up too much medium, and therefore, waste paint or make colors appear dull.

2. When undercoat grounds are used between the support and the painting medium, be sure that compatible media are used. This will prevent problems of adhesion, bleeding, cracking, etc.

3. Determine the kind and amount of surface texture desirable. Establish whether you want a smooth surface, or a little tooth to stop beading. If you want a coarser texture to show, select the degree of surface texture that would be best as well as the nature of the surface pattern (brushed, woven, pebble, etc.).

4. Note that the color of the support surface or any undercoats will influence all but the most opaque layers placed on top. This is especially important for artists who use transparent applications in their work. Even artists who prepare their grounds with acrylic gesso will sometimes spray an added coat of a truer or brighter white or the white they use to mix their colors.

Be sure that the surface is clean and that any residue from the cleaning agent is removed before applying media. Some surfaces must be treated with a proper conditioner to counter such factors as acidity, oxidation, and salts. Surfaces such as illustration board, watercolor paper, and canvas may be clean and ready to use when purchased. If handled in stores or stored improperly, they may have oil or dirt on them that must be removed.

Before spraying, view the support at an angle in a strong light to check for surface variations. Replace surfaces with problems that cannot be repaired or cleaned. In cleaning, use cloths, Kimwipes, or other materials that are lint-free. The appropriate cleaning technique will depend upon the surface material. Consider the following examples:

1. On paper surfaces, dirt can be removed with an appropriate eraser. If you erase too hard with an abrasive eraser, the marks will show after spraying. Kneaded and white vinyl erasers work well on many smooth surfaces used with airbrushes. On acrylic gesso or canvas, water and a mild, nondetergent soap can be used. Normal handling of papers or light boards in an art store may also produce a scratch or other abrasion that will not become visible until after the surface has been sprayed. Examine closely before buying.

2. Wax, oil, or grease (as well as static electricity) can be removed with an appropriate solvent that

does not itself leave a residue or damage existing surface materials. Cleaner/removers are available for lacquers and enamels, and the nonporous surfaces to which they are applied. Isopropyl alcohol is commonly used on these surfaces. For artists working on paper and gesso surfaces, rubber cement thinner and isopropyl alcohol work well. However, notice that the isopropyl alcohol will remove more of the acrylic surface. Normal handling may also leave on the surface the natural oil from someone's hands. This, too, may not show until after spraying. These oil marks often remain even after heavy spraying. Their effects sometimes can be minimized by spraying high enough above the surface so that the spray quickly dries on contact with the surface.

3. Artists working on wall murals should be sure that the wall surfaces are properly conditioned (neutralized) for the media they will use.

4. Artists preparing bare metals should use recommended methods of removing or stabilizing oxides. For example, metals that include iron should be prepared with a metal conditioner and rust inhibitor.

Undercoats

Undercoats fulfill various functions and usually can be sprayed or brushed. They may establish a white or colored surface, create texture, provide a surface that can be cleaned easily, or check chemical problems between the support and the painting media. These functions and others may be fulfilled by a specific ground medium or a number of qualities may be combined into one medium. For example, acrylic gesso is commonly used by artists on a wide range of surfaces with some porousness because it combines many functions: it provides a white surface; it seals reasonably well; it has excellent adhesive qualities as a primer; and it can be sanded.

The following descriptions may be useful in distinguishing ground materials:

1. Sizing is a thin, pasty substance that is used as a glaze or filler on such porous materials as plaster, paper, or cloth. Sizing is also used to stiffen flexible materials. It prepares surfaces for coats of media but is technically not a coating because it does not form a level, continuous layer.

2. Sealers and sanding sealers are used to prevent solvents used in some media from penetrating into lower surfaces. Some sealers are used over media containing dye pigments; this prevents bleeding.

3. Primers are used to improve adhesion on a surface such as metal so that paint overlays will have greater permanence. Some primers, such as ferrochrome, also function as sealers and are called primer-sealers. To a limited degree, primers serve as fillers that can be sanded. For this purpose, primers that have greater solid content are used to fill scratches, minor abrasions, and other indentations. Rougher surfaces are filled with glazing or spot putty, which includes even more solid content.

Preparing acrylic gesso grounds

The application and finishing of ground material will be different for various supports or grounds. The preparation of acrylic gesso grounds is discussed in more detail because so many artists (especially fine artists) work on supports that can be prepared with this material.

Acrylic gesso is essentially a surface material. It does not penetrate substantially into support materials. Acrylic gesso does not adhere well to glossy, nonporous surfaces. Some tooth or texture is necessary for it to grab.

Gesso can be brushed or sprayed; when sprayed it provides a smoother surface that may require less sanding. Remember that the spraying of large areas usually is accompanied by heavy overspray and particle fallout.

Gesso is a viscous material that should be diluted for spraying. It is best sprayed with an air gun (a small one on regular-sized supports). Diluted gesso can be sprayed through a large-barrel airbrush. When using a double-action airbrush, set the needle back a little so that the airbrush sprays simply by pressing down on the front lever.

Spray or brush the gesso onto the support in even layers **(16-8)**. You may want to apply it a little more thickly where there will be more sanding. It is best to apply several thin coats rather than one heavy layer. Spray from a variety of angles to ensure a more even coating and, where appropriate, good application to the sides of the support.

If you apply gesso with a brush, use a good quality, fine-haired brush that will not produce a heavy texture. To minimize texture, apply brushed coats first in one direction and then the other. Finish each brushed coat with strokes the full dimension of the

support and be sure that no excess material collects over the edges.

Even though holes or dents in the support surfaces may have been filled before the first coat of gesso, additional problem areas may become visible after the first coat of gesso dries. A convenient material for additional minor filling is the thickened gesso around the lip or lid of the can. Instead you can use acrylic modeling paste; reduce cracking by applying

16-9

only thin layers. A little acrylic medium, gesso, or gel can be added to acrylic modeling paste to reduce cracking.

Acrylic gesso and related water-soluble acrylic media that have thoroughly dried can be hand-sanded with wet or dry sandpaper (**16-9**). Depending upon how much gesso thickness or texture must be removed, use the appropriate paper coarseness. Gradually use finer grades of paper until the smoothness you wish is achieved. Work with a sponge and a small bucket of water. Wet both the sandpaper and the ground surface before sanding. If you begin to see the support or if you sand through the ground, stop sanding and apply more acrylic gesso. Continue this process of sanding and applying additional layers of gesso until you achieve an even, uniform surface.

Although commercially prepared acrylic gesso includes titanium white, you may still wish to apply a white base coat after the ground has been prepared and before starting the actual artwork. A toned ground can also be applied at this time.

Chapter 17 **Painting Overlay Surfaces**

The surfaces of airbrush paintings may require special treatment because they will show the results of soiling, damage or poor lighting. An overlay surface may be laid or spread over artwork as a coating or a separate sheet. In general, these surfaces protect, establish a better surface on which more media can be applied, and create or retain some qualities of the artwork. The properties of overlay surfaces and other factors that contribute to their use can be important.

Overlays are usually transparent so that visual qualities of the artwork can be retained. They should stay transparent and not turn yellow or in any other way change so that the painting is altered.

For reasons such as permanence, reproduction, and retention of the absorbent qualities of the surface, artists may want to keep the option of exposing the painted surface. In these situations, a removable overcoat or a sheet covering, such as glass, is used.

Reestablishing the painting surface may be necessary when the existing surface becomes unsuitable for additional layers of media. This may be because of a change in media or because the surface resists the addition of new layers of the same media. It may be necessary to coat the surface to resist bleeding from one surface to another. A loose material such as charcoal may have to be fixed to the surface to allow application of additional layers. A surface that has become too smooth may bead when sprayed. This can be countered by spraying high above the surface with an appropriate (compatible) medium. With this technique, the drops of spray partially dry before hitting the surface and do not level into a smooth surface. Workable fixative or a retouch medium that provides a tooth may be used to counter beading.

Additional factors in choosing an overlay may include hardness, smoothness, durability, reflective qualities, weight, and cost. See "Sheet Coverings" and "Overcoats" in this chapter.

Specific Uses of Overlays

Correction of viewing problems

Clear overlays may serve to retain or improve viewing conditions. For example, glossy surfaces may produce too much distracting glare that can be modified with a matte or satin surface. A porous surface may absorb the painting medium and produce the dead look of a matte surface. A proper overlay can make the colors look more vivid. Painted surfaces often reflect light differently; one part may be glossy and another matte. These uneven surfaces can be made more uniform with a clear overlay.

Surface protection

Overlays are used to counter problems caused by normal handling, transportation, storage, and weathering. They may be used to seal one layer of a painting from the next, preventing bleeding and similar problems of chemical incompatibility. A protective overlay may be a clear, possibly harder barrier, placed over the painting; or it may be a layer that is more resistant to scratches, abrasions, weathering, or other problems. Delicate collages, canvas or board paintings, murals, both indoors and out, and airbrushed paintings on cars or vans all may need extra protection.

The even, often delicate, sprayed layers of media usually need to be protected in some way. These surfaces seem to show scratches, abrasions, or other marks more than do surfaces created by other means. To counter this problem, some artists use very hard and durable paints such as those that are primarily designed for industrial uses. However, most artists use media that should be protected in some way. For example, a fragile material, like tissue collage, or one

that does not have a strong binder, like charcoal, can be strengthened or guarded with an overlay. For this purpose, a fixative or another medium that helps to bind or unify these materials with other areas of the surface may be used, or the painting surface may simply be covered with a transparent sheet material such as glass.

Cleaning

Sprayed surfaces often seem to attract dirt. Although the surface may look even and uniform, if it has a matte appearance, it probably has a miniature pebble-like texture that readily holds foreign material. A coating will fill these textured areas or a sheet material will, of course, simply cover it.

Cleaning can be a special problem on sprayed surfaces. Normal methods used on an unprotected surface may mar or in some other way alter the work. Overlay material must usually be strong enough to counter this problem.

Sheet Coverings

Sheet coverings allow the surface of the painting and possibly the ground to remain intact without any attached covering that might alter their visual appearance. Protective sheets can be removed quickly when it is necessary to see the work in its original state.

17-1

Because the sheet can function separately from the painting surface, it can be changed, discarded when damaged, or reused on other paintings. On the other hand, these sheets can be cumbersome, heavy (glass), expensive, or have reflective qualities that distract.

Glass

Glass is the most frequently used material on work that is hung for exhibition. This hard surface does not scratch easily and is easy to clean. Its limitations include fragility and weight. Its reflective surface can be a distraction. Nonreflective glass is not suggested because it can influence clear viewing of the painting.

Hard plastic

Hard plastics such as acrylic are lighter than glass and do not break as easily. They are often used on larger surfaces and on works that will be transported. This material is slightly more expensive than glass and it scratches easily so it should be protected carefully when handling, transporting, or storing. Clean hard plastics with mild soap and water, plastic cleaner, or polish. Do not rub the surface very hard, especially when abrasive dirt is being removed.

Thin plastic sheets

Clear, .005 mil acetate sheets are commonly used to cover graphic material. This thin, flexible material is also available in separate plastic envelopes or envelopes bound in folios. Cellulose acetate is commonly used under mats. It is relatively inexpensive, easily prepared, lightweight, and allows easy access to the painted surface.

Paper

Lightweight, flexible paper is often used as a protective layer. Tracing paper is most commonly used. This simple covering is usually used over light boards or matted material on work that will not be hung.

When using paper as a protective cover sheet, cut three sides exactly to match the borders of the board. The top of the paper should fold a little more than an inch down the back, where it is then taped. On the back, cut the paper at an angle so that it slants about one inch into where it is taped (17-1). It is best not to tape at the top of the board because the sticky side of

the tape becomes exposed when the flap is folded back. Crease from both the front and back sides so that the paper lies flat, either when the paper is covering the front or folded to the back.

Overcoats

Overcoats are adhered directly onto the painting surface. They may be of the same medium as the one used in the painting, as when acrylic medium is used on acrylic polymer. An overcoat may be of a contrasting medium, as when an acrylic fixative is used over designers' colors. Coatings should be compatible with the surfaces on which they are applied.

Coatings allow the work to be viewed without the obstruction of sheet coverings. They are a lighter, less expensive covering material than sheet coverings.

In addition to protecting the surface, overcoats have other functions that may be fulfilled by one or more media. They may fix, strengthen, or more firmly secure material to the painting surface; serve as a glaze that gives a glossy surface; provide a surface that can be polished; create a different texture or a tacky quality that can be reworked; or establish a barrier that prevents the colorant of a lower layer from bleeding into upper layers.

A variety of effects can be achieved with coatings, especially when they are sprayed. With the proper technique, it is often possible to create a coating that is not easily discernible. Notice that these layers usually cause some changes that may limit or improve the painting. Some coatings will slightly darken the painting and make colors appear brighter or imagery clearer. Coatings that actually produce a change in hue (such as yellowing) normally should be avoided unless a specific degree of tinting is desired. Note that most clear coatings will significantly darken or reduce the effects of pastels.

An overcoat allows control of the degree to which light is reflected from the painted surface. Coating materials may be formulated to produce a gloss, satin, or matte surface. A similar range can be achieved by altering the spraying technique used with a gloss medium.

A gloss will be achieved by spraying a wet (not too thick!) layer, especially over a smooth surface. A matte surface will develop when spray is applied high above the surface so that the drops partially dry before reaching the surface; spray lightly enough that

17-2

the surface does not get wet **(17-2)**. Be sure that you have normal room temperature and humidity when you do this or the spray may dry too quickly. These matte surfaces collect dirt and are harder to clean.

To develop a satin surface between the extremes of matte and gloss, first establish a matte surface. Let it dry thoroughly and then apply a wet gloss coat (preferable with a diluted medium).

Before coatings are applied, surfaces should be meticulously cleaned and possibly retouched. Unless this is done, all marks or damaged areas will be sealed in. As much as possible, work on overcoats in a clean and dust-free area.

Predetermine the thickness you need. Apply a series of thin coats rather than a very thick one. Apply even layers of the coating material carefully so that there is no flooding, dripping, or sagging. Be sure that the surface remains clean between applications.

After coatings have been applied, check the surface for any material that may have been immersed in the coating medium or may have fallen to the surface. Before the coating becomes too viscous (before it coalesces), this foreign material usually can be removed with a pin or a similar tool.

The clear coating you should use will depend upon the painting medium or other materials over which it will be applied. The surface you need is another factor. Among the coating materials that are available in spray cans for photo retouchers and graphic designers are some that yield matte, gloss, reflective qualities between matte and gloss, and coatings that prepare the painting for additional applications of media.

Artists working with acrylic polymer (or media over which this medium can be applied) may want to use either acrylic matte or gloss medium. If the manufacturer states that the matte medium is not formulated for an overcoat, it may cloud darker colors. In this case, an acrylic matte varnish is available that is meant to be used as an overcoat.

Clear overcoats are not always formulated to be permanently adhered to the painting surface. Removable varnishes are available in both liquid form and aerosol spray cans for oil and acrylic polymer surfaces. These picture varnish media can be applied and then safely removed with the proper solvent (usually turpentine), even years later when it may be necessary to clean or restore the painting.

Protective coatings can serve as buffer layers that guard the painted surface against dirt, scratches and marks that violate the surface. The overlay is a layer that will not easily rub away when cleaned. This coating should be thick enough or durable enough that scratches will not easily penetrate the surface; however, they should not be so thick that they become unnecessarily noticeable. Thicker coatings will show discoloration more than thin coatings. It should be possible to remove marks that have broken this surface but have not reached the painted surface. To do this, soap and water or the proper light solvent (often isopropyl alcohol) are rubbed into the area until the mark is removed. Before doing this, always try to test your solvent materials and the amount of rubbing you can exert. Always use lint-free rags or tissues such as Kimwipes when cleaning.

Chapter 18 **Setting Up the Studio or Classroom**

Studio spaces and classrooms used for airbrush painting vary according to the art being produced. They differ from other studios only in the way the requirements of spray are met. Instead of specialized air-painting studios, we normally see fine art, graphic design, taxidermic, and other studios or shops that are modified to permit use of airbrushes or air guns.

Studio requirements usually relate to aesthetic, health, and functional needs:

- Clean air, of the right temperature and humidity, free of excessive paint particle fallout.
- A pleasant, well-organized, clean work area.
- Appropriate and properly set up equipment and facilities.

Ventilation

Clean air must be available during airbrush painting. Health and safety require the removal of air which carries paint particles.

In recent years, artists have recognized the importance of good ventilation. This awareness is due to increased information on the immediate effects of inhaled contaminants and their long-range, unhealthy influence. (For additional information on pigments, vehicles, and solvents, see chapter 13.)

Unfortunately it is not possible to give numbers to describe the amount of ventilation necessary. In determining the velocity of air necessary to remove contaminants, consider the following points:

- The size (volume) of the space to be ventilated.
- The nature of contaminants. This may vary from solid particles to the vapors of volatile solvents.
- The amount of the contaminant at the point of generation and where the air is breathed. Ventilation to remove this material is important not only because of the immediate effects of overspray, but also because after prolonged spraying, the density of suspended dry particles in the air can build up to unacceptable levels. This is especially a factor when

there is the possibility of toxic pigments being inhaled.

- The degree of toxicity of the contaminant.
- The amount of evaporated or misted volatile solvent material in the air. It is important not to breathe substantial amounts of many of the solvents commonly used in lacquers, enamels, and varnishes.

Proper ventilation is determined by the number of air changes per hour. Local ventilation refers to the movement of air in a limited area such as a spray booth. General ventilation refers to large area (normally room) ventilation and usually costs more.

It is important for those who work with spray to be sure that they have good ventilation in their art studio or classroom. Experts in this field should be consulted before ventilation equipment and design are selected. Equipment dealers or environmental control officers can determine your needs according to government or industry specifications.

Although ventilation that recycles air may be appropriate where there is limited spraying with the airbrush, exhaust ventilation is necessary where there is heavy spraying and where air guns are used. Exhaust fans normally exit to the outside and ideally are not dependent upon open doors or windows. It is best to have them placed in front of the artist. The fan switch should be in a convenient place.

Proper ventilation can also be gained with a spray booth or an auxiliary spraying room. A spray booth is a temporary or permanent structure in which spray is contained and removed. It may be large enough to walk into or may be placed on a counter and sprayed into (**18-1** shows a bench-top model).

A spray booth is a box that may have one side (the front) open or closed with a door or curtain. In back (the direction of the spray) there is a filter; behind this is an exit fan that draws air through the filter. The fan motor should be separated from the fan with a belt, so the motor will not clog.

18-1 Courtesy of the Paasche Airbrush Company.

These spray enclosures may be used where it is necessary to spray heavy applications, where paint is sprayed over long periods of time, where extreme cleanliness is important, or where there is limited space and spray must be segregated from other activities. A spray booth is often used with such media as ceramic glazes.

The requirements of spray ventilation may also be met with hoods that include exit fans placed over the spraying area. These hoods are similar to hoods over kitchen ranges.

Temperatures and humidity must be considered when planning ventilation for airbrush painting. Above-normal room temperature may become a negative factor in spraying. The medium may dry too quickly at the airbrush tip. When techniques are used that require holding the airbrush far from the support, warm air may dry the spray too quickly.

These problems are greater when the humidity drops below normal levels. In studios with very dry air, a humidifier may be useful.

Artists in hot, dry climates may have problems spraying a medium such as acrylic polymer. A water evaporative cooler may bring moist air into the studio but may not cool sufficiently. An air con-

ditioner may cool the air but take out too much moisture.

Media such as acrylic lacquer may require the use of a dehumidifier under extremely humid conditions.

Work Area

The working area should be large enough to handle the painting support, palette, tools, and materials. Movement and viewing should be easy. The surface should be perpendicular to the spray. Tables or easels that can be adjusted for different angles are good. Set up the working area carefully so it is clean and uncluttered.

Be sure the hose is properly set up so that it does not become a nuisance. There should be a specific place to stand or lay the airbrush. Other materials that will be used should be positioned so they can be retrieved easily or will not get in the way. If your compressor is at some distance from your working area, you may wish to consider using a heavier auxiliary ½-inch hose (¼-inch ID) from the compressor to the working area. This heavier-duty hose can take minor abuse and be walked on. The more flexible, easier-to-handle ¼-inch (⅛- or ⁵⁄₃₂-inch ID) hose can be used at the working area.

Overspray

It is difficult at times to anticipate the results of overspray and particle fallout (suspended dried spray). Simple, procedural steps cover most problems.

First, after determining the amount of air and paint that will be used, cover any area that you do not want affected by spray, overspray, or particle fallout. This may mean covering all areas of the painting support and working area that are not to be sprayed, even when doing small-area spraying. Whenever the amount of particle buildup in the air will probably increase noticeably, the ventilating system will not at first be able to remove the particles fast enough. In studios where there is heavy spraying, it is advisable to store everything in cabinets or under protective covers.

Storage

Artwork storage areas also should be protected from overspray and fallout. If stray paint falls uniformly

over the surface of a stored painting, it may change the painting's color (normally its value). Because the changes are subtle, you may not notice them. After this, however, noticeable marks will be produced by touching the surface. If unplanned overspray or fallout reaches the painting's surface unevenly, areas with noticeable edges may be produced.

Delicate and even sprayed surfaces demand careful handling and well designed storage areas. Small scratches, abrasions, chips, dents, or smudges that would not be a problem on other surfaces may be unacceptable on a sprayed surface.

Studio Equipment

Compressor

If spraying is done on an individual basis, one or more portable compressors might be suitable; for airbrush classes, however, larger centralized compressors are best. Unless the compressor also services other areas, a five-horsepower, three-phase compressor on 220 voltage should meet most full classroom needs. However, compressor dealers should be consulted on how you can meet your special needs. Because of hazards and noise, the compressor should be placed outside the classroom in a secure place. It should be maintained regularly. If the classroom compressor is on during limited periods, you may want to have small, portable compressors for students who need to work at other times.

Air, electricity, and water

Air connections should be firmly attached and should be checked by brushing a water/soap solution over joints to test for air bubbles. Figure **18-2** demonstrates application of soap solution and bubbles formed by air leak.

Electrical wires and connections should be grounded and sufficiently protected for studio use. Electrical circuits should not be overloaded. Your compressor may require extra power in starting; greater demand is also placed on the circuit after the compressor has been running for a while. Be sure the

18-2

circuit used is rated high enough to handle the cumulative requirements of the compressor and anything else on the line.

It is important to have water available in the working area. Water containers must be changed, tools must be cleaned, and hands should be kept clean. It is easier to accomplish this if the water supply is a convenient distance from the working space.

Lighting

Lighting should be properly placed for full, virtually shadowless working conditions. Whatever lighting you select, recognize that its quality largely determines how you perceive color. Lights should be strong enough that subtleties of colors can be distinguished. Create the appropriate balance between warm and cool lighting.

There is disagreement among artists on the best lighting for spraying. Some believe in natural north lighting, a combination of natural and artificial lighting, tungsten lighting (usually where the work will later be viewed in settings using tungsten bulbs), combined tungsten (warm) and fluorescent (cool), a combination of warm and cool fluorescent tubes, or color-balanced, fluorescent bulbs. The color-balanced, fluorescent tubes are recommended here.

Appendix 1 **Annotated Materials**

This basic list is designed for most airbrush needs. Other materials are mentioned throughout the book; note especially the following areas:

Chapter 4 Masking and Stenciling
Chapter 7 Special Techniques
Chapter 9 Mixed Media
Chapter 11 Retouching
Chapter 14 Equipment
Appendix 2 Painting Media

An asterisk is placed next to the supplies required for the projects in this book.

Drawing supplies

Drafting set The compass is especially useful.

Pencils The 2H pencil is used for lightly drawn lines that should barely be seen. An HB is needed for regular work and a 3B to 6B for establishing strong dark and light contrast in preliminary value drawings.

Erasers Useful are a pink pearl for regular erasing, a plastic eraser for light erasing, and a kneaded eraser for picking up smudges.

Guides

* **T square and/or straight edge** Choose either a beveled, metal-edged T square or straight edge that is of sufficient length for the painting supports to be used. The metal edge is needed for cutting. The beveled edge allows a raised edge when turned one way and a flat, thin edge when turned the other way. The best ones are stainless steel. A variety of kinds and sizes is available. These edges may also be used as a raised bridge for guiding the brush or airbrush. (See "Miscellaneous Uses of Tools and Media" in chapter 7, for further information.)

* **Angles** A large, 12-inch 45- or 30/60-degree triangle is used as a drawing guide and as a spray guide. It is placed directly on the support or raised by placing it on another guide. A second triangle may be useful because of its angle and because it can be used with the first triangle to make a raised guide. You may want to have one clean guide for drawing and one over which to spray.

Curved guides, templates, and other guides These guides come in a variety of sizes and shapes. One French curve and one isometric ellipse guide is suggested for the beginning student. For projects in this book, a guide that includes major axis measurements of 1⅜ to 2½ inches is suggested.

Masking materials

* **Frisket materials** Unprepared, medium-weight frisket paper is suggested in projects in this book. You may also want to consider commercially prepared frisket paper or clear vinyl or cellulose acetate friskets.

Rubber cement and rubber cement thinner These are needed in preparing frisket paper, as is a rubber cement pickup, unless you prefer to prepare your own out of dried rubber cement (see details under "Frisket Materials" in chapter 4).

* **Frisket knife** One that will accept interchangeable blades is suggested. Frisket blades for the mechanical compass (in the drafting set) also are needed.

Sharpening stone A small, fine-textured, oil honing stone or a ceramic sharpening stone for the frisket knife is useful if you plan to sharpen blades rather than replace them.

Liquid stencil This latex base solution is brushed or penned onto surfaces as a mask and then peeled or rubbed off.

Acetate, .005 mil Used in making masking stencils (see "Preparing Acetate Masks" in chapter 4).

Miscellaneous Supplies

Dust brush

Fixative With designers' colors and watercolor dyes, use clear fixative to protect finished work. Use

workable fixative to control paint beading or crawling.

Magnifying glass This is needed to check the airbrush needle and tip, to check areas to be retouched, and to view finely drawn or painted areas. The small linen tester type is suggested.

Nonbeading or noncrawl medium These products can be put into water-soluble painting media to reduce surface tension and limit paint beading and crawling.

Painting supplies

Painting media See appendix 2. Designers' colors are used in most of the projects of this book. Dr. Ph. Martin's Synchromatic black watercolor dye is used in project 4.

Brushes

* *Bristle brush,* round no. 5 or 6. Used primarily for mixing paint, applying paint to the airbrush color cup, and cleaning out the color cup.

* *Sable brush,* round no. 3 or 4. Used for applying medium to the color cup and for line work. Large, round brush; a good quality watercolor brush is suggested for general use.

* **Plastic or porcelain palette** The type with round wells to store paint and rectangular slanted areas for mixing and thinning is suggested. To keep dried paint from popping out of the storage area of a plastic palette, the surface of the well can be sanded. This gives it the tooth to which dried paint can adhere (See **A–1-2**).

* **Water containers** In addition to the recommended airbrush jar assembly, two plastic water containers are useful. Clean your brushes in them in progression so that one is for dirty water and the other for relatively clear water.

Supports

Normally, airbrush painting requires a reasonably firm support that will not buckle when wet. Smooth surfaces usually are best because adhered masks such as friskets stick to them better and because spraying may exaggerate the appearance of rough textures. In addition to the following supports, you should have on hand a supply of clean, nonoily, and inexpensive papers and boards for practice, masking, and covering.

* **Illustration board** Inexpensive illustration board

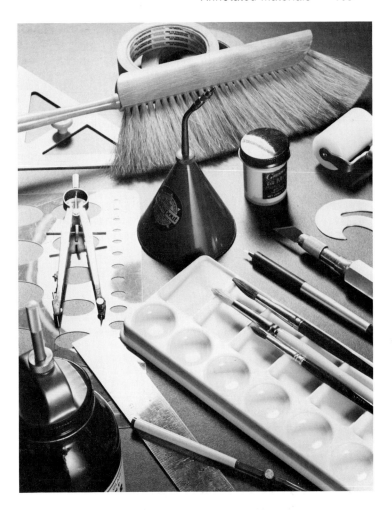

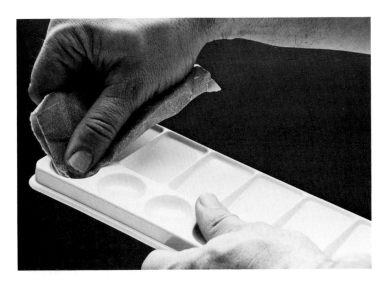

is used in the projects in this book. A good quality, cold-press board is recommended for general use.

Other supports Depending upon your objectives you may wish to consider other supports, which are explained in more detail in chapter 15: 3-ply bristol board (kid finish), heavy watercolor paper (note the texture), or a hardboard such as medium-tempered Masonite or canvas.

*** Tracing pad, 9 by 12 inch or 14 by 17 inch** Because this paper is semitransparent, corrections can be planned on it while it is placed over the work. It can be used as a protective cover for finished work. Tracing paper can also be used as a mask with tape or when prepared with rubber cement.

Tapes

Masking tape The adhesive on masking tape will rip paper and paper boards. It is suggested for general use on other surfaces. The ¾- or 1-inch width is suggested.

*** Drafting tape** This tape is suggested in the projects because, when carefully and correctly used, it works well on illustration board. The ½-inch width is suggested.

Charting and graphic art tapes For tape masking that requires more precision.

Teflon tape Used to wrap the threads on fittings to stop air leaks.

Jeannie Kim. Student work, 1979.

Appendix 2
Painting Media

The painting media suggested in this book are for general use and have been selected according to the way colors interact to produce a balanced and complete color range.

Only selected palettes for water-soluble paints and watercolor dyes are included. In selecting your own palette, consider interests and needs and the degree to which you want to mix your own colors. For example, consider the range of color that can be mixed from a limited selection of tubes or jars of color. Commercially prepared colors offer a limited color range; palette mixing, of course, allows for the creation of many variations. Through spraying it is possible to broaden this range substantially.

Gouache

Gouache is an opaque, water-soluble paint.

Retouch grays

Retouch colors, such as the Grumbacher Gama retouch series of black, white, and grays, are designed primarily for photo retouching. They come in cool, warm, and neutral series. If they are used for projects in this book, the neutral series of grays plus black and white is suggested.

Designers' colors

Because the beginning series of projects emphasizes the use of limited palettes, only a selected number of designers' colors is suggested at first. A broader palette is selected for later projects. Colors are selected on the basis of how well they mix and their relative permanence, opacity, and tendency to bleed (stain). In addition, a few lake colors are listed for artists who are not concerned with permanence and wish to use more brilliant colors.

One asterisk (*) designates the minimum palette

for all projects in this book. Two asterisks designate suggested palette additions for projects 9 through 14.

* Lemon Yellow	Olive Green
* Cadmium Yellow	** Yellow Ochre
Pale	** Raw Umber
* Cadmium Orange	** Burnt Sienna
Orange Lake Light	Red Ochre
Flame Red	
* Cadmium Red Pale	* Permanent White
Geranium Lake Pale	* Ivory Black
* Alizarin Crimson	* Gray No. 2
Purple Lake	* Gray No. 4
* Ultramarine Blue	
** Phthalocyanine Blue	
Viridian Lake	
* Phthalocyanine	
Green	

Transparent Watercolors

This traditional medium of the watercolorist is an excellent complement to the opaque designers' colors. Although they are not quite as easy to use as transparent dyes, watercolors are a better choice for the fine artist because of their high degree of permanence. Artists who work with both designers' colors and transparent watercolors on the same work are encouraged to work with the same brand to achieve better palette uniformity.

The asterisks in the left column designate a recommended limited palette designed for artists who wish to complement their designers' colors palette with transparent overlays. The full palette is suggested for those who will use this medium extensively. All are considered of acceptable permanence for the fine artist.

* Lemon Yellow	* French Ultramarine
* Cadmium Yellow	(Blue)
Pale	* Phthalocyanine Blue
Cadmium Yellow or	Hooker's Green
Yellow Deep	Dark or Viridian
* Cadmium Orange	* Phthalocyanine
Cadmium Scarlet	Green
* Cadmium Red Deep	
* Alizarin Crimson	Yellow Ochre
Violet	Burnt Sienna

Indian Red or	Sepia
Venetian Red	Payne's Gray
Raw Umber	Olive Green
Burnt Umber	

NOTE: If black is included in the palette, Ivory Black, the most transparent, is suggested.

Transparent Watercolor Dyes

Transparent watercolor dyes are very transparent and include brilliant colors. Because of the problem of permanence, they should be used for graphic design work prepared for reproduction.

This palette is based on the Dr. Ph. Martin's Synchromatic colors, which are more transparent and less viscous than Dr. Ph. Martin's Radiant colors or the Luma colors. The asterisks designate a limited palette.

* Lemon Yellow	Hooker's Green
Cadmium (Yellow)	
Chrome Yellow	Yellow Ochre
* Cadmium Orange	Van Dyke Brown
* Scarlet	Sepia
* Magenta	
Violet	Light Gray
Payne's Gray	Medium Gray
* Ultramarine	Dark Gray
Cerulean Blue	Black
* Nile Green	

NOTE: Special opaque whites are available that retard bleeding when it is necessary to white out areas sprayed with dye. Workable fixative can be used to retard bleeding from one layer of watercolor dye to another.

Acrylic Polymer

Because of the properties of the acrylic binder, these paints are durable, waterproof, and can be applied with a great range of techniques. The preparations sold in jars are more appropriate for airbrush painting than those sold in tubes.

A limited palette may be especially useful with these paints because acrylics cannot be remoistened once they harden. With this limitation, it is feasible

for you to mix an amount that is close to what you will use immediately, or to prepare a few jars of diluted colors that are ready to spray.

The asterisks designate a limited palette that includes both transparent and opaque colors. The colors designated as transparent may be selected as a limited watercolor palette.

Yellow Light, Hansa (transparent)	Phthalocyanine Blue (transparent)
* Cadmium Yellow Light	* Phthalocyanine Green (transparent)
Yellow Orange, Azo (transparent)	Chromium Green Oxide (included because of its opacity) or Hooker's Green (transparent)
Cadmium Orange	
* Cadmium Red Light	
Naphthol Red Light (transparent)	
* Naphthol Crimson (transparent)	Yellow Oxide (Ochre)
Quinacridone Violet (transparent) or Dioxazine Purple (Violet)	Burnt Sienna Raw Umber
* Ultramarine Blue (transparent)	* Titanium White
Colbalt Blue (included because of its opacity)	* Mars Black (warm)

Glossary

Acrylics Plastic media derived from acrylic resins.

Acrylic Polymer Water miscible medium which has an acrylic resin base.

Additive and Subtractive Technique Process of attaching media to or removing media from a painting surface.

Aerial Perspective One system for two-dimensional representation of three-dimensional views. Distant objects are shown smaller, sometimes bluer, and with less contrast, clarity, and color intensity than near objects.

Aerograph The name used for the first airbrush.

Air Supply The source of air used: compressor, CO^2 tank, etc.

Airbrush A tool the size of a large fountain pen; operated by compressed air and used to spray fluid onto surfaces.

Airbrush Holder A device for holding the airbrush when not in use.

Air Eraser A miniature abrasive gun (sandblaster), the size of a large-barrel airbrush, which has a container mounted on it for abrasive material and is operated by compressed air.

Air Gun A spray gun operated by compressed air. Air guns are used for industrial, production, and home uses; artists also use them for large-scale work.

Art Elements Non-objective graphic devices. The following terms are used in this book: line, shape, form, color, surface, texture, space, and plane.

Art Fundamentals Art content which includes the elements and principles of design and perspective.

Art Principles of Organization Principles which guide the use of art elements. These include harmony, contrast, direction, balance, and rhythm.

Assemblage Three-dimensional art which contains a combination of various materials or objects (cf. **Collage**, which is two-dimensional).

Assembly Jar A glass container for fluids. The lid

has a connected stem which can be inserted into an airbrush.

Atomizer A device for changing liquids into spray or mist.

Basic Geometric Form Simple three-dimensional form that relates to two-dimensional geometric shape; cube, cylinder, cone, and sphere.

Binder The cementing substance in a paint vehicle.

Bleach Verb: to remove or diminish transparent color on paintings or photographs.

Bleeding The process of a colorant staining from one layer or area to another. For example, the watercolor dye from a lower layer may bleed through a top layer of gouache.

Bleeder and Non-Bleeder Guns Bleeder air guns always have the air on. Non-bleeder guns have a valve which stops the air when the trigger is released.

Brayer A hand-operated roller which may be used to mount photographs and frisket material.

Bridge A raised surface or edge over a working surface, used to steady or guide the hand.

Bristol Board Light board available in several thicknesses.

Cel An acetate or paper overlay. This term is commonly used in animation.

CFM Cubic feet per minute.

Chiaroscuro See **Light and Shade Theory.**

CO2 Tank Heavy metal tank containing compressed carbon dioxide.

Coldpress A medium-smooth, kid surface on paper or cardboard. Coldpress is usually recommended for airbrush painting.

Collage Artwork which is essentially two-dimensional and includes materials attached to the support.

Color Schemes Systems used to designate the predominant color combinations occurring in a composition. They are most easily understood with the use of a color wheel. *Monochromatic*—one hue. *Analogous*—hues adjacent to each other on the color wheel; will combine to make color variations between them. *Complimentary*—hues opposing each other that make gray when mixed.

Color Cup For an airbrush, a removable metal container for fluids that has a connected stem which can be inserted into an airbrush.

Colorant Material such as pigment which provides the color in paint.

Composition The visual sense of orderliness in a design.

Compressor A machine which utilizes a motor, pump, and other devices to compress gaseous material. *Safety precautions should be followed when using pressurized gasses.*

Compressor Check Valve Valve which controls the direction of air so it flows only from the pump. Compressors may use combination unloader and check valves.

Compressor Relief (Pop-off) Valve Device which releases excess pressure in a compressor tank; *important for safety.*

Compressor Tank A reserve container that allows air pressure to build up and compressed air to be stored so that it can be released as needed. Reserve tanks also reduce the pulsation caused by the pump.

Compressor Unloader Valve Valve which discharges pressure in the air lines so the compressor doesn't have to work against pressure when it starts again.

Copolymer A medium which contains more than one kind of plastic molecule. Artists frequently use paints which include both acrylic and vinyl resins.

Cross-section A rendering which is drawn to look as though it has been cut all the way through.

Cutaway A rendering which is drawn to look as though it has sections or layers removed so that interior areas can be observed.

Diluent A material that dissolves or dilutes.

Double-action Airbrush An airbrush which is operated by pressing down on a nob for air and pulling back for medium. Most double-action airbrushes utilize this independent action; there is a fixed-double-action airbrush which mixes the fluid and air with one movement of the finger lever, as well.

Drybrush A brush technique using thick paint to create a textured effect. The paint does not evenly cover all of the surface, but leaves parts of it exposed.

Drymount The process of applying flat material (usually paper) to a surface with mounting tissue and a hot iron or press.

Dye A colorant which is soluble in its medium. Dyes are used to stain surfaces or to be absorbed into materials like textiles or inert pigments (cf. **Paint**).

External Mix Variety of air tool in which fluid is atomized with air outside the spraying tool's head assembly. In internal mix, fluid and air mix within the head assembly, producing a more uniform spray. The spray from external mixing is usually coarser than that of internal mixing.

Figure-ground Relationship The manner in which shapes, forms, and objects relate to what is around or behind them.

Film Masking See **Masking**.

Filters Devices for collecting water, oil, dirt, or dust particles. Filter/moisture traps block the travel of contaminants from the air supply to the air tool. Filters may be placed where air enters the compressor, as well.

Fixative A fluid, normally sprayed over surfaces to hold particles or in some way protect art work. Workable fixative is formulated so that work may be continued after the fixative is applied.

Fixed Double-action See **Double-action**.

Flocking Gun An air gun used to obtain suede- to velour-like surfaces by blowing a fine fiber material onto a surface prepared with adhesive material.

Frisket Mask made of relatively thin paper (tissue) or plastic (film) and coated with an adhesive that provides a tacky surface. Frisket material should cut easily with a frisket knife and easily release from the painting surface after it is used.

Frisket Knife A very sharp knife which has a blade angled for optimum cutting through friskets. There are three basic kinds: the fixed blade, the removable blade, and the swivel blade.

Gesso A white coating material which includes chalk and a binder, normally used as a ground for painting.

Ghosting Rendering internal areas which are not normally visible to the eye; shown as though the viewer is looking through almost transparent outer layers.

Glaze A layer of transparent color on an underpainting.

Gouache A water miscible, opaque paint (cf. **Watercolor**).

Gradation A gradual change of value, intensity, or hue from one area to another.

Gravity Feed Variety of airbrush in which the medium flows from a container on top of the air tool down to the air tool point, where the medium can be sprayed in combination with air. See **Siphon Feed**.

Ground The surface over which the paint is applied. The ground may be the material of the support or an intermediary substance between the support and the paint medium.

Gauges, Air Devices which indicate tank pressure or the pressure released to an air tool.

Hardboard Support A sheet material, commonly used for construction purposes, and used by artists as a painting support.

Hotpress A kind of surface on paper or cardboard, very smooth.

Independent Double-Action See **Double-action**.

Internal Mix See **External Mix**.

Kid Finish A slightly textured, medium-smooth surface, recommended for airbrush painting.

Light and Shade Theory The methodical use of value to describe light, shade, and shadow as they present the illusion of three-dimensional forms. There are usually six value areas: highlight, quarter tone (or light tone), halftone, base tone, reflected light, and cast shadow.

Linear Perspective A representational system in which distant objects are shown smaller than near ones, parallel lines converge, and close objects may obscure those which are distant.

Liquid Cleaners Solutions used in cleaning airbrushes, pens, and other metal tools, especially precision tools. Liquid cleaners include detergents and wetting agents that help loosen or dissolve foreign matter. They can be used in ultrasonic cleaners.

Liquid Mask A masking material which is applied in liquid form and sprayed over after it has dried.

Mask In airbrush painting, a device for preventing spray from reaching portions of a surface.

Medium Plural: Media. **(1.)** A mode of expression in art or the material used for expression; e.g., printmaking or printing inks, painting or paints, sculpture or the stone used in sculpture. **(2.)** A liquid mixed with an art material to give it the ability to flow; will not decrease binding, adhering, or filmforming qualities.

Miscible The quality of being mixable or easily mixed; water miscible media, for example, can be blended and dispersed with water.

Mixed Media A combination of media materials used in a work of art (e.g., gouache, charcoal, collage).

Mixed Technique A combination of techniques used on an artwork; e.g., airbrushing, brushing, printmaking, and drawing. With mixed techniques, one medium or mixed media may be used.

Moisture Trap See **Filters.**

Montage A composite of different pictures (usually photographs or prints) in a composition; a montage is a specific kind of collage.

Mouth Sprayer A simple spray-producing tool usually made of two tubes. A thin tube is held upright with one end in the liquid. One end of a thicker tube is blown through while the other end rests on and perpendicular to the upper end of the thin tube. Airflow through the thick tube draws fluid up the thinner tube and propells the fluid as spray. *Use caution to avoid drawing the liquid backward into the mouth.*

Nozzles, Air In air tools, the part which includes the opening through which fluid is released. There are internal and external mix air nozzles. See **External Mix.**

Oil Colors Paints with pigments that are dispersed in an oil such as linseed oil.

Opaque Not able to let light through. Opaque layers block any view of layers which they cover. See **Translucent** and **Transparent.**

Overcoat Liquid applied to a painted surface for the purpose of protecting, glazing, producing texture, or producing a surface which can be polished.

Overlay Surface A sheet or a coating which is laid or spread over art work.

Overspray (1.) Noun: the excess spray which occurs outside the area toward which the air tool is directed. **(2.)** Verb: to modify or alter with a layer of spray.

Paint A fluid, coating medium composed of pigments dispersed in a vehicle (a binder and sometimes a diluent) and, possibly, other ingredients. Paints are designed to cover, color, or protect surfaces (cf. **Dye**).

Palette (1.) A surface on which paints are organized and mixed. In airbrush painting, palettes normally include mixing wells for preparation of diluted media. **(2.)** The selection of colors an artist uses.

Perspective Formation of line, shape, or color to project in two dimensions the character of a three-dimensional view, showing depth, distance, or position. See **Aerial and Linear Perspective.**

Photo Retouching See **Retouching.**

Pigment A fine particle material used as a colorant; not soluble in paint vehicles.

PSI Pounds per square inch; a measurement of air pressure.

Power Eraser A device which holds and spins a long cylindrical eraser. Erasers with various abrasive qualities are available for various surfaces and media.

Pressurized Containers Metal tanks and cans filled with compressed gas which can be used to provide the propellant for air tools. *Safety procedures should be followed when using pressurized containers.*

Production Work The construction or finishing of products used in sales, display, reproduction, etc.; may demand elementary or advanced airbrush skills.

Propellant The air or gas used to operate an air tool.

Quick Connector Couplers Fast release devices that are connected to hose fittings and allow easy hose changes.

Rag Content The percentage of pure cellulose in fine art paper. The best fiber is linen or cotton.

Reamer, Cleaning A needle-like tool which is used to clean the airbrush tip or needle channel.

Regulator, Pressure A device which controls the pressure to the air tool.

Rendering Two-dimensional graphic work that clearly describes a subject; "rendering" is a more specific term than "illustrating," and usually refers to work demanding greater accuracy.

Respirator A filter worn over the mouth or mouth and nose to prevent inhalation of harmful substances.

Retouch Colors Media specifically formulated for photo retouching.

Retouching The process of making alterations by adding, deleting, correcting, or restoring. Photo retouching on prints, transparencies, and negatives is an important area of airbrush painting.

Shape The configuration of a two-dimensional surface. Basic geometric shapes are the rectangle, triangle, and circle.

Sheet Covering Protective, flat overlay material, such as acetate or glass, not adhered to the painting surface.

Single-action Airbrush An airbrush operated by pressing down on the finger lever for both air and medium.

Siphon Feed A kind of airbrush in which air, passing over the opening for fluid, creates a partial vacuum. This draws the liquid up or over to where the air can spray it.

Solvent A substance that will dissolve another substance. A volatile solvent is an organic liquid which easily evaporates and is used to thin or dissolve oils, synthetic resins, or lacquers. *Safety procedures should be followed when using volatile solvents.*

Spray Booth, Hood, or Enclosure A structure designed to protect other areas from spray and particle fallout and to protect painted surfaces by removing overspray and particles from the immediate area.

Stencil A mask which can be used repeatedly.

Stipple A coarse spray which produces a grainy, evenly-textured effect.

Subtractive Technique See **Additive Technique**.

Support, Painting The physical material and structure on which painting media are applied; e.g., paper, hardboard, stretched canvas.

Template A guide that is accurately formed for the purpose of providing a prescribed, measured shape. Templates and other pre-cut stencils may be used as masks in spraying.

Thinner A volatile liquid used to thin or dilute paint. *Safety precautions should be followed when using thinner.*

Thinning In painting, the process of making media more fluid, using the proper diluent.

Tooth The slightly roughened texture on grounds. The proper tooth allows good adhesion of applied media.

Translucent Allowing light to pass through, but diffusing the light. Objects behind translucent materials are not distinguishable. See **Opaque** and **Transparent**.

Transparent Allowing light to pass through without significant diffusion or clouding. Objects behind transparent surfaces are clearly distinguished, although they may be distorted or partially hidden by reflections. See **Opaque** and **Translucent**.

Ultrasonic Cleaners Devices which clean by the agitation of sound waves beyond the frequencies audible to the human ear. Sound waves are passed through fluid (water, water-soluble cleaners, volatile solvents, etc.). This method can clean interior, hard to reach areas of airbrushes.

Undercoating Any preliminary layer of a painting between the support and the painting itself. An undercoating may be the painting's ground, a support conditioner, sizing, sealer, or primer.

Underpainting A preliminary stage of a painting such as a background color, an application of texture or pattern, or any early stage on which later stages are directly or indirectly applied (as with an overlay in animation).

Value The lightness or darkness of a color.

Vehicle A liquid in paint which serves as a binder for pigments and makes the paint adhere to surfaces. The term can also apply to the diluent or a mixture of the binder and diluent.

Vignette Verb: To gradually shade an image off at the borders of a work or isolate a subject by spraying surrounding areas. This term may be used as a noun, as well.

Viscosity A liquid's resistance to flow.

Viscosity Cup A device, also called a viscosimeter, used to measure the correct thickness of paint for spraying.

Volatile Solvent See **Solvent**.

Watercolor A water miscible paint with a gum arabic or similar binder. Watercolors are more transparent than gouache media.

Workable Fixative See **Fixative**.

Bibliography

Out of print books are designated with an asterisk (*). Sources which normally may be obtained only through airbrush or other specialized suppliers are designated with two asterisks (**).

Dember, Sol. *Complete Airbrush Techniques*. Indianapolis: Howard W. Sams and Co., Inc., 1974.

*Fluchere, Henri A., Grainger, Melvin J., Musacchia, John B. *Airbrush: Techniques For Commercial Art*. New York: Reinhold Publishing Corp., 1953.

*Kadel, George W. *Air Brush Art*. Cincinnati: The Signs of the Times Publishing Co., 1939.

**Knaus, Frank J. *How to Paint With Air*. Chicago: Paasche Airbrush Co., 1947.

Maurello, Ralph S. *The Complete Airbrush Book*. New York: Wm. Penn Publishing Corp., 1955.

Missteas, Cecil. *Advanced Airbrush Book*. New York: Van Nostrand Reinhold Co., 1984.

Paschal, Robert. *Airbrushing for Fine & Commercial Artists*. New York: Van Nostrand Reinhold Co., 1982.

Rubelmann, Steven D. *Encyclopedia of the Airbrush: Volume One, Basics*. New York: Art Direction Book Co., 1981.

———. *Encyclopedia of the Airbrush: Volume Two, Work Procedures and Maintenance*. New York: Art Direction Book Company, 1981.

*Tobias, J. Carroll. *A Manual of Airbrush Technique*. Boston: American Photographic Publishing Co., 1941.

Tombs Curtis, Seng-gye and Hunt, Christopher. *The Airbrush Book*. New York: Van Nostrand Reinhold Co., 1980.

Vero, Radu. *Airbrush: The Complete Studio Handbook*. New York: Watson-Guptill Publications, 1983.

Books with Specialized Content

Childers, Richard H. *Air Powered: The Art of Airbrush*. New York: Random House, 1979.

Haynes, Michael D. *Haynes on Air Brush Taxidermy*. New York: Arco Publishing, Inc., 1979.

**King, Walter S. and Slade, Alfred L. *Airbrush Technique of Photographic Retouching*. Chicago: Paasche Airbrush Co., 1965. This is a briefer version of the out-of-print edition published in 1954 by the Macmillan Company.

Podracky, John R. *Photographic Retouching and Air-Brush Techniques*. Englewood Cliffs, New Jersey: Prentice-Hall, Inc., 1980.

Booklets

**Caiati, Carl. *Air-Brushing Techniques for Custom Painting*. Franklin Park, Illinois: Badger Air-Brush Co., 1981.

**Caiati, Carl. *Hobby & Craft Guide to Air-Brushing*. Franklin Park, Illinois: Badger Air-Brush Co., 1978.

**Clark, G. Maynard. *The Art of Airbrushing for Ceramics and Crafts*. Los Angeles: Potluck Publications, 1977.

**Desauteis, Donald S., ed., Davenport, Donald J., contributing ed. *Paint by Ditzler: Custom Finishing Systems*. Southfield, Michigan: Ditzler Automotive Finishes PPG Industries, Inc., 1977.

**Gick, Terri L. *Sandblasting, Etching and Other Glass Treatments*. Laguna Hills, California: Gick Publishing Inc., 1980.

**Scharff, Florence D. *Airbrushing with Stains*. Hapeville, Georgia: Florence's Rainbow Products, 1973.

**Ditzler Repaint Manual*. Southfield, Michigan: Ditzler Automotive Finishes PPG Industries, Inc., 1976.

Subject Index

W

Water containers, 169
Watercolor
 dyes, 99, 130, 171
 transparent, 99, 111, 171
Wood, 124

X

Xerography, 100

Artist Index

Allison, Gene, VIII, color section, 108, 119
Altoon, John, color section

Bengston, Billy Al, color section
Caiti, Karl, 124
Close, Chuck, 5
Dailey, Dan, 126
Davis, Brian, VIII
Eddy, Don, 122
Fitzpatrick, John, 127
Fullner, Norman, color section
Glass, Sylvia, 26, 123
Grubb, Louis, color section
Hanson, Duane, color section
Heinz, Peter, 127
Jervis, Margie, 126
Kandinsky, Wassily, 3
Krasnican, Susan, 126
Leech, Richard, VI, 107, 108
Litschurt, William F., 117, 119
Marsh, Cindy, 100
Melia, Paul, X, 106
McGinty, Mick, 73

Molly, 124
Monahan, Leo, 102
Olitski, Jules, color section
Petty, George, 4
Polombi, Peter, VI, 2, 104
Przelomiec, Chester, 64, 97
Rodriguez, Robert, VIII, 70
Sarkisian, Paul, color section
Scoble, Nansea, 125
Schorr, Todd, VIII, color section
Shepard, Otis, 5
Spencer, Duncan Allison, 110
Valentine, De Wain, color section
Walt Disney Productions, 105
White III, Charlie, color section, 87
Wild, Tim, 118
Willardson, Dave, color section, 105
Zaslavsky, Nancy and Morris, color section

Marking and mutilation of books are prohibited
by law. Borrower is responsible for all material
checked out under his name.